Richard Tuttle

I Don't Know

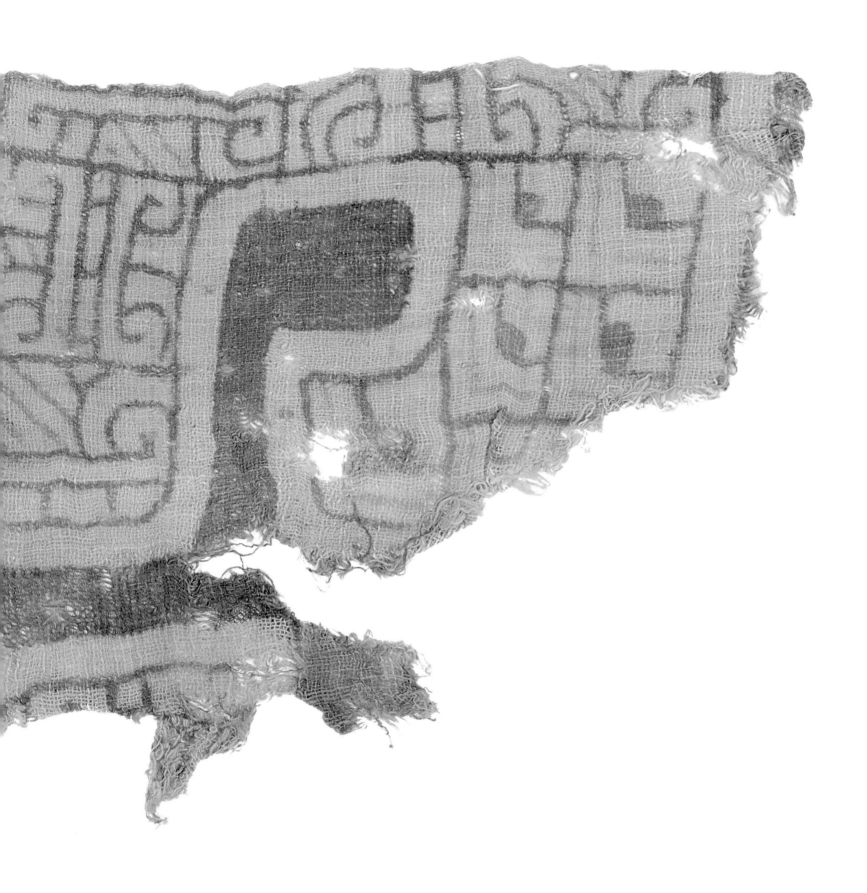

Tate Publishing
Whitechapel Gallery

The Weave of Textile Language

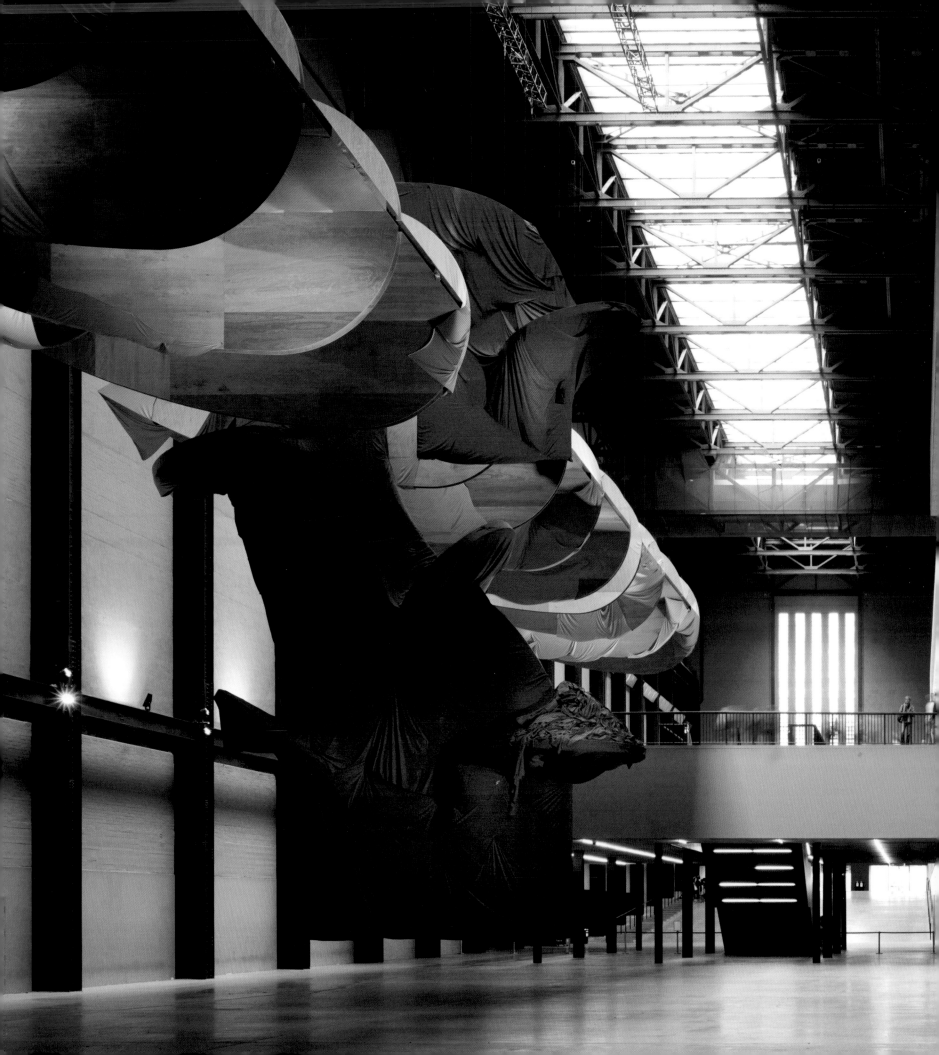

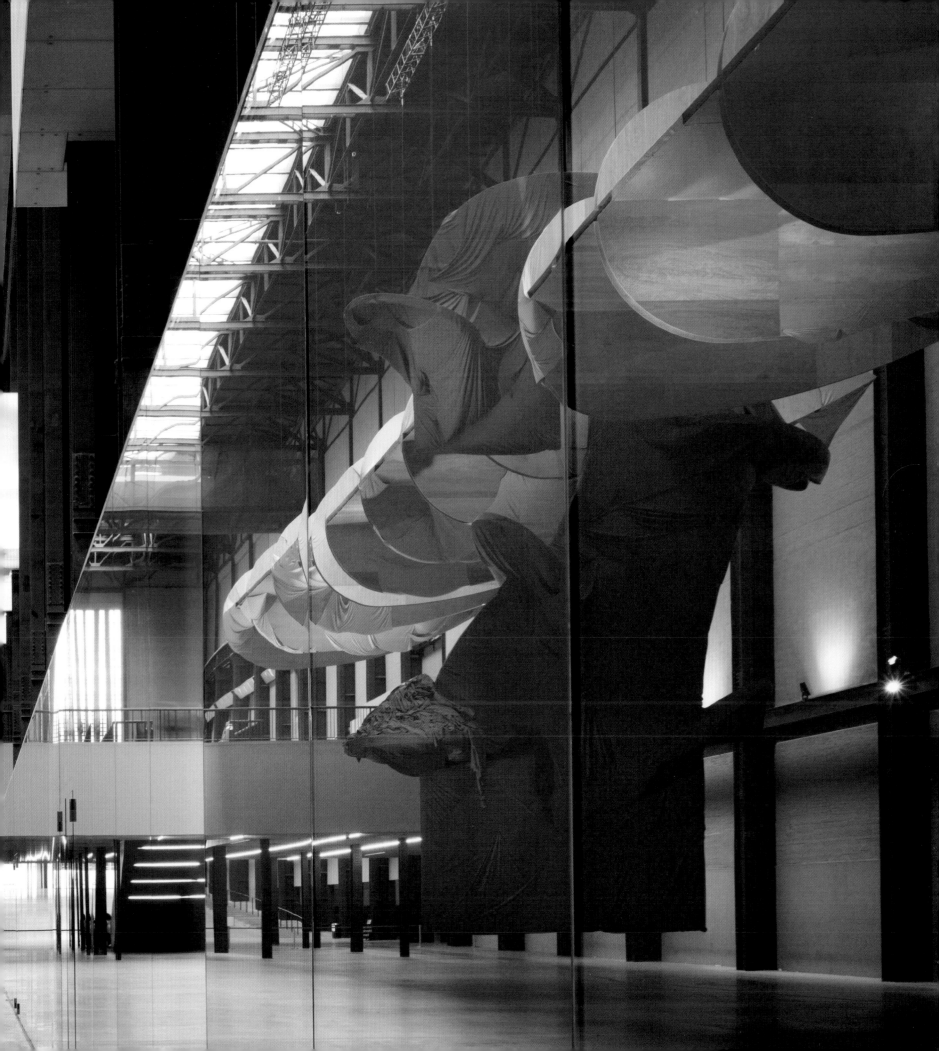

I

Reveal

A Structure of Space

RICHARD TUTTLE

While comfortable with the mystery of textile, there is yet a mystery of language. Connected to sounds we make – meanings attach themselves when sounds are produced in certain order. While phenomenal, I don't know if it is yet mysterious. Mystery comes when we are aware that the slightest interjection of a sound can create huge difference in meaning. The centre holds, parameters do not. Proportions, normally assessed, are useless, redundant (in terms of schema), are often replaced by wonder. The brain's electrical pathways, and schema they use, evaporate. If that is not mysterious enough, being of this world, which we can see, feel and touch, it can only happen where we can't see, feel, touch. It suggests existence of a grammar already in place. Oddly, we are able to imagine a structure for this grammar, a structure which must be interwoven, for a grammar is what makes a language have sense and meaning. I don't know how a grammar may be interwoven, then, as a textile in schema.

Though grammar may be out there, we may like to have it in here. When we employ it in language, it disappears, becomes arduous to learn, practise, expound. The mystery, so full of light out there, becomes dark in here. The textile weave is more available for being out there, not in here.

If grammar is the heart of language, what is its ground? Where does it sit? Where is out there? Well, the unknown. Does language give us a healthy relation to the unknown? If so, is it because of the structure of the weave in which it sits? How odd: grammar is one thing, language another. They are far apart, must be – one of the most exciting of all relationships – connected but so far apart. Where is language? Definitely not out there. Out there is already occupied by its opposite. So let's look for the most opposite place not out there but in here. So 'in here' has to be unknown. What is in here and cannot

be known? You could say language, but language is knowable. Anything knowable is speakable. How do the two – the known and the unknown of language – come together? You guessed it, the weave. But this time I don't know how to imagine it. For that we need love. Where the weave must be unknowable, though here, and language must be knowable, we cannot know (feel, touch) the weave until it passes through love.

How to bring out-there weave and in-here weave together to make something good? The great weaver is necessary, the one who has access to out-there and in-here. Tangible, she must understand the very threads she uses, answering a huge need – and able to unify all but unfathomable complexity – cannot really unify and, in fact, should not. This is why some of the greatest weaving traditions agree, the master weavers are the ones who can weave the most space into their work. As we know, available space, because of its availability, is perfect, both out there and in here. I don't know what happens to the great weaver who spends his life bringing these perfections together, weaving, managing fullness by making fullness. Through the work of the great weavers, we can know the perfection of the unknowns that surround. I don't know if the only way we know this is that we know, through the mystery of language, how this world is perfect too?

Reveal comprises textiles and texts selected by Richard Tuttle, design by Mark Thomson with photography by Nick Danziger.

Dust sheet, industrially produced felt, early twenty-first century

1. If a young girl is along for the sowing, who is being initiated for the first time into the work, this is the occasion for a small feast. Everyone dances late into the night to the sounds of the bamboo zither, the goatskin drums and the xylophone. The girl dresses in all her finery because she, especially, must dance by herself. Around her wrists and ankles she wears chains of cotton bolls that rustle softly during the dance; with both her hands she flourishes finely woven cloths. The village girls are wont to blow cotton fluff in her face and ears, to throw it into her hair, and to play other tricks on her. She is sure to find bolls and cotton fluff in her fish sauce; while trying to fall asleep she will leap from her pillow because it has been filled with cotton bolls … No young man, on the other hand, may dare the slightest affront to the newly initiated girl. For him she personifies the cotton maiden, who assumes a mystical and awe-inspiring relationship to the spirits. However, a young man will try to catch a bit of cotton fluff that falls from her and hide it against his chest as a charm to protect against attack by animals, humans, evil spirits, and angry souls of ancestors. (Tietze 1941, p.12)

Tietze, Käthe, 'Sitten und Gebräuche beim Säen, Ernten, Spinnen, Ikatten, Färben und Weben der Baumwolle im Sikka-Gebiet (östliches Mittel-Flores)', 1941, *Ethnologica*, vol.5, pp. 1–64
as quoted in Roy W. Hamilton, *Gift of the Cotton Maiden: Textiles of the Flores and Solor Islands (Indonesia)*, Los Angeles 1994, p.12

13

Possibly upholstery, French or Italian brocade, silk, eighteenth century

Possibly upholstery, French or Italian brocade, silk, eighteenth century (verso)

2. Indian textiles apparently have been a major export article from the subcontinent for several thousand years. The production of fabrics was already well documented by writers of Mediterranean antiquity, and references to the cloth trade can be found in Chinese, South-East Asian, and Islamic sources, all of which pre-date the arrival of Europeans as participants in the maritime Asian economy by centuries. However, while text documents are revealing as historical evidence, they cannot supply any visual impression. When one finds a reference in Pliny's *Natural History* about the transparent nature of Indian muslins, or reads in eleventh-century Javanese records about the sumptuous quality of certain types of cloth possibly brought from India, one cannot have a mental image that reflects anything actually seen from that distant past. Unlike stone and metal sculpture, textiles do not generally survive.

Yet it is certain that the making of cloth was a major industry on the one hand, and the source for artistic invention and creativity, on the other. The silk industry of China and the manufacturers of cotton goods in India were the suppliers for a pan-Asian market that extended into Mediterranean societies certainly by the time of classical antiquity. The combination of technical skill and aesthetic confidence assure them a market wherever their cloth was taken.

Ruth Barnes, *Indian Block-Printed Textiles in Egypt*, Oxford 1997

14 REVEAL

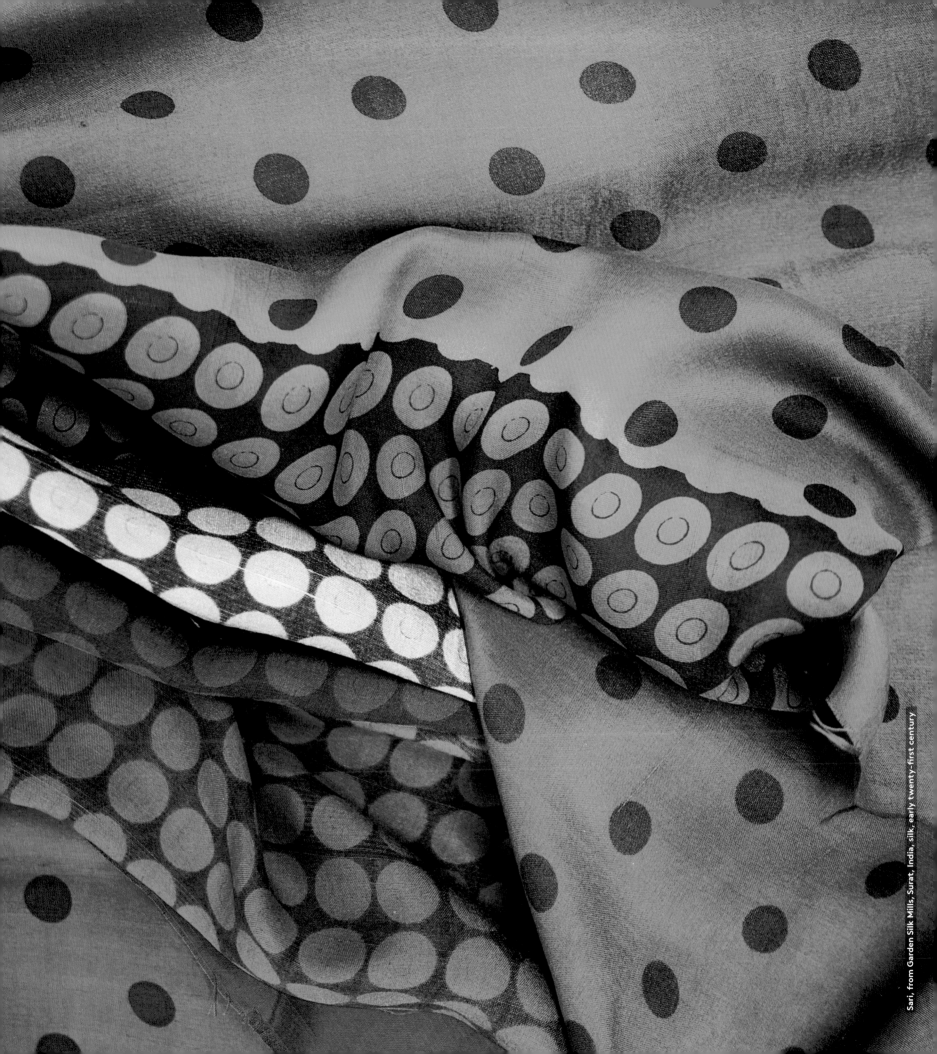

3. From the seventeenth Century on, France was the epicenter of the fashion world. The formidable combination of Paris fashions and Lyon silks – plus a host of subsidiary manufactures, organized into a highly efficient, government-regulated guild system – set the course of European fashion. As Jean-Baptiste Colbert (1619–1683), finance minister to Louis XIV (1638–1715), put it: 'Fashions were to France what the mines of Peru were to Spain' – that is, an extremely lucrative domestic and export commodity. (Louis-Sebastien Mercier, *Tableau de Paris*, ed. Jean-Claude Bonnet, Paris: Mercure de France, 1994, II.1194.)

Historically, fashion has been a major economic force in France, but it was only in the eighteenth century that it began to be regarded as something more than a mere trade. 'The work of fashion is an art,' wrote journalist Louis-Sebastien Mercier (1740–1814). 'Darling, triumphant art, which, in this century, has received honors and distinctions. This art enters into the palace of kings, where it receives a flattering welcome.' (Ibid., I.1481.)

Sharon Sadako Takeda, Kaye Durland Spilker et al., *Fashioning Fashion*, New York 2010

4. The origins of needle lace lie in the increasingly visible use of white linen in fashionable dress and furnishings during the first half of the sixteenth century. In the fashion of this period, fine linen, although an important component, was visible only in certain areas, through slashed or open sleeves, filling in the fronts of low bodices, and at the neck and wrists. This restrained exposure stimulated its decoration with fine embroidery including whitework (white thread on white ground), elaborated with lines of openwork and cutwork. Decorated edges were given to the visible areas of shirts and smocks by cutting the linen into indentations, pulling or withdrawing threads on the inner side, and making tiny frills. Needle lace developed in the working of tiny detached edgings to the collars and cuffs, and in the fillings of cut-out holes and openwork grids of pulled-thread and drawn-thread areas. Seams were decorated by lacing together the edges of two pieces of material or by attaching needle-made insertions, from simple loops to complex interlacings.

Clare Browne, *Lace*, London 2004, p.8

17

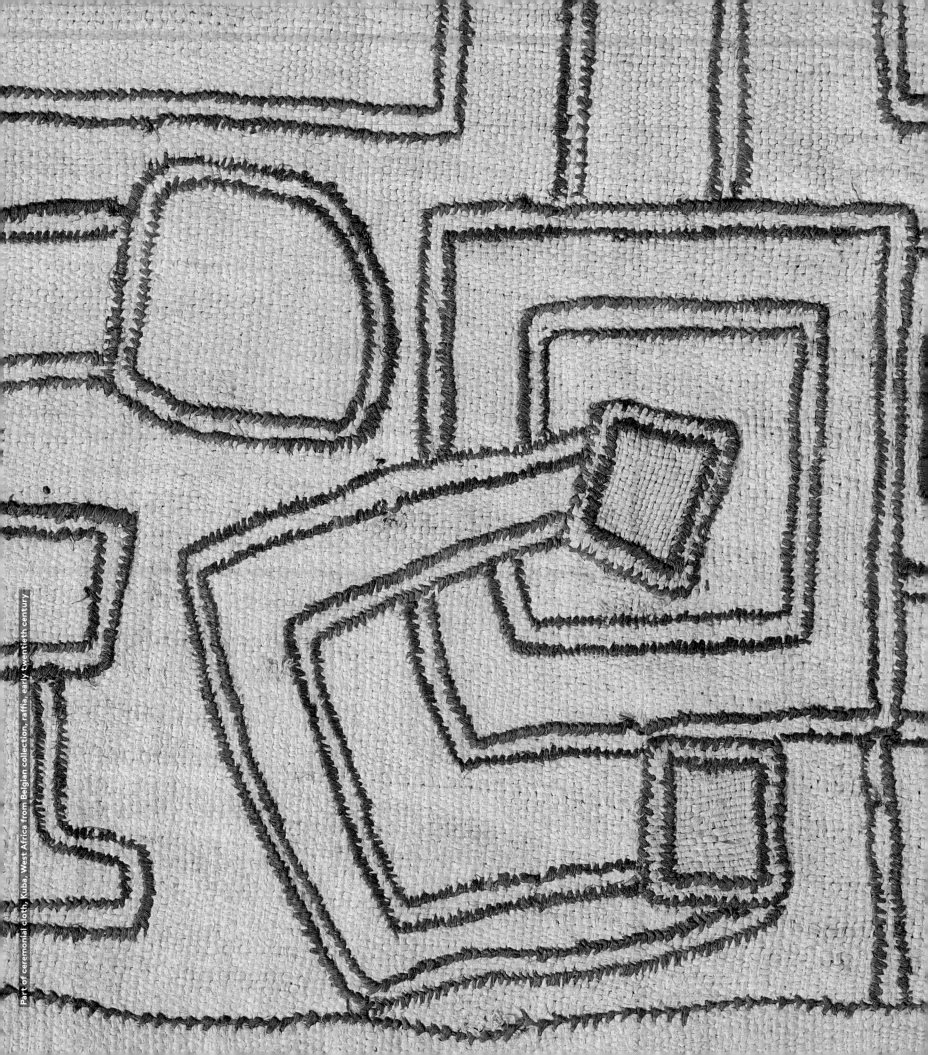

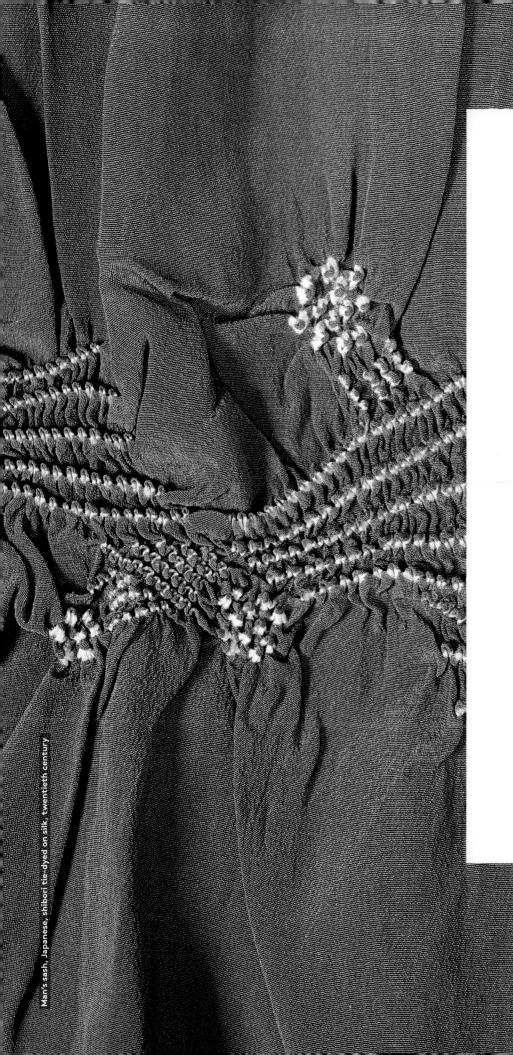

Man's sash, Japanese, shibori tie-dyed on silk, twentieth century

5. The Japanese synthetic fibre industry began in the early 1950s with the introduction of foreign technology. Toray Industries and Nippon Rayon obtained nylon technology, and with Toray and Teijin gained access to polyester technology. The companies' high profits encouraged others to enter the market after the 1960s. Between 1961 and 1963, Kanebo, Teijin, Kurehabo and Asahi Chemical all obtained nylon technology, while Toyobo, Nippon Rayon and Kurare agreed to obtain the technology for the polyester field. The industry was confronted with serious management problems in the 1970s and 1980s largely because of recessions caused by the two oil shocks and the appreciation of the yen. However, it recovered a competitive edge afterward partly because of the device of shin-gosen (new polyester) in 1989.

The synthetic fibre industry was the first among the Japanese manufacturing sectors to begin production in overseas markets. Major fibre producers actively established production plants in Taiwan and Hong Kong in the late 1960s and in South Korea, Singapore and Thailand in the 1970s. However, severe management problems caused by the first oil shock in 1973 forced the producers to curtail overseas operations in efforts to retrench business operations.

Hidetaka Yoshimatsu, 'Japan and Industrial Adjustment in Asia: Overproduction Problems in the Synthetic Fibre Industry', *Pacific Affairs*, vol.75, no.3, Autumn 2002, pp.381–2

6. Dougen created rituals expressing reverence for the kesa in cases where the vinaga or pure rules appeared to be lacking in this regard ... For Dougen, reverence for the kesa is the same as reverence toward the Buddha.

'Being covered by Sakyamuni Buddha's robe, one is covered by the robes of all the Buddhas in the ten directions. Being covered by Sahyamuni's robe is to be covered by the kesa. The kesa is the banner of the Buddhist assembly ...' (Dougen)

Although Dougen begins rather conventionally with the statement that the kesa is the garment worn by all Buddhas and the appellation of the kesa as the 'banner of Buddhism', he soon shifts toward identifying the kesa with the body of the Buddha ... Each time one dons the kesa therefore, one recreates the former vows of Sakyamuni Buddha, thereby creating the body of the Buddha.

Diane Elizabeth Riggs, *The Cultural and Religious Significance of Japanese Buddhist Vestments*, Los Angeles 2010, pp.224–5

Junichi Arai, Japanese, 'finished' surface, heat-treated to turn the colours under the control of artist/designer, man-made and metallic fibres, twentieth century

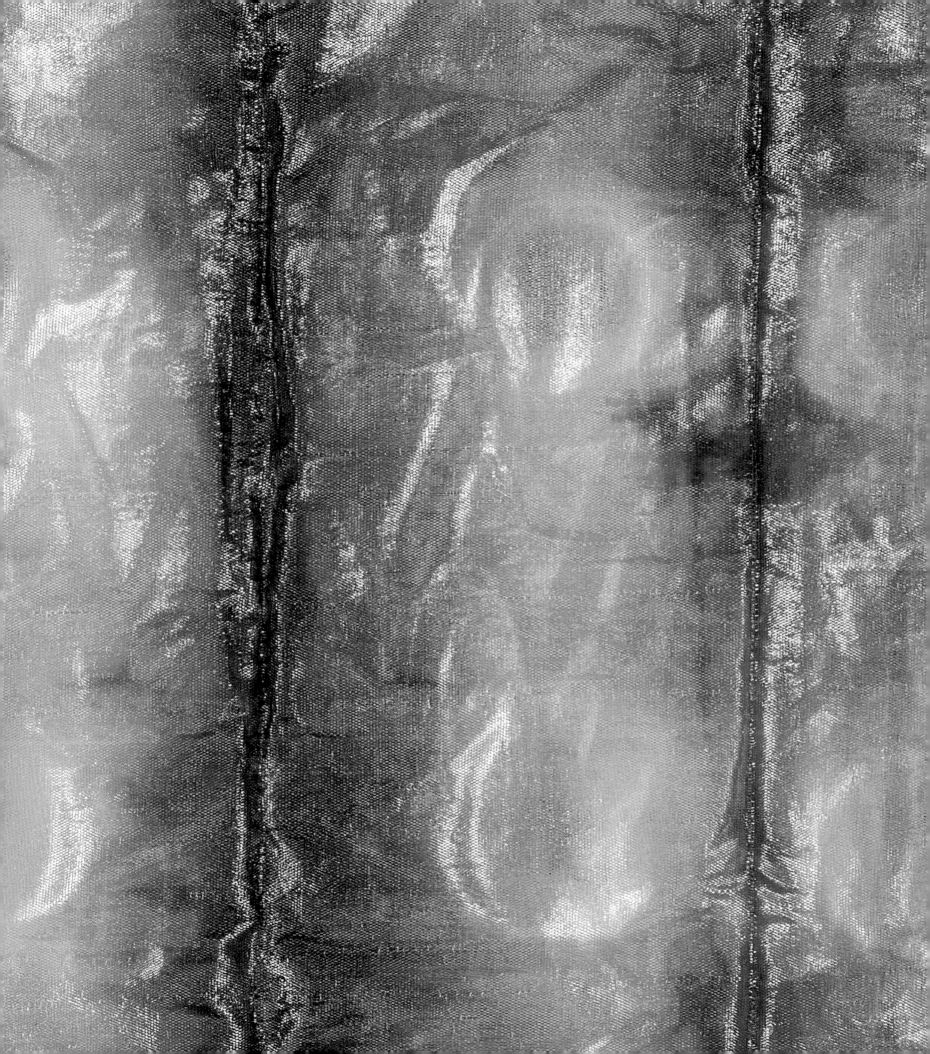

7. Centuries before the term 'sashiko' ever came into common use, the recycling of cloth fragments by stitching them together into a whole cloth and even into a robe was practiced in Japan by devout Buddhists. One type of 'kesa' (the Japanese term for a Buddhist mantle), known as funzou-e, was made from small pieces of discarded cloth or rags and symbolized the vow of poverty taken by priests, monks and nuns. An eighth-century 'funzou-e' has been preserved in the collection of the Shousouin, an imperial repository that was built on the temple grounds of Toudaiji in Nara.

Sharon Sadako Takeda, 'Japanese Fishermen's Coats from Awayi Island', UCLA Fowler Museum of Cultural History Textile Series, no.5, 2001, pp.35–6

8. Interest in Indonesian textiles gained momentum in the United States in the late 1970s through a number of exhibitions and accompanying publications (Kahlenberg 1977, Gittinger 1979, Fischer 1979).

Roy W. Hamilton, *Gift of the Cotton Maiden: Textiles of the Flores and Solor Islands (Indonesia)*, Los Angeles 1994, p.12

9. The Ait Bou Ichaouen associate powerful rituals with weaving. The first such rite involves the sacrifice of a sheep at shearing …

Other rites accompany the wool through its transition from raw material to finished product. Thus, weaving involves two parallel procedures: the physical processes … and their associated rites to protect …

Alfred H. and Suzanne S. Saulniers, *Ait Bou Ichaouen, Weavings of a Nomadic Tribe*, p.38

23

Segment of ceremonial cloth, West African, Kuba, raffia, nineteenth century

10. Why do dyes dye textile fibers? This question has been asked by many people for many years; and many explanations have been offered. Today this question can be answered, in all truthfulness, as follows: 'We do not know.'

William Postman, *Dyeing: Theory and Practice*, New York 1959, p.1

11. Chemists classify indigo as a vat dye. This is a category consisting of dyes that are insoluble in water and thus unable to bind with the fiber under ordinary conditions. They become soluble only in the specially maintained oxygen-reduced environment of the vat in which dyeing takes place. On Flores the chemical process of oxygen-reduction is produced by natural fermentation, usually in locally made clay pots.

Roy W. Hamilton, *Gift of the Cotton Maiden: Textiles of the Flores and Solor Islands (Indonesia)*, Los Angeles 1994, p.62

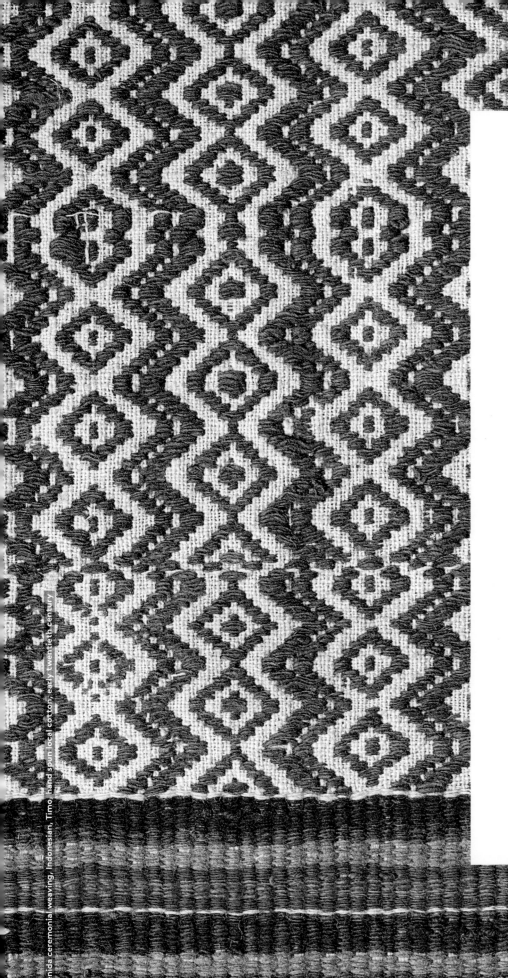

12. The cloth had then to be prepared to receive the red dye. It was washed and bleached repeatedly with dung, then steeped again in myrabolan and buffalo milk. Any white lines that were to be reserved against a red background were drawn in with wax. The alum mordant, lightly tinted with sappan wood to make it visible to the painter, was then applied with the Kalam. The cloth was subsequently immersed in a vat containing a hot solution of the red dye from the chay root, which would colour only those areas that had been treated with alum mordant. When the cloth was thoroughly soaked with the red dye, it was removed and washed, bleached in a dung bath and washed again repeatedly over four days.

The cloth was then covered in beeswax, except for those areas to be blue in the finished textile. The waxed cloth was left in the sun to melt the wax just enough for it to penetrate to the reverse of the cloth. The cloth was subsequently handed over to a specialist indigo dyer who immersed it in an indigo vat for about an hour and a half to produce the blue areas.

Rosemary Crill, *Chintz, Indian Textiles for the West*, London 2008, pp.12–13

25

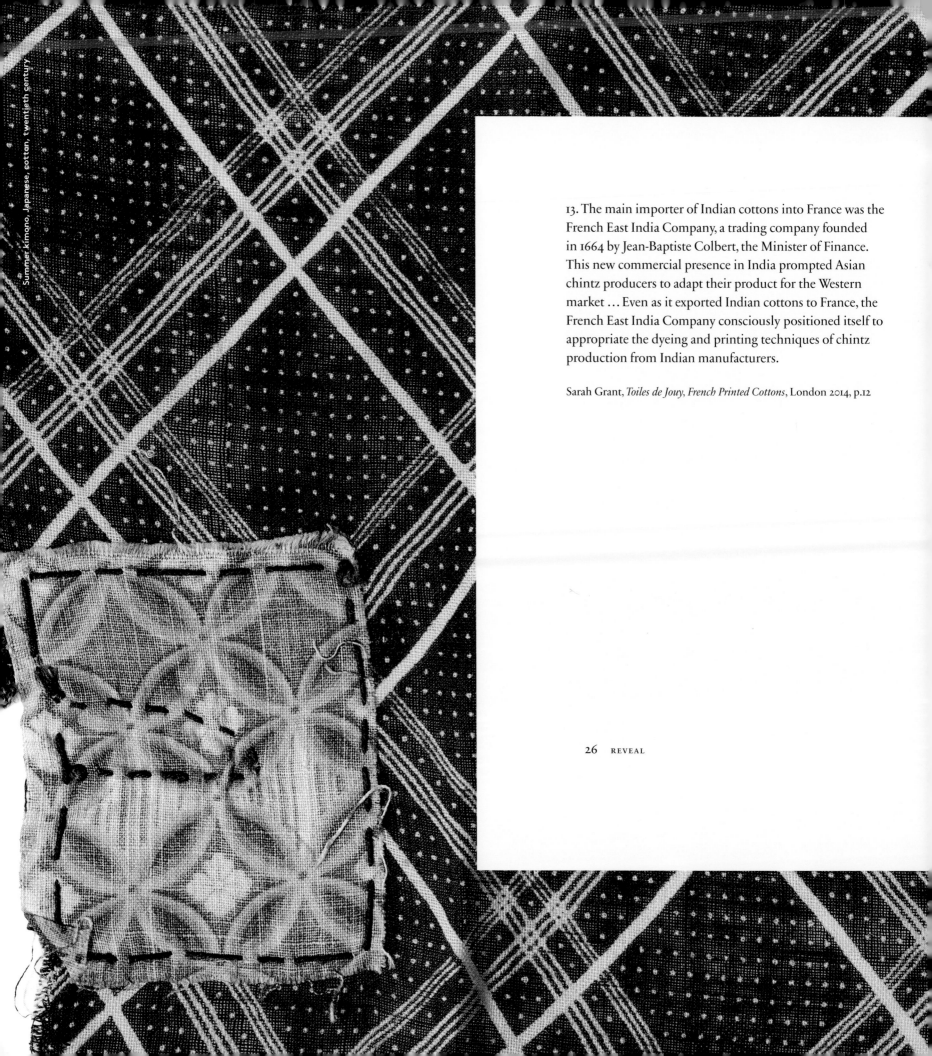

Summer kimono, Japanese, cotton, twentieth century

13. The main importer of Indian cottons into France was the French East India Company, a trading company founded in 1664 by Jean-Baptiste Colbert, the Minister of Finance. This new commercial presence in India prompted Asian chintz producers to adapt their product for the Western market … Even as it exported Indian cottons to France, the French East India Company consciously positioned itself to appropriate the dyeing and printing techniques of chintz production from Indian manufacturers.

Sarah Grant, *Toiles de Jouy, French Printed Cottons*, London 2014, p.12

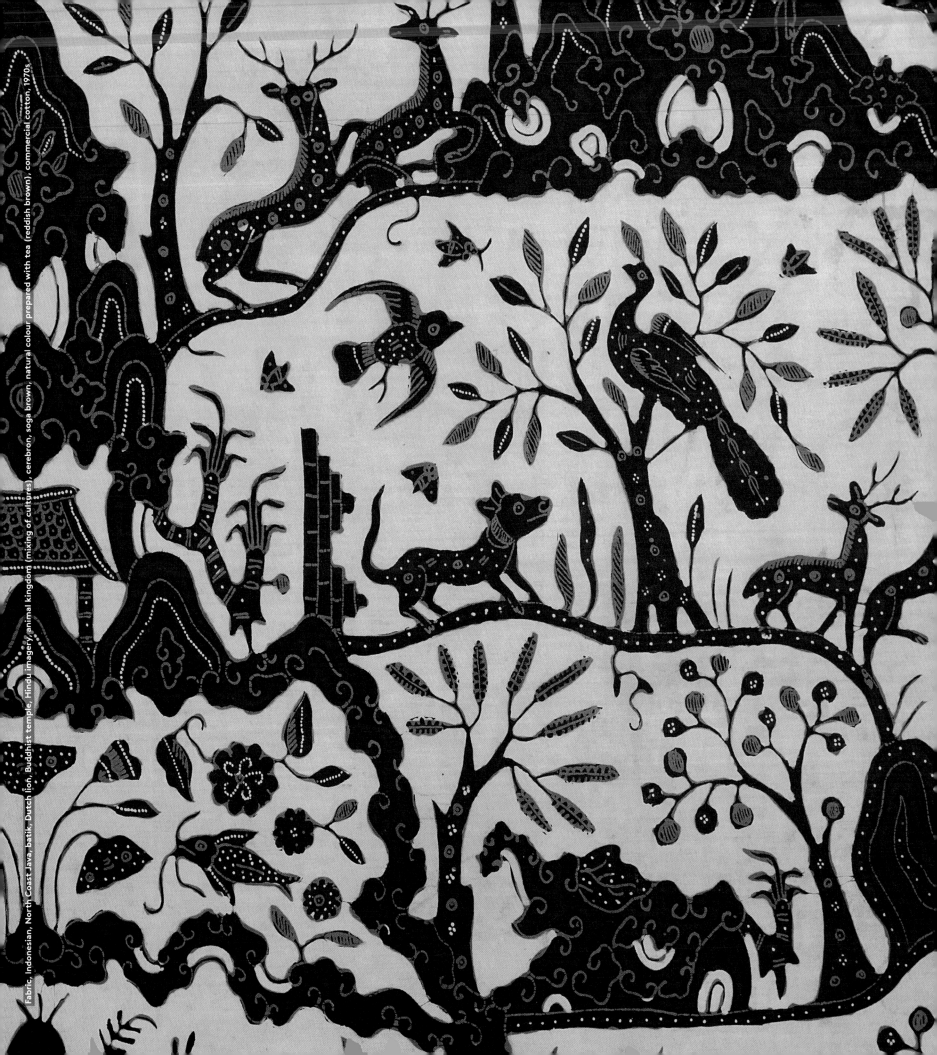

14. The role of cloth continues to expand as highly specialized textiles are being engineered for particular needs. Spurred by the research for new markets and an acknowledgment of the world's finite resources, some Japanese textile manufacturers are turning their attention to such pervasive health and environmental issues as allergies, skin diseases, radiation from computers, and land erosion. In an effort to control the temperature of highways, they have begun to line roads with fabric that can be 'plugged in' to heat the icy pavements. Because of the versatility that can be achieved with their durable structures, the functional properties of their fibers, their manipulability – rigid or pliable, molded or sculpted – and their thickness, textiles will play an even larger role in our lives in the future.

Cara McCarty and Matilda McQuaid, *Structure and Surface, Contemporary Japanese Textiles*, MoMA, New York 1998, p.14

15. Clearly the shares of the worldwide textile and apparel markets held by the industrialized West and Japan have declined over the past two decades. However, some of the most advanced nations continue to have vibrant industries. In both Germany and Japan, textile and apparel account for even higher percentages of manufacturing output than in the US.

And what of the US? Supporters and critics alike claim that trade policy changes which open up the US market will add to a decline in the mass end of textile and apparel production. But simultaneously, industry observers suggest that places such as New York City will retain a role in the industry due to their capacity for design and coordination. This argument has been used to suggest that there will always be some portion of the industry in the US, and that this will include a high value service future. However, there is growing evidence that the design function is portable. Conception can occur on one continent and be realized in the form of a physical product half-way around the world. Hong Kong's strategy has been to become the global organizer for a complex and far-flung textile and apparel empire.

Amy Glasmeier, Jeffery W. Thompson and Amy J. Kays, 'The Geography of Trade Policy: Trade Regimes and Location Decisions in the Textile and Apparel Complex', *Transactions of the Institute of British Geographers*, New Series, vol.18, no.1, 1993, pp.22, 31–2

16. The past century was a period of vast turmoil and transition for people involved in the creation of objects, particularly those we regard as craft objects. The world of weaving and dyeing was no exception: we saw both the concept of design gaining prominence and the objectives of creative activity broadening. With attempts to produce work directed at reflecting what was within the individual, not at producing something useful, diversity and individuality began to coexist; perspectives on textiles changed, depending on what the viewer sought in them. For some, while wavering between craft and design, these changes led, by a complex route, to the domain of the fine arts and to a reassessment of the relationship between textiles (as form) and weaving and dyeing (as techniques and materials), which had been stable within a single style. Artists working in weaving and dyeing as a means of individual expression focused more on form than on the materials and methods that make the form possible. They rejected the fetters on creativity that textiles had long implied, broke the conventions with work that sought to achieve a dramatic transformation, to be a new form of weaving and dyeing.

Yoko Imai, 'Textiles as Form', *Contemporary Textiles, Weaving and Dyeing Ways of Formative Thinking*, The National Museum of Modern Art, Tokyo, p.84

31

Pleated dress, African tie dyed, raffia, twentieth century

17. China textile industry will endeavor to promote the healthy and sustainable development of textile industry and maintain the prosperity and stability of global textile and clothes market by unremittingly accelerating restructuring and transformation of development mode, advancing technical innovation and R&D, promoting science and technology and brand value, and meanwhile enhancing energy saving and emission reduction and environment improvement, promoting international cooperation on every side and opening more fields to the outside world and safeguarding free trade.

Mr Du Yushou, President of China National Textile and Apparel Council (CNTAC), in *The Fiber Year 2009/10, A World Survey on Textile and Nonwovens Industry*, Oerlikon online publication (www. indotextiles.com/download/Fiber%20Year%202009_10.pdf), p.58

West African, high fashion, printed in Africa, cotton, early twenty-first century

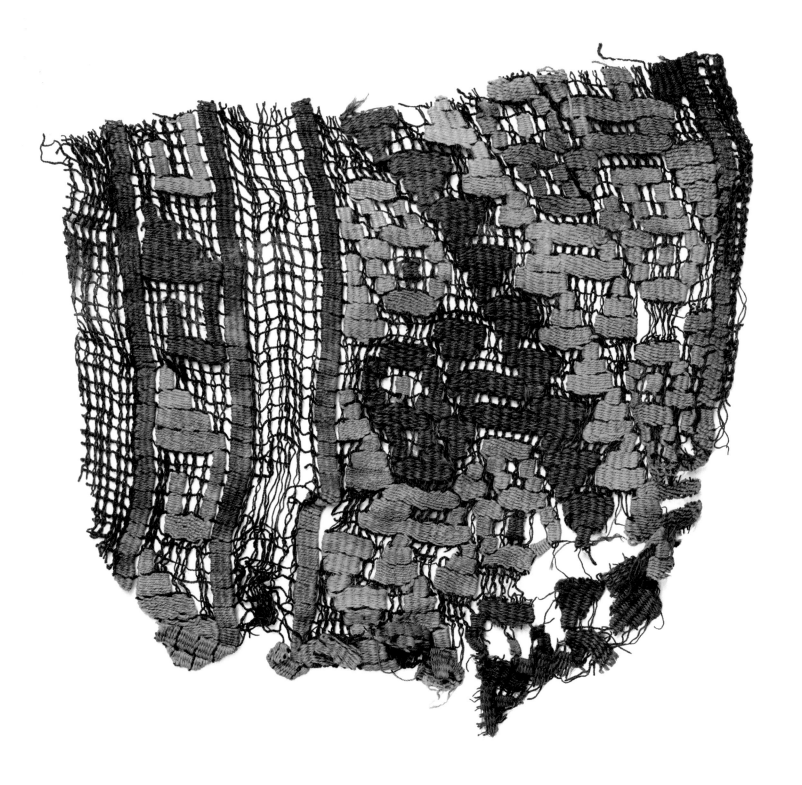

Fragment, Paracas Culture, Peru, open work with wrapped threads, cotton, 1000–500 BCE

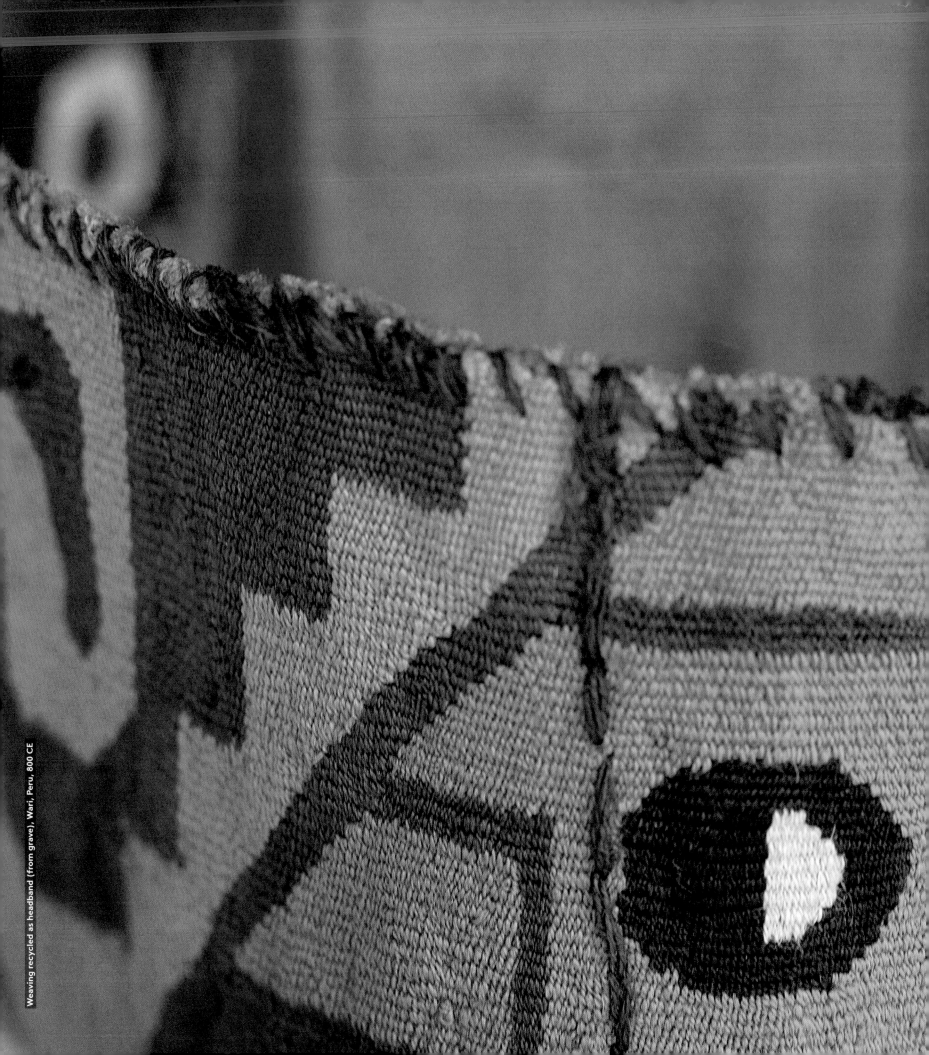

18. The target to reduce Chinese imports to 50% from currently 82% opens up a roughly US$10 to 15 billion opportunity that garment facilities in Bangladesh, Cambodia, Indonesia, Thailand and Vietnam might tap. As a consequence, imports from Vietnam already surged by 19.8% in 2009. A strong increase in deliveries also took place from Bangladesh and Cambodia, although from much lower levels. India, Indonesia, Malaysia and Thailand also experienced a steady growth in exports to Japan in the last two years, as a clear sign that China may progressively lose its edge on this market.

Mr Du Yushou, President of China National Textile and Apparel Council (CNTAC), in *The Fiber Year 2009/10, A World Survey on Textile and Nonwovens Industry*, Oerlikon online publication (www. indotextiles.com/download/Fiber%20Year%202009_10.pdf), p.63

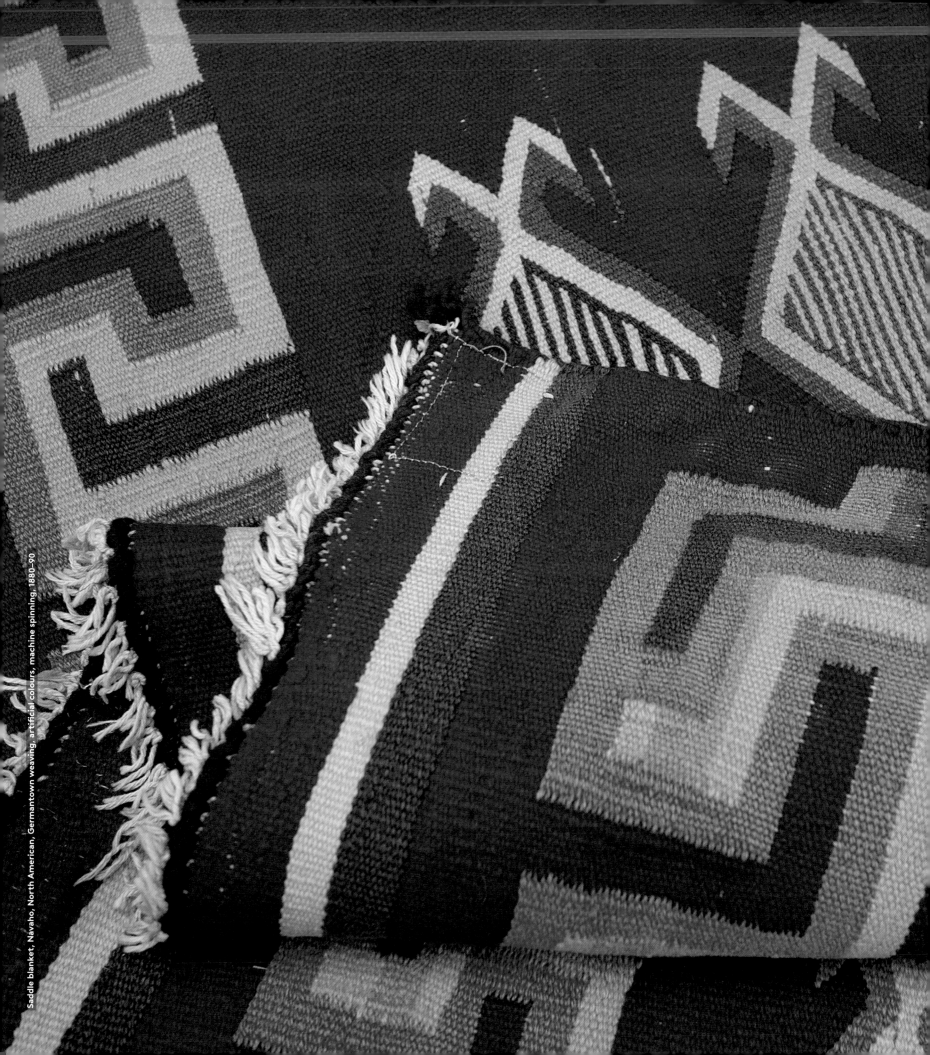

Saddle blanket, Navaho, North American, Germantown weaving, artificial colours, machine spinning, 1880–90

19. The silk weavers of Spitalfields, many of whom were first- or second- generation Huguenots, established societies for mathematics, history, horticulture, and entomology. They also grew exotic flowers and trained singing birds 'probably by a French method unknown to the English people.'

Trade with India had exposed the British market to fast-dyed, brightly colored "calicoes," also known as "chintz," with which no domestic product could compete. British manufacturers lacked the dyestuffs and technical knowledge of their Indian counterparts, as well as the ability to make suitable cloths to dye. The use of cotton had been subject to legal controls since 1666, but demand continued unabated.

Alicia Weisberg-Roberts, 'Surprising oddness and beauty: textile design and natural history between London and Philadelphia in the eighteenth century', *Knowing Nature, Art and Science in Philadelphia, 1740–1840*, New Horizon 2011, pp.163, 169

Child's quilt, American, natural and synthetic colours on cotton, nineteenth century

20. Hemp is among the oldest used material on the planet going back more than 10,000 years to the beginnings of pottery. The Columbia history of the World states that the oldest relic of human industry is a bit of hemp fabric dating back to approximately 8,000 BC. Hemp was probably first domesticated by the Chinese who developed advanced breeding, farming and processing techniques in the 2nd century BC. They used the fiber to make paper and textiles and the seeds for food and medicines.

Alicia Weisberg-Roberts, 'Surprising oddness and beauty: textile design and natural history between London and Philadelphia in the eighteenth century', *Knowing Nature, Art and Science in Philadelphia, 1740–1840*, New Horizon 2011, pp.163, p.81

21. Before the arrival of the winter wind from the north, the stalks must be processed into fiber (ntuos). If this is not done in a timely manner, the resulting fiber will be dry, less durable, and difficult to twist.

The loose fiber is tied into small bunches and pounded in a mortar for about half an hour. This makes the fiber stronger and more flexible, decreasing the likelihood of tangling.

Tran Thi Thu Thuy, 'Hemp Textiles of the Hmong in Vietnam', *Material Choices, Refashioning Bast and Leaf Fibers in Asia and the Pacific*, eds. Roy W. Hamilton and B. Lynne Milgram, Los Angeles 2007, p.45

22. The question 'Is it he whose tale I hear as I work at the loom?' tells us something else about weaving, namely that it was not an activity carried out in silence. There may even have been songs used to keep up the rhythm of the weaving process.

Michael Vickers, *Images on Textiles: The Weave of Fifth-Century Athenian Art and Society*, Konstanz 1999, p.15

23. 'There were always a lot of ceremonies being performed,' said Loretta Benally, now in her seventies, telling of her younger years. 'When the world was very holy, every neighbor had some kind of ceremony in preparation or in practice.' Weavers would attend them all, hearing the songs again and again. 'The prayers and the chants would stay with you and come back to you as you'd weave.'

Roseann Sandoval Willink and Paul G. Zolbrod, *Weaving a World: Textiles and the Navajo Way of Seeing*, Santa Fe 2003, p.24

Boys' shirt, Bangladesh, graffiti design, polyester, early twenty-first century

24. Contemporary resist dyeing is increasingly challenging the traditional canons and conventions established by katazome and dyed crafts in general, dismantling, experimenting and seeking to reinterpret forms of artistic expression. One trend that has emerged within the field of art textiles in recent years is screen printing using computer graphics. However, this new genre has still to come to terms with the significance and underlying questions involved in the act of dyeing before it can distinguish an identity distinct from other forms of pictorial art. For this reason no examples were included in the present exhibition. In the future an ever-increasing diversity of techniques and styles will continue to call into question with ever-increasing intensity the autonomy of stencil dyeing or dyeing art in general.

Hiroshi Ueki and Kenji Kaneko, *Contemporary Stencil Dyeing and Printing: The Repetition of Patterns*, exh. cat., The National Museum of Art, Tokyo 1994, p.24

Sari, from Garden Textile Mill, Surat, India, silk, early twenty-first century

25. These Indonesian textiles are based on a spirituality in which acute sensitivity to the materials used in each phase of their making is integral. The attention to the physical properties of the cloth imparts a necessary dimension to each textile's spiritual or ritualistic roles. The process of dyeing to obtain the saturated colors is closely connected to concepts of purity and is determined by seasonal and lunar cycles. The precise tying of the ikat threads is considered to be directed by personal links, developed over a lifetime, between each weaver and her spiritual guides. The skillful placement of the weft or the tying of the warp that forms the pattern reflects a weaver's ability to imbue her weavings with her knowledge of her culture's beliefs, be they symbolic meanings or the portrayals of the sacred spaces of spirits that animate her world.

Ruth Barnes and Mary Hunt Kahlenberg (eds.), *Five Centuries of Indonesian Textiles*, p.13

Sash, Bali, Indonesia, ikat and supplementary weft, cotton, early twentieth century

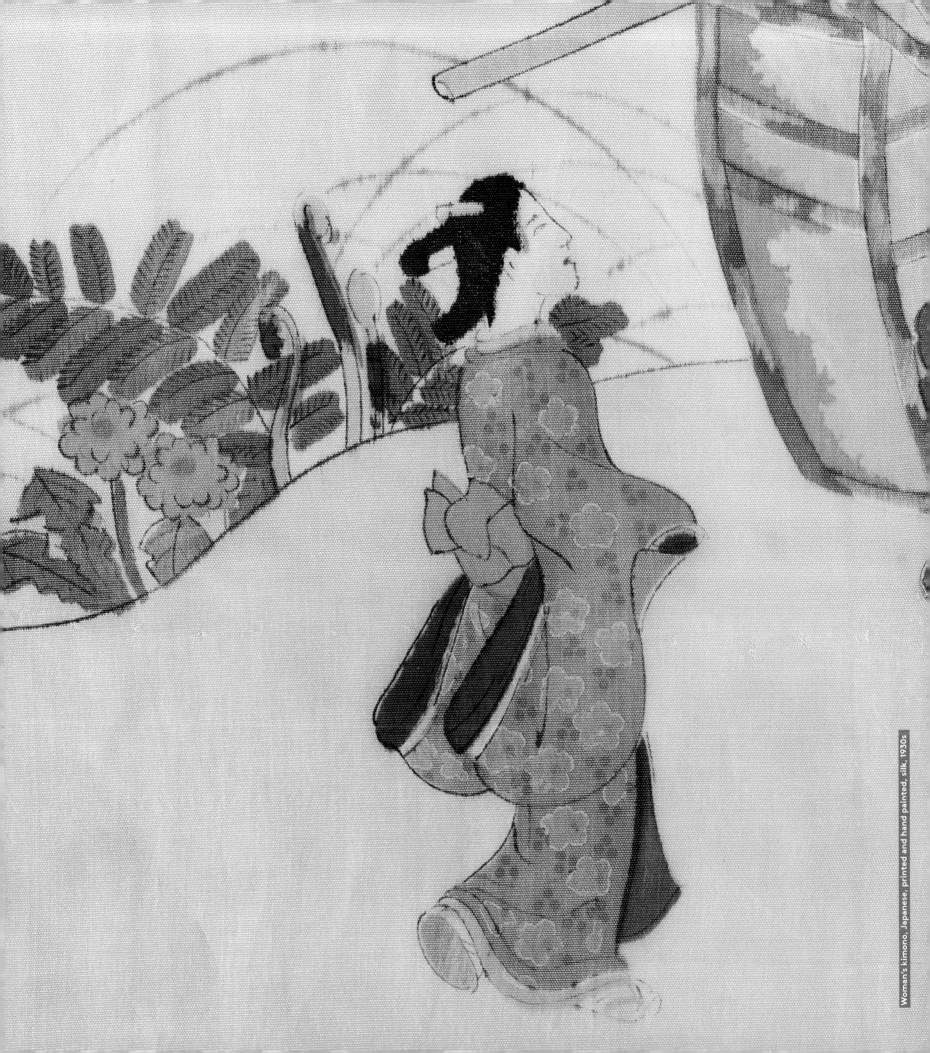

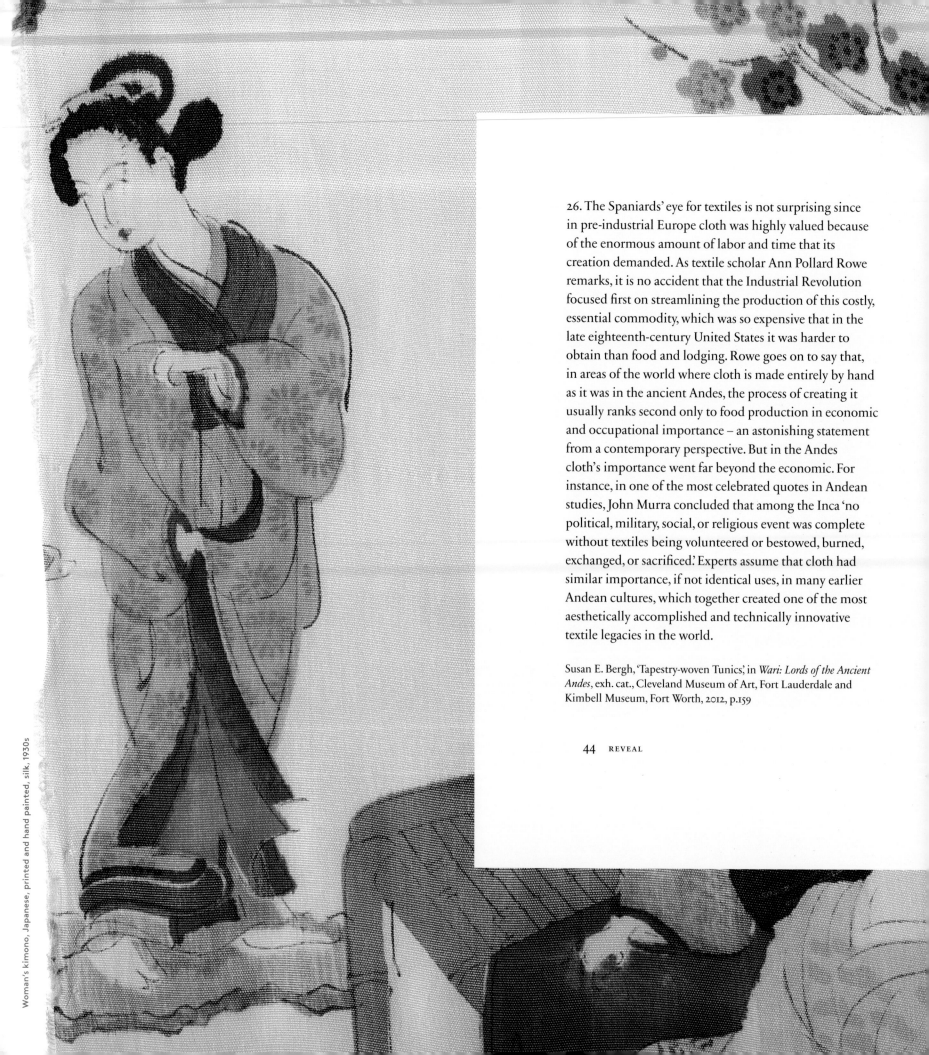

26. The Spaniards' eye for textiles is not surprising since in pre-industrial Europe cloth was highly valued because of the enormous amount of labor and time that its creation demanded. As textile scholar Ann Pollard Rowe remarks, it is no accident that the Industrial Revolution focused first on streamlining the production of this costly, essential commodity, which was so expensive that in the late eighteenth-century United States it was harder to obtain than food and lodging. Rowe goes on to say that, in areas of the world where cloth is made entirely by hand as it was in the ancient Andes, the process of creating it usually ranks second only to food production in economic and occupational importance – an astonishing statement from a contemporary perspective. But in the Andes cloth's importance went far beyond the economic. For instance, in one of the most celebrated quotes in Andean studies, John Murra concluded that among the Inca 'no political, military, social, or religious event was complete without textiles being volunteered or bestowed, burned, exchanged, or sacrificed.' Experts assume that cloth had similar importance, if not identical uses, in many earlier Andean cultures, which together created one of the most aesthetically accomplished and technically innovative textile legacies in the world.

Susan E. Bergh, 'Tapestry-woven Tunics', in *Wari: Lords of the Ancient Andes*, exh. cat., Cleveland Museum of Art, Fort Lauderdale and Kimbell Museum, Fort Worth, 2012, p.159

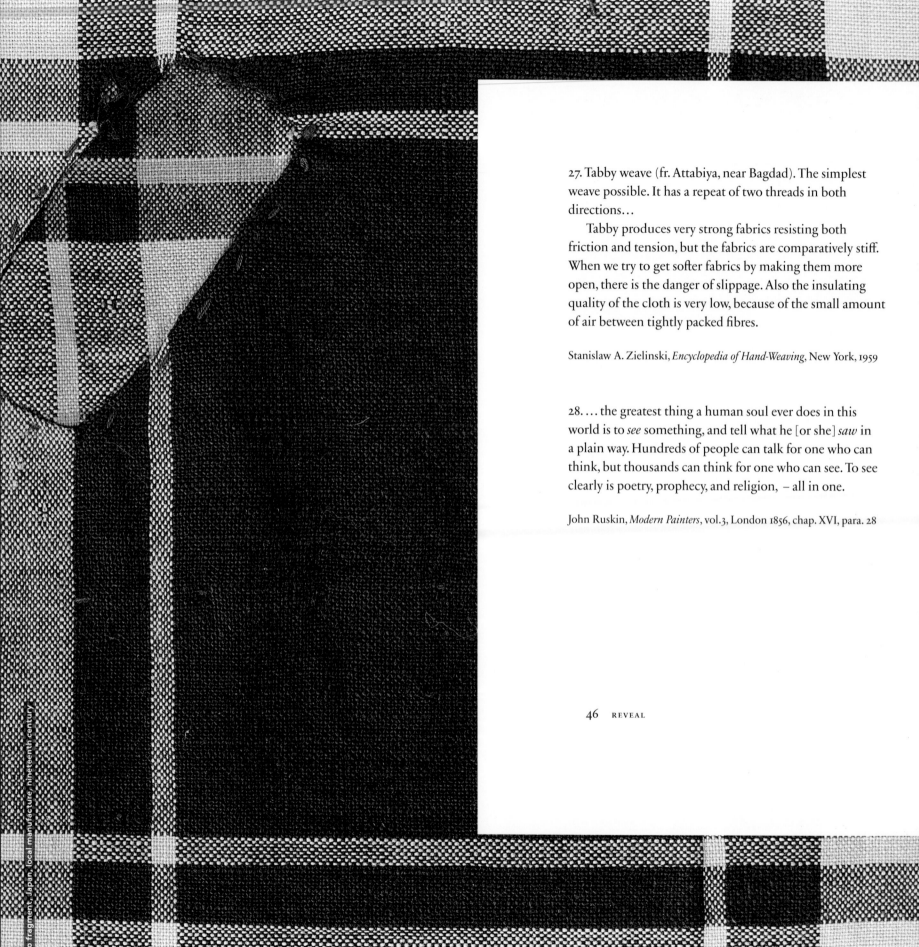

27. Tabby weave (fr. Attabiya, near Bagdad). The simplest weave possible. It has a repeat of two threads in both directions…

Tabby produces very strong fabrics resisting both friction and tension, but the fabrics are comparatively stiff. When we try to get softer fabrics by making them more open, there is the danger of slippage. Also the insulating quality of the cloth is very low, because of the small amount of air between tightly packed fibres.

Stanislaw A. Zielinski, *Encyclopedia of Hand-Weaving*, New York, 1959

28. … the greatest thing a human soul ever does in this world is to *see* something, and tell what he [or she] *saw* in a plain way. Hundreds of people can talk for one who can think, but thousands can think for one who can see. To see clearly is poetry, prophecy, and religion, – all in one.

John Ruskin, *Modern Painters*, vol.3, London 1856, chap. XVI, para. 28

Fabric recycled as bag face, Nazca culture, Peru, bifurcation illustration, natural dyes, cotton, 500 CE

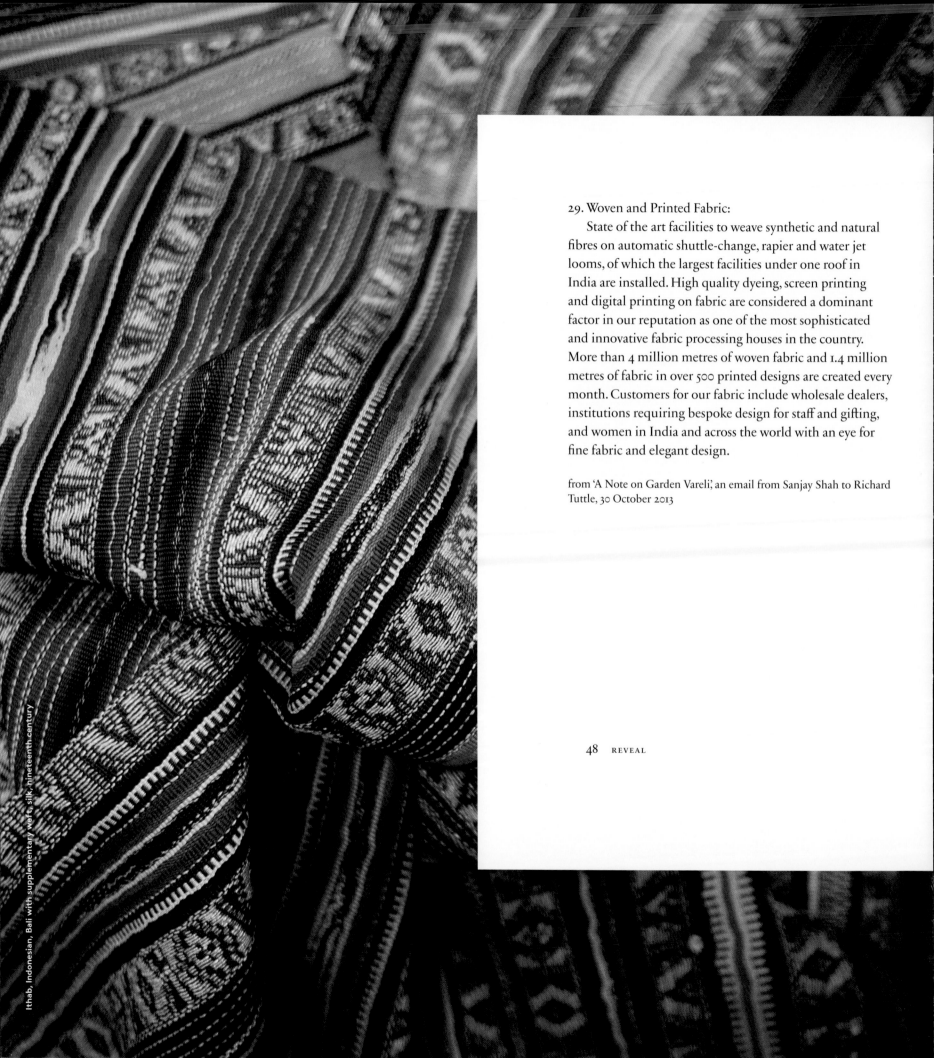

29. Woven and Printed Fabric:

 State of the art facilities to weave synthetic and natural
fibres on automatic shuttle-change, rapier and water jet
looms, of which the largest facilities under one roof in
India are installed. High quality dyeing, screen printing
and digital printing on fabric are considered a dominant
factor in our reputation as one of the most sophisticated
and innovative fabric processing houses in the country.
More than 4 million metres of woven fabric and 1.4 million
metres of fabric in over 500 printed designs are created every
month. Customers for our fabric include wholesale dealers,
institutions requiring bespoke design for staff and gifting,
and women in India and across the world with an eye for
fine fabric and elegant design.

from 'A Note on Garden Vareli', an email from Sanjay Shah to Richard
Tuttle, 30 October 2013

30. If we look at nature carefully, we shall find that her colours are in a state of perpetual confusion and indistinctness.

John Ruskin, *Modern Painters*, vol.1, London 1843, chap. V, para. 8

31. Of all things man-made, textiles most easily provide the broken color as seen in natural things …

Azalea Stuart Thorpe and Jack Lenor Larsen, *Elements of Weaving*, New York 1967, p.214

49

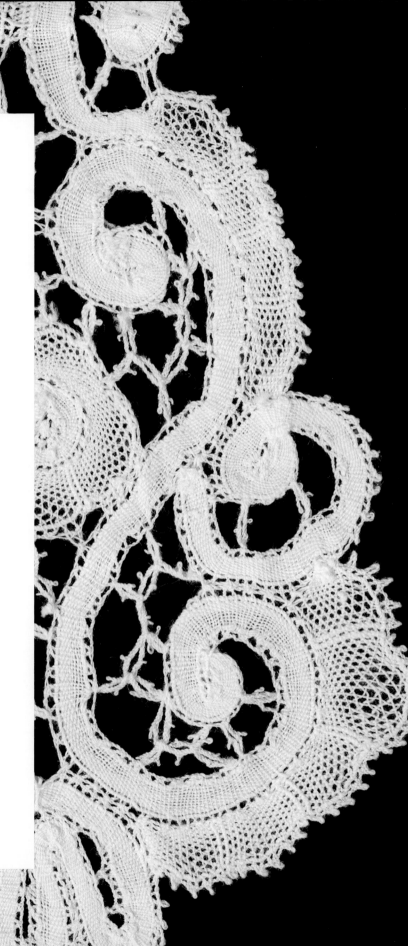

Men's cravat. Flemish (now Belgian) bobbin lace, eighteenth century

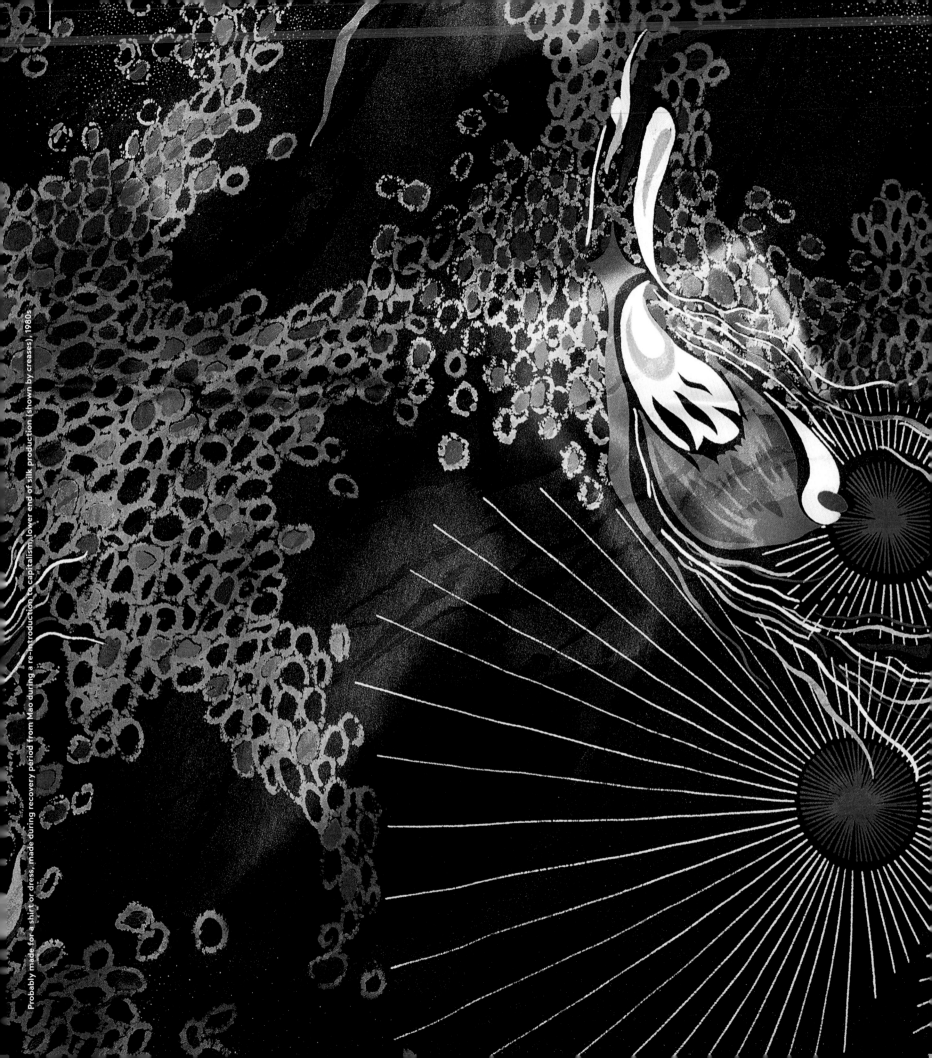

Probably made for a shirt or dress, made during recovery period from Mao during a re-introduction to capitalism, lower end of silk production (shown by creases), 1980's

32. Most hand weavers greatly underestimate the importance of sett. (This is one thing that commercial weavers understand perhaps better than those textile designers who have been trained in art schools.) A keener appreciation of sett may dawn if the weaver reflects that broadcloth, batiste, cheesecloth, canvas are all in plain weave, all woven with much the same kind of cotton yarn.

Azalea Stuart Thorpe and Jack Lenor Larsen, *Elements of Weaving*, New York 1967, p.214

51

Woman's under-obi wrapper, Japanese, probably printed twice, the flight of cranes is a symbol of health (would be worn visiting a sick friend)

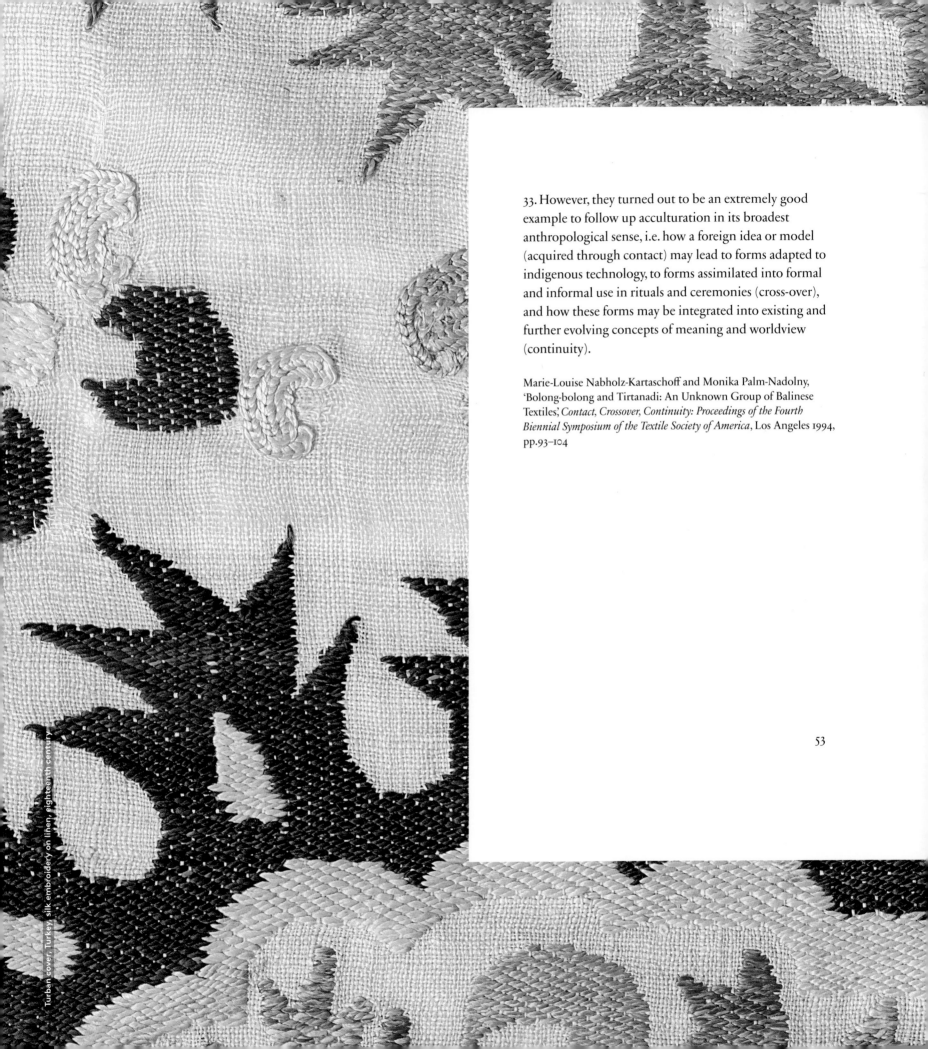

Turban cover, Turkey, silk embroidery on linen, eighteenth century

33. However, they turned out to be an extremely good example to follow up acculturation in its broadest anthropological sense, i.e. how a foreign idea or model (acquired through contact) may lead to forms adapted to indigenous technology, to forms assimilated into formal and informal use in rituals and ceremonies (cross-over), and how these forms may be integrated into existing and further evolving concepts of meaning and worldview (continuity).

Marie-Louise Nabholz-Kartaschoff and Monika Palm-Nadolny, 'Bolong-bolong and Tirtanadi: An Unknown Group of Balinese Textiles', *Contact, Crossover, Continuity: Proceedings of the Fourth Biennial Symposium of the Textile Society of America*, Los Angeles 1994, pp.93–104

53

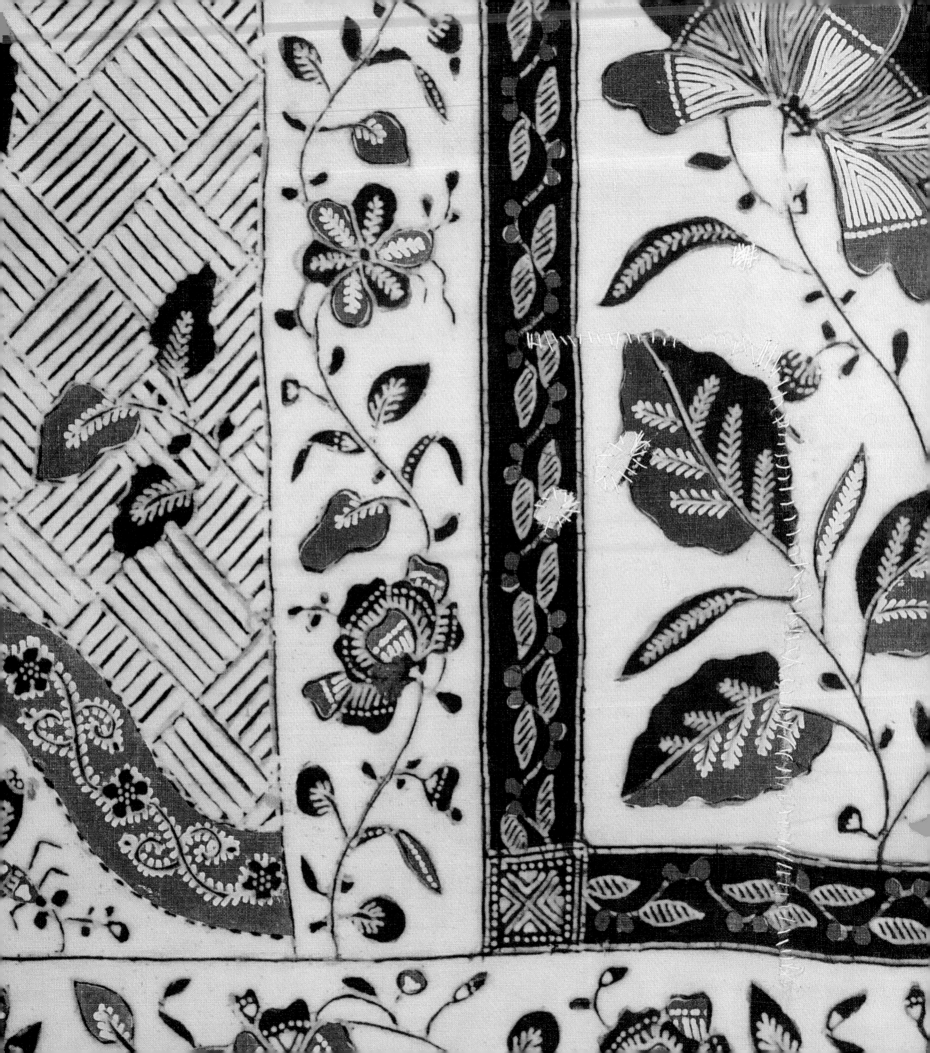

34. Of Professor Teufelsdrockh, it seems impossible to take leave without a mingled feeling of astonishment, gratitude, and disapproval. Who will not regret that talents, which might have profited the higher walks of Philosophy, or in Art itself, have been so much devoted to a rummaging among lumber-rooms; nay too often to a scraping in kennels, where lost rings and diamond-necklaces are nowise the sole conquests? Regret is unavoidable; yet censure were loss of time. To cure him of his mad humors British Criticism would essay in vain: enough for her if she can, by vigilance, prevent the spreading of such among ourselves. What a result, should this piebald, entangled, hyper-metaphorical style of writing, not to say of thinking, become general among our Literary men! As it might so easily do. Thus has not the Editor himself, working over Teufelsdrockh's German, lost much of his own English purity? Even as the smaller whirlpool is sucked into the larger, and made to whirl along with it, so has the lesser mind, in this instance, been forced to become portion of the greater, and, like it, see all things figuratively: which habit time and assiduous effort will be needed to eradicate.

Thomas Carlyle, *Sartor Resartus: The Life and Opinions of Herr Teufelsdrockh*, London 1836, book 3, chap. XII, 'Farewell'

Fabric, North Coast Java, use of blue requires an additional dye stage, cotton, twentieth century

35. WJL 501 Water Jet Loom for Interweave Net

Technical information:
1. Reed width: 190–280 cm.
2. Weft insertion speed: 350–400 rpm of plain weave; 500 600 rpm of interweave
3. Fitting material; plastic protofilament of PE, PP, etc.
4. Fabric range: high density mesh, sparse packing-net and air condition filter

Contact Orient Machineries, Wangtai District, Qingdao City, China

57

Fabric, Dutch for African Market, cotton, mid-twentieth century

36. Tsudakoma offers a great variety of products applicable for all kinds of woven items from natural to synthetic fibers. Our looms weave everything from filament and spun products to glass fiber and various industrial fabrics.

Tsudakoma home page (www.tsudakoma.co.jp/textile/english/product/)

Responding to a boost in the state-of-the-art Jet Looms, modern production facilities such as renewed molding lines and melting furnaces were introduced in 1988. Tsudakoma now prides itself on our current production capacity of 1,200 tons of castings monthly.

Tsudakoma, 'Introduction of Casting Section' (www.tsudakoma.co.jp/foundry/english/)

Commercial cloth, West African, cotton, 2005

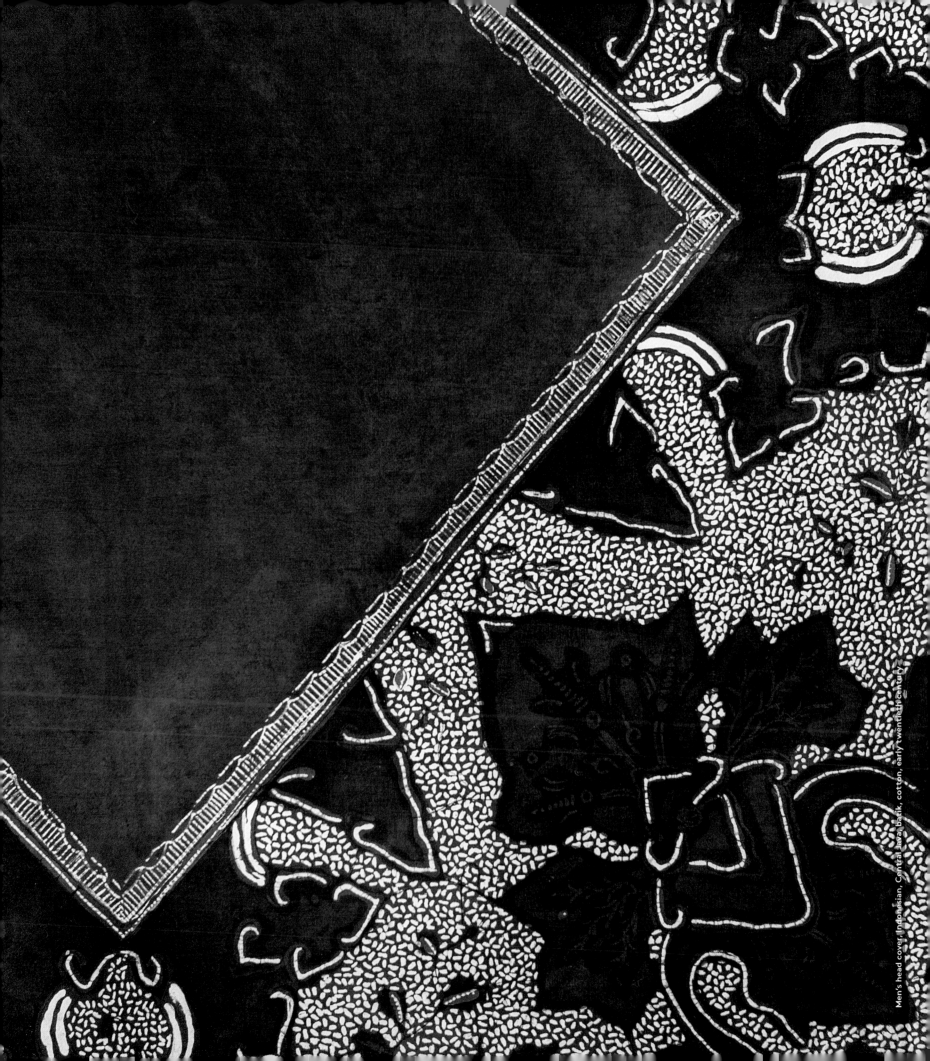

37. This pretty plaiting was especially in vogue at Nazca. It requires twenty-four strands of diverse thickness and of three colors. These varying thicknesses produce heavy relief symmetrically arranged resulting in a special esthetic effect ... The purpose of the yellow strands is to outline the motifs and the pattern formed by the red and gray strands.

Raoul d'Harcourt, *Textiles of Ancient Peru and Their Techniques*, 1934, trans. S. Brown, Seattle 1962

Commissioned in China, designed abroad, expensively printed in China for export, cotton, early twenty-first century

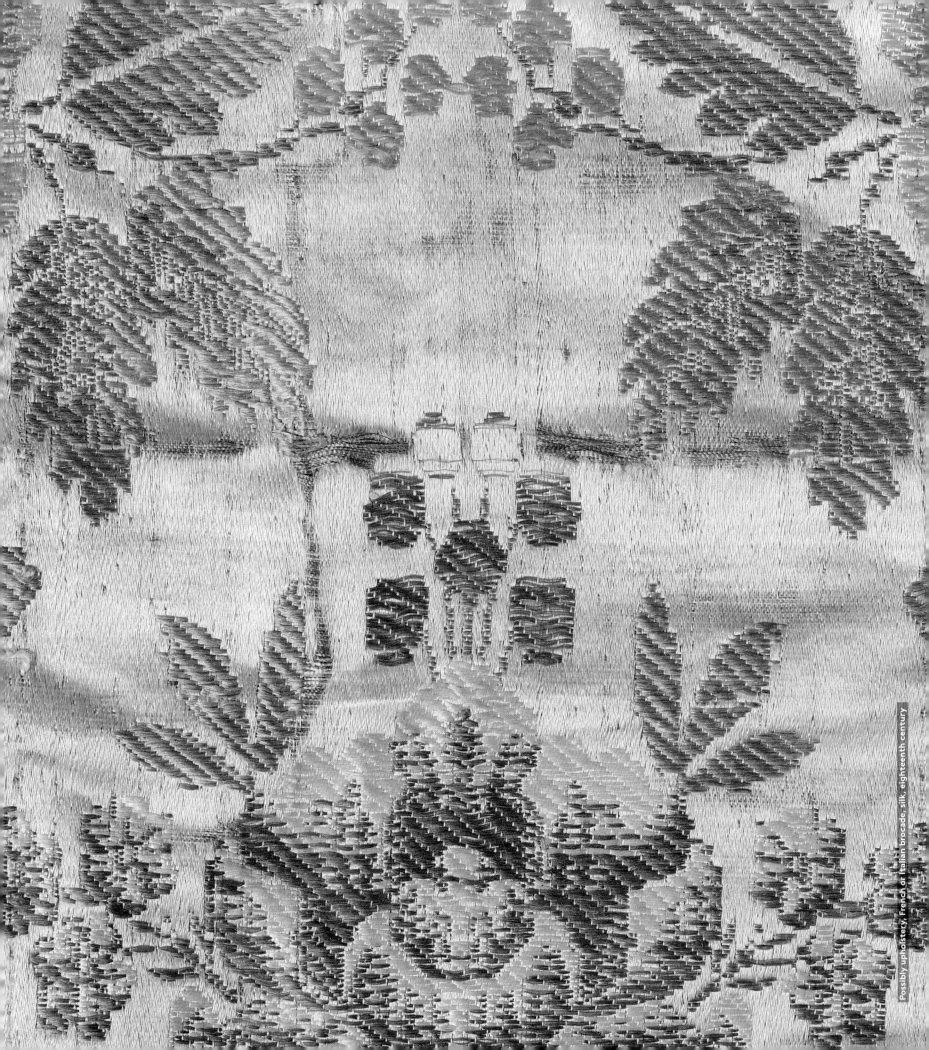

38. Everyone is surrounded by textiles from birth to death. We walk on and wear textile products, we sit on fabric-covered chairs and sofas; we sleep on and under fabrics … Knowing how fabrics are created and used will give a better basis for their selection …

Norma Hollen, Jane Saddler, Anna L. Langford and Sara J. Kadolph, *Textiles*, 5th edn, New York 1979

39. The year 1856 divides the ancient world from the modern in the matter of dyes … Since this first coal tar dye thousands have come from the same source …

Mary Schenck Woolman and A.M. Ellen Beers McGowan, *Textiles*, London 1936, p.418

63

Men's head cover, Indonesian, Central Java, batik, cotton, early twentieth century

40. There are 19 families of man-made fibers:
Acetate (1925)
Triacetate (1955)
Acrylic (1950)
Aramid (1963)
Azlon
Glass (1935)
Lastrile
Matalic (1948)
Modacrylic (1949)
Novoloid (1969)
Nylon (1939)
Nytril (1950)
Olefin (1958)
Polyester (1951)
Rayon (1911)
Saran (1938)
Spandex (1960)
Vinal
Vinyon (1940)
Dates: original production in US

Norma Hollen, Jane Saddler, Anna L. Langford and Sara J. Kadolph,
Textiles, 5th edn, New York 1979

Fiji printed bark cloth, stamp printing with bamboo sticks, twentieth century

Dust sheet, industrially produced felt, early twenty-first century

Show

Abstraction

The work of Richard Tuttle is central to the elasticity and multivalence with which we understand abstraction today. His forms and objects may be assemblages, but they do not represent, narrate or make allusions through found objects. They do, however, proceed across a floor, up a wall or around a corner with the energy of living things. Their titles – for example, *Ten Kinds of Memory and Memory Itself* – denote subjectivity and philosophical speculation. They also imply that materials themselves have a kind of sentience. Structures support, hide and swaddle, fabrics unfurl and rollick around one another, while silhouette and colour offer a graphic lexicon. Tuttle's 'abstraction' brings to our attention the actuality of the material world.

Books

Since 1965 when he made his little book of woodcuts, *Story with Seven Characters* (in an edition of seven), Tuttle has continued to draw, print, bind and publish books as works of art. Their board covers may juxtapose a beguiling lavender or a powder blue with letters that skip across their surface, making each book an object. Inside, unexpected fold-outs, changes in paper stock, cuts and incisions make each book into an event. For London the artist, with friend Kie Ellens, makes a selection from the archive.

Dye

Inspired by how weavers and artisans have used the mineral and vegetable world to create pigments, Tuttle often stains the cloth in his works, fusing painting, printmaking and dyeing. Many of his pieces have a crepuscular tonality, marking the passage of colour as it makes its osmotic journey through fabric, interacting with its weave, encouraged or repelled by its rates of absorption. In a way, these are 'action paintings', where the action is undertaken by the pigment itself.

Installation

This book accompanies two manifestations of Tuttle's work, a single installation in the Turbine Hall of Tate Modern and a retrospective exhibition at the Whitechapel Gallery. The latter takes us on a spatial and retinal voyage where the gallery environment is active in setting up figure/ground relations. Taking the floor as its base, a sculpture sprawls forwards and then stacks upwards, a constructivist armature hoisting planes of fabric and colour into the air. There is a sense of both conceding to and defying the force of gravity.

Conventionally, pictures in a gallery are hung on a sightline set at 150 cm off the floor, so as to meet our upright gaze. Tuttle confounds this expectation by presenting what appears to be a completely blank wall. We blink and look again to find an almost imperceptible vertical line pulling our eyes down to a level just above our toes. There, Tuttle situates a small, brightly hued and patterned object. He thus sets in motion small yet vivid incidents. The modest scale and unorthodox location of many of his works make us look at the overlooked. Using ubiquitous things such as scraps of fabric, grommets and construction timber, he inspires his viewers to engage with the everyday. In this, his work has both a poetic and a political dimension.

Richard Tuttle: A Glossary

IWONA BLAZWICK

Line

If Paul Klee takes a line for a walk, Richard Tuttle makes it dance in space. His London *Wire Pieces* are installed according to a method he has used since the 1970s. First he makes a graphite drawing directly on the wall. He then hammers a nail into the beginning of his line and wraps a piece of wire around the head. Using the nail as an anchor, he unreels the metal thread to trace the drawn line. The wire itself 'remembers' the spool, following yet resisting the first drawing. The human hand itself struggles with the rigidity of metal, giving line number 2 a wobbly, kinesthetic quality. Tuttle has spoken of his 'fascination with the relation between '2s' – is it that slippery notion of duality embracing unity and difference? These two spawn yet more lines. The white wall of the gallery becomes the ground for a spatial drawing, where spotlights add delicate shadows, additional lines that describe three-dimensional voids.

Graphite lines, wires, rope, electrical cord, thread and string play other important roles in Tuttle's oeuvre. The line may add an optical element through a mark or a sign. It may also be used to physically bind disparate elements, ephemeral yet strong.

Neither

'The best new work in the last few years has been neither painting nor sculpture.'
Donald Judd, 1965

'It is not possible to say whether a Tuttle is a painting or a sculpture; it uses properties of both and is probably neither.'
Scott Burton, 1969

'language and image are two worlds constantly seeking stability, the best possible relationship the two can have … is neither language, nor image …'
Richard Tuttle, 1989

Octagonals

'In '67 … I would choose a material and look at it and try to get out of it the thing that both satisfied my interest and explored that material simultaneously … And of course when it came to textile, the piece became an irregular octagonal but it had no back, no top, no front, it could be on the wall or it could be on the floor.'
Richard Tuttle, 2013

There is a transcendent quality to the Euclidean logic of geometry, to the properties of angles, points and lines, as there is with processions of numbers or the growth of an algorithm. These hermetic orders are as central to Tuttle's work as are chance and the fallibility of the human hand. In a number of octagonal works he has made out of paper and canvas, Tuttle combines hard-edged geometric abstraction with malleability and irregularity. He has given some of his works not one but two sets of numbers: *Perceived Obstacle No. 75 (Oil painting #4)* or *In 23 (Sculpture '99)*. In many of his works Tuttle deploys the rule of a system and then rebels against it. He releases a protean indeterminacy of form, balancing eternal truths with the contingent and imaginative act of perception.

Poetry

Since the 1960s Richard Tuttle has collaborated with many poets, including his wife, Mei-mei Berssenbrugge, to create book works. It can be argued that his works are themselves a form of poetry. Their syntax could be said to comprise:
· the title – for example 'Walking on Air'
· textile with its woven structure of repetitions and pauses acting as rhyme
· correlations and dissonances between textures, between the rigid and the flexible, the ragged and the precise
· sequences of marks and lines
· scale as succinct as a haiku or a fragment of verse by Sappho
· and the associative resonance of colour.

Textiles

For Tuttle's London project *I Don't Know . The Weave of Textile Language*, his use of and interest in textiles provide the central theme. It was in the late 1950s that artists began to use canvas, not as a support for paint but for its intrinsic qualities. Tuttle has been a pioneer in revealing its myriad sculptural qualities – the architecture of the weave, its combination of delicacy and resilience, the fact it can be hung or laid, the way it absorbs colour and takes up the shape of what it surrounds. His use of fabric also draws on how it presents two surfaces simultaneously.

Tuttle also collects textiles, adding connoisseur, anthropologist and cultural historian to his role as artist. His collection comes from around the world and from across centuries. It spans fabrics that have been grown, spun and dyed by artisans, to industrially manufactured textiles made from synthetic fibres. The pieces he collects testify to histories of labour, craft and technology, and to the rituals and aesthetic forms developed by world cultures. They also speak of the body – of the weaver and of the wearer.

Whitechapel Gallery

For over a century the Whitechapel Gallery has offered a platform for radical developments in sculpture, many of which, in the postwar period, originated in America. Richard Tuttle picks up the mantle from his compatriots, Whitechapel alumni David Smith, Robert Rauschenberg, Eva Hesse, Robert Smithson, Donald Judd, Carl Andre and, more recently, Paul McCarthy, Rachel Harrison and Josiah McElheny. Working with curator Magnus af Petersens, he stages a series of encounters with over forty remarkable works, dating from 1967 to the present. It is a privilege to present this survey alongside the twenty-first century's most important platform for new commissions, the Tate Modern Turbine Hall, where Chris Dercon and Achim Borchardt-Hume have helped deliver a major installation. It is a mark of Richard Tuttle's generosity and the breadth of his vision that he has moved so effortlessly between us to deliver the micro and the macro, the quotidian and the poetic, the concrete and the transcendent.

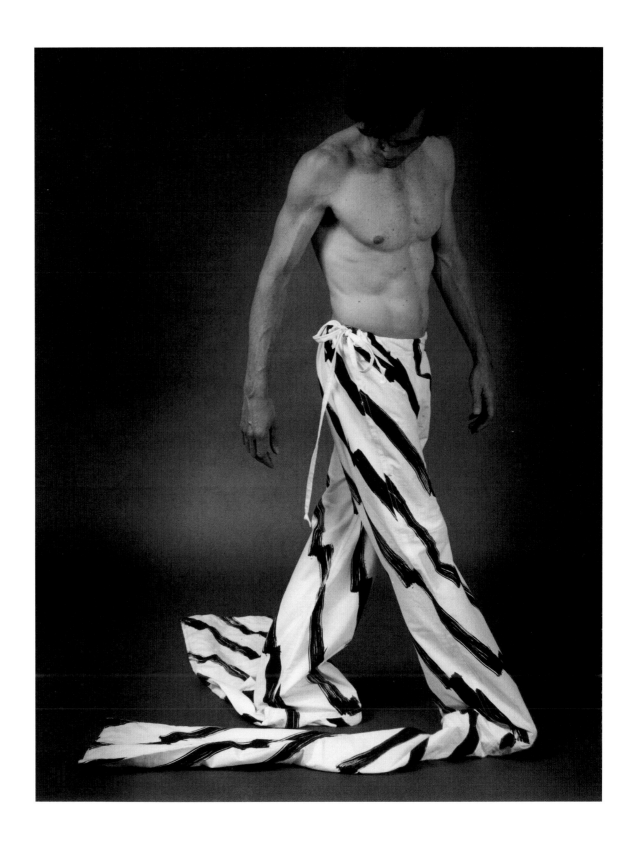

Pants 1979

Richard Tuttle, in collaboration with the Fabric
Workshop and Museum, Philadelphia
pigment on bleached cotton muslin, 183 × 66
edition of 5, worn by the artist

Letters (The Twenty-Six Series) 1966

galvanised iron, twenty-six parts, each approximately
15.2 × 22.9 × 1.6, overall dimensions vary with
installation
The Museum of Modern Art (MoMA), New York

The Visual Poetry of Richard Tuttle

MAGNUS AF PETERSENS

'Artists, it is obvious, have always loved drapery for its own sake – or, rather, for their own. When you paint or carve drapery, you are painting or carving forms which, for all practical purposes are non-representational.'
 Aldous Huxley, *The Doors of Perception*[1]

'A lot of animals are born hairless, but we have continued cute, like babies, born not being able to speak. Then, cloth takes over. What a great thing it must have been when the first person decided to paint on cloth!'
 Richard Tuttle[2]

Richard Tuttle continues to inspire us almost fifty years after his first exhibitions. The main focus of the present survey is the variety of ways in which he has employed textiles and fabric in his work. Although it is not exhaustive, it contains work from each decade of Tuttle's oeuvre, from the 1960s until 2014. This survey is one of three parts of Tuttle's ambitious project to 'identify, reveal and recognize the textile.'[3]

The title of the present exhibition, *I Don't Know*, is an expression of Tuttle's humble approach to the first question he asks himself: 'What is the textile?' Its subtitle, *The Weave of Textile Language*, suggests that the textile is, or could be seen as a form of language. The fact that the words 'textile' and 'text' have the same root has inspired many theories about the relationship between the two and Tuttle is critical of many of these. But he retains a keen interest in both textile and language, which therefore work as a useful starting point here.[4] Although he is first and foremost a visual artist, Tuttle is also a poet. This essay contextualises these two themes within an overview of his art and is complemented by short introductions to a selection of his works in the exhibition.

Entering the New York art scene, 1965

Richard Tuttle's first solo exhibition took place at Betty Parsons Gallery, New York, in 1965. Among the works he showed were a group of *Constructed Paintings* 1964–5. These are monochrome paintings on plywood sawn into clear geometric shapes to make each painting resemble a pictogram, somewhere between an abstract object and a sign or an image. The shapes were sawn from two pieces of plywood that were then joined by a strip of wood to become a 3-in-thick relief. Even earlier, in 1963–4 (and not included in the Betty Parsons exhibition), Tuttle had made small paper cubes from cardstock with openings in the form of geometric shapes cut into them. The light paper cubes were small enough to be held in one hand and were available for the viewer to pick up and handle, thus also offering a tactile experience.

The Betty Parsons exhibition was well received and the untitled paper cubes were mentioned in one of the most important essays in defining minimal art, Barbara Rose's

'ABC Art' in *Art in America* magazine (October 1965). At this time many artists in New York made works that were 'neither sculpture nor painting', as Donald Judd wrote in his seminal essay 'Specific Objects', first published in *Arts Yearbook 8* (1965). Tuttle's work, like minimal art, was abstract and reduced in form and colour. It soon became obvious, however, that his art was in fact a radical break with the ideals of contemporary minimal and conceptual art. He was soon identified as a post-minimalist, along with Eva Hesse, Gordon Matta-Clark, Richard Serra, Keith Sonnier and others, who reacted against the impersonal, theoretical and slick industrial aspects of minimal art. The minimalists were materialist in the sense that they denied any kind of spiritual content in art: 'What you see is what you see', as Frank Stella famously phrased it. Tuttle, on the other hand, has said that 'The job of the artist is to come up with ideas of how the mystic can be accommodated'.[5] He has always been interested in early German romanticism, in which he sees a synthesis of art and science contributing to a more holistic understanding of the world. He has also spoken warmly of Joseph Beuys, whom he met and considered a true artist. Tuttle's belief in the transformative power of art makes him a hopeful romantic. Yet he does not see art merely as an expression of the subject: his is a more Zen-like approach, where the aim is to remove as much ego as possible from the work.

Stella's 'What you see is what you see' may be compared with Tuttle's similarly often quoted statement 'To make something which looks like itself is, therefore, the problem, the solution'.[6] Thus he describes a task that many abstract or concrete artists have set themselves: to escape representation, to make us see things as they are and not as symbols of something else. But in this ambition there is also a respect for individuality; Tuttle has often talked of his own art as being not closely related to himself, explaining how his work has a will of its own. At a simple level, for example, some of his works demand a certain installation. The idea of 'looking like itself' becomes not only a question of abstraction or concrete art in a semiotic or phenomenological sense – that is, creating images that do not represent something else – but they also assume their own reality. The ideal becomes an ethical question, almost like respecting the individual personality of a work.

Tuttle had worked as an assistant at the Betty Parsons Gallery before his first solo exhibition there and had made friends with the generation of older artists it represented.

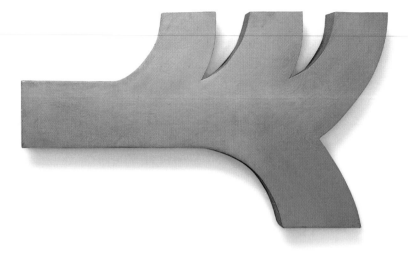

Sum Confluence 1964

acrylic on plywood, 52.4 × 92.7 × 7.6
Collection Judith Neisser. Promised gift to The Art
Institute of Chicago

Untitled 1964 (detail)

coated cardstock, ten parts, each 7.6 × 7.6 × 7.6,
overall dimensions vary with installation
Moderna Museet Stockholm. Gift 1985 from the
Betty Parsons Foundation through the American
Federation of the Arts

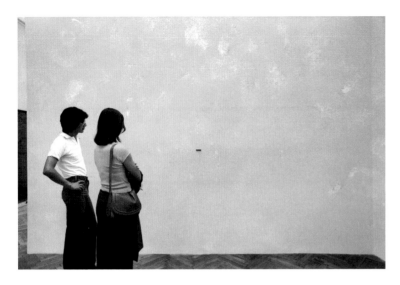

Photograph published in the article by Robert Hughes, 'Phoenix in Venice', *Time Magazine*, 26 July 1976, showing Venice Biennale visitors viewing Richard Tuttle's *Portrait of Marcia Tucker*; at Venice, 1976

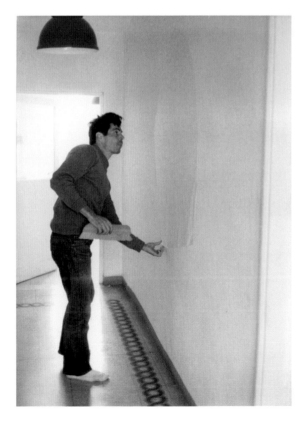

Richard Tuttle in Rome, c.1980s
Courtesy the artist and Pace Gallery

These were among the most established American artists of the time and included Ad Reinhardt, Barnett Newman and especially Agnes Martin, who became a lifelong friend. Tuttle's relationship with this generation of artists was not confrontational, as it had been between them and the minimalists: since the minimalists had already formulated a critique of abstract expressionism, he explains, there was no need for him to do it.

Towards nothingness: reduction

The small size of Tuttle's early works, such as his paper cubes, has remained characteristic of his work ever since – even if he has also made large and even very large-scale works, including the piece for the Turbine Hall at Tate Modern. Betty Parsons once told him that the abstract expressionists made large-scale work as an expression of the expanding universe. He was interested in the idea that if this were true, there must be an equally strong and opposite inward force.[7]

The small size and fragile, delicate quality of these smaller pieces, often made from simple everyday materials, are both humble and demanding. While conceptual artists in the mid-1960s were interested in the dematerialisation or even the disappearance of the art object from a more theoretical point of view, Tuttle made physical work that was on the verge of disappearing while at the same time having distinct visual qualities. Unlike conceptual artists, Tuttle has never provided instructions for his works so that they might be constructed or in other ways realised by anyone else. This is not because he is interested in the work as an expression of himself but simply because he believes that he cares more about the making of the work than others would.[8]

In these early years Tuttle made groups of works that were reduced in colour and form. The *Cloth Pieces* 1967 (see pp.84–9) are made of dyed canvas cut into various shapes, left without a frame to stretch it and either hung on nails on the wall or placed flat on the floor. His *Paper Octagonals* 1970 are sheets of white paper glued directly onto the wall. These are approximately 54 inches in diameter – the artist's arm span, thus relating directly to his body. Depending on the level of illumination in the room, they can be quite hard to discover at first. In some ways they function as interventions in the space and they draw attention as much to their surroundings as to their own physical form.

The *Wire Pieces* 1971–2 (see pp.90–1) are also very light, consisting of a graphite line drawn directly on the wall and a wire, attached to the wall by one or two nails, bent to follow the graphite pencil line. The wire is then released, springing out from the wall to cast a shadow onto it. These works are extremely simple, reduced and transparent and yet also complex and intricate. The play between line, wire and shadow, a line drawing that reaches out into space and creates volume, is among many aspects to consider. Tuttle's installation of these works demands a high concentration and is close to a performance: the fact that they are installed in situ and only by Tuttle renders them ephemeral. Yet the artist does not put himself at the centre of the work. An element of chance is introduced by the wire that springs out from the wall and its shadow, which are out of the artist's control: 'At the beginning of the *Wire Pieces*, the question for me was: "how can I keep myself out of my work?"'[9]

3rd Rope Piece 1974 is a piece of cotton washing rope attached to the wall with three nails. Although small in size (½ × 3 × ⅜ in), its shadow is easily seen from a distance against the wall, which is otherwise bare: its size and placement on the wall and in relation to the surrounding space work together to make its presence strongly felt. This piece allegedly led to the sacking of Marcia Tucker, curator of Tuttle's controversial solo exhibition at the Whitney Museum in 1975 – although the reality was no doubt more complex. Tuttle's experimentations at the limits of art were just too much for many critics and the show received vehemently aggressive reviews. Conservative art critic Hilton Kramer, for example, wrote in *The New York Times*: 'One is tempted to say that, so far as art is concerned, less has never been less than this.'[10]

Assemblage, expansion

Tuttle continued making small works that had reduced material and physical presence. But in the early 1980s he developed the aspects of relief seen in some of his earlier works, such as the constructed paintings, wire pieces, cloth pieces and rope pieces, into playful assemblages. These included combinations of drawing and painting on paper, wood and other everyday objects and materials, and were often painted in strong, bright colours.

Monkey's Recovery for a Darkened Room 6 1983 is an array of small objects linked together with what looks like a bent

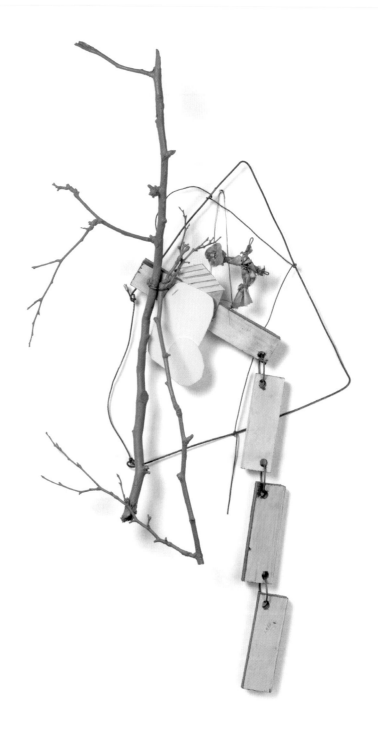

Monkey's Recovery for a Darkened Room (Bluebird) 1983

wood, wire, acrylic, matboard, string and cloth, 101.6 × 52.1 × 31.8
National Gallery of Art Washington. Dorothy and Herbert Vogel Collection 2001

Installation view of the 1992 exhibition *Richard Tuttle* at Mary Boone Gallery, New York, showing line pieces from the series *Fiction Fish*, 1992

string coat-hanger. Painted bright red, the coat-hanger is as much a part of the work as the other objects in the piece: a delicate branch painted blue, four small pieces of a board linked by wires like a chain, a piece of cloth and a piece of paper stapled to one of the small boards. The delicate parts are loosely held together, the joints exposed, looking paradoxically both strong and vulnerable. The spaces in between the objects are equally important parts of the whole, which looks both playful and truly eccentric.

Richard Tuttle has spent long periods travelling in Europe, Japan and India. His interest in culture and art knows no geographical or historical boundaries. He is a reader and studies many languages. Since he constantly works, his art also travels light in the sense that he has no need of a large studio with many assistants to help with its production: he works with what he has to hand, often in hotel rooms. Of *Replace II*, made at Kunsthaus Zug, Switzerland, for example, he said: 'Making this work was a most pleasant experience. As before, miraculously, we found everything we needed nearby.'[11] But the fact that some of his works are small does not preclude them from occupying space in a strong way. On the contrary, their installation – how they are attached to the walls or laid out on the floor, sometimes even painted or drawn straight onto the wall – makes their relationship with the space very precisely calibrated. *Fiction Fish* 7 1992 (see pp.104–5), for example, is installed just 1¼ in above floor level, with a single vertical line drawn on the wall from sculpture to the ceiling above. Rather than being a separate surface onto which the work is hung, the wall now becomes a component of the work, its entire surface area transforming the notion of scale and presence experienced by the viewer.

At times Tuttle changes the installation of works during the run of an exhibition. This is partly to indicate that the works are open to variation and partly to show how different they can appear. Some works are described as being without an orientation, whereas others have very specific instructions on their installation. But almost all of Tuttle's art enters a dialogue with the space in which it is shown. This might be said of any work of art, but the point is that for Tuttle this is a vital consideration: in the words of Madeleine Grynsztejn, curator of his major touring retrospective of 2006, his work is 'site-responsive' rather than 'site-specific'.

Textiles

By 1967 when Richard Tuttle made *The Cloth Pieces*, he had already become fascinated by the possibilities offered by textiles. As the present exhibition shows, he has worked with fabric throughout his career. He is also a collector of textiles: the first section of this catalogue presents a selection from his collection.[12] Although many other artists share his passion for textiles, in Western culture fabric has typically had a secondary status, considered as craft rather than fine art.[13] But for Tuttle the opposite is true, even if the distinction does not seem particularly relevant for him. He is also interested in the ambiguous nature of Western attitudes towards textiles: being in common everyday use, we take them for granted and tend not to see or think about them – the material becomes invisible. At the same time, they are a part of everyday life that is also appreciated, even loved. Tuttle himself talks of textiles in terms of love, saying that when we wear clothes we are literally surrounded by this love. He sees a development here: 'First there's Love … then there's fabric'.

One of the functions of textiles is to conceal. The theme of concealing and revealing is one that fascinates Tuttle. It can be found in the weave of fabric, where warp and weft create an over-under, under-over of threads: Tuttle compares this with the grid motif that is central to abstract art from Mondrian to minimalism and beyond. The warp and weft have also been compared to grammatical structure on which to build sentences. This link connects the visual and tactile qualities of Tuttle's work with his interest in poetry, in which the specific form of language – words, sound and metre and, not least the visuality of writing – takes on a meaning outside that of communicating a content that is easily translatable.

In his catalogue essay 'A Love Letter to Fontana', for the 1988 Lucio Fontana exhibition at the Whitechapel Gallery, Tuttle comments on Fontana's delight in dressing well. This could equally be said of Tuttle. At an exhibition at The Fabric Workshop in Philadelphia in 1979 he used silkscreened bleached cotton muslin to make shirts and a jumper and, most radically, a pair of trousers with extremely long legs entitled *Pants*. Wearing these is a kind of performance. This was his first venture into the realm of design, making objects that could be considered to have functional use.

He is especially interested in the work of John Ruskin, whose writing was an inspiration for the Arts and Crafts movement and who, like Tuttle, embraced a boundless view of creativity and its intrinsic relationship to society and knowledge.

Another example of Tuttle's use of fabric and space is his textile sculpture titled *Replace the Abstract Picture Plane I* 1996, part of a three-part cycle that took more than five years to complete and which, in some senses, continues at the Kunsthaus Zug. Here Tuttle created a long sculpture consisting of fabric stretched over a skeleton of narrow pieces of wood that snaked its way through galleries and down a spiral staircase. Thus he balances lightness with large scale, made possible by the long rolls of textile. The spiral is a form that often features in his work: he is not afraid of beauty or ornament, which much modern art criticism considers decorative and shallow.

Between image and sign:
language and poetry

There is a complex relationship between Richard Tuttle's visual art and his language, in particular his poetry. Not only is he often described as a visual poet, he also writes poetry and makes artist's books that sometimes include poetry – either his own or that of a poet with whom he collaborates. For example, his 1998 publication *Reading Red* was made in collaboration with the American poet Charles Bernstein.

Already, in the first painting Tuttle made when he arrived in New York in 1963, language is paradoxically both present and absent at the same time. Here he painted words from a statement by the philosopher Alfred J. Whiteread and then painted over them with a thin layer of white, making the words almost disappear. He later described this as a painting of 'ambiguity', suggesting an early choice of media – paint rather than the written word – but still, the writing is there, underneath.[14] There is of course no contradiction in being a well-read intellectual and appreciating that which escapes written and spoken language.

His first artist book was *Story with Seven Characters* 1965, in which the seven characters are printed with wood blocks. Although they look like numbers or alphabetical letters, they are not from any existing alphabet. They are also characters in that they are the protagonists of an implied narrative.

Another early example of Tuttle's interest in this borderland between image and language, representation and object, is *Letters (The Twenty-Six Series)* 1967. This consists of

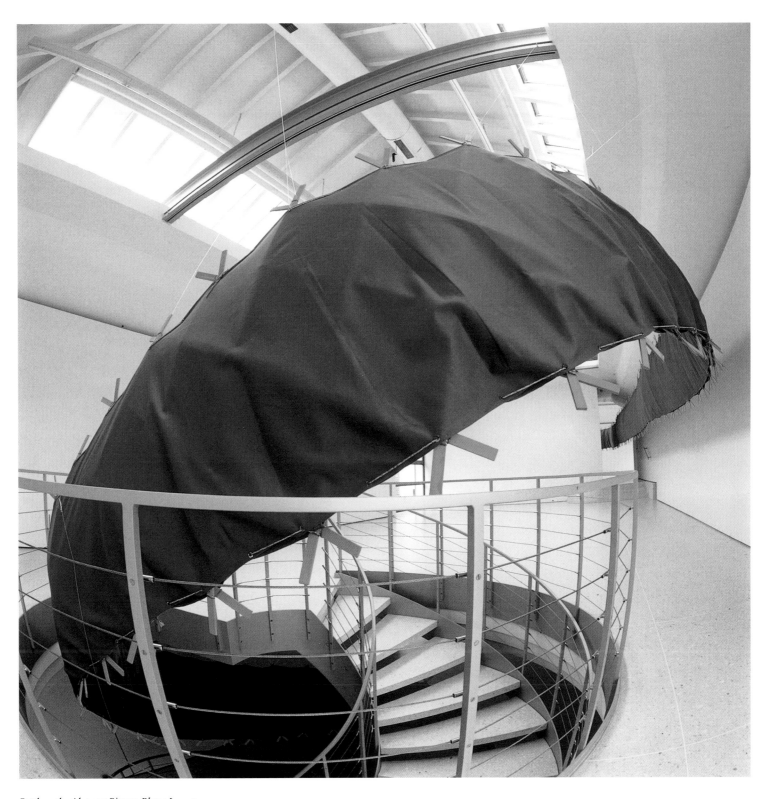

Replace the Abstract Picture Plane I 1996

cotton twill, grommets, wood, acrylic, string,
monofilament, 100 × 4400 × 15
Kunsthaus Zug

26 sculptural shapes, echoing the number of letters in the English alphabet, laid out on a platform, inviting viewers to hold them in their hands. The small sculptures do not represent real letters but are quite close to them in shape. They can be seen as an alternative language of Tuttle's own invention, abstract in that it does not represent any known letters – but still referencing them. The need to invent a new language was perhaps a challenge to all artists. As Madeleine Grynsztejn has pointed out, the sculptures also call attention to the formal, visual aspects of letters in general – beyond their function as signifiers.[15] This is further evident in another alphabet created by Tuttle, *Type* 2004 (see pp.114–17) included in the present exhibition.

Tuttle's interest in language as an artistic material is something he shared with many other artists of his generation, such as Mel Bochner, Joseph Kosuth, Sol LeWitt, Lee Lozano, Bruce Nauman, Robert Smithson and Lawrence Weiner, to mention just a few American artists. The list could be made much longer since this was one of the most characteristic developments in the art of the late 1960s and early 1970s. But Tuttle's invented alphabets set him apart from most other artists: he rarely uses written language in his visual art. With his extensive knowledge of the history of poetry and his special interest in modern poets from Mallarmé onwards, he considers the physical materiality of language, with typography and the design of the page as vital elements of the poetry. This intersection of word and image is the place in which concrete poetry is born. Tuttle's interest in making books also reflects his attitude towards language and images in books as more than just representations of other, existing works. One can differentiate between exhibition catalogues, where works of art are represented in images as well as words, and artist's books where the images and words are created specifically for the book.

When discussing the production of the present book, concerns were raised, as always, about the quality of reproductions and of the difficulties of representing three-dimensional artworks on the pages of a book. But Richard Tuttle, who has always had a positive approach to work, reminds us that while a reproduction is not the same as the work itself, 'a book is also a real thing in the real world.'[16]

1 Aldous Huxley, *The Doors of Perception*, London 1954.
2 Richard Tuttle, email to Magnus af Petersens, 8 September 2013.
3 Richard Tuttle in a catalogue meeting at Tate, September 2013.
4 One of many theories of relations between poetry and weaving is that language – metrical narration and singing – was used by weavers in India and Central Asia to remember numerical and colour-related information needed in the very complex production of elaborate patterns in weaving. See Anthony Tuck, 'Singing the Rug: Patterned Textiles and the Origin of Indo-European Metrical Poetry', *American Journal of Archeology*, October 2006.
5 Richard Tuttle quoted by M. Grynsztejn, 'A Universe of Small Truths', in *The Art of Richard Tuttle*, exh. cat., San Francisco Museum of Modern Art, San Francisco 2005, p.00.
6 Richard Tuttle, 'Work is Justification for the Excuse', first published in *Documenta 5*, exh. cat., Kassel 1972, reprinted in *Richard Tuttle: Wire Pieces*, exh. cat., CAPC Musée d'Art Contemporain de Bordeaux, 1986.
7 Online filmed interview for San Francisco Museum of Modern Art (SFMoMA), 2005, http://www.sfmoma.org/explore/multimedia/videos.
8 Richard Shiff, 'It Shows', in *The Art of Richard Tuttle*, exh. cat., San Francisco Museum of Modern Art, San Francisco 2005, p.268.
9 Ibid., p.265.
10 Hilton Kramer, 'Tuttle's Art on display at Whitney', *New York Times*, 12 September 1975.
11 Richard Tuttle quoted in Matthias Haldeman (ed.), *Richard Tuttle: Replace The Abstract Picture Plane*, Ostfilden 2001, p.39.
12 Tuttle has also curated an exhibition of Indonesian textiles, for which he wrote and edited the accompanying catalogue, as well as an exhibition at Boijmans van Beuningen, *Red Oxide* (1992), comprising objects from the collection that had been coloured with oxide hues. In the catalogue to the exhibition of Indonesian textiles, he wrote: 'The word "textile", and all its derivatives like "text" or "context", can be traced at least to Sanskrit where the meaning of weaving and construction attach themselves to over/under, under/over.'
13 This lower status is also connected to the fact that textile art has mostly been practised by women, whose work was more or less consistently dismissed by critics as being of a lesser status within mainstream artistic culture. In fact, many of the words used to describe Tuttle's art, such as 'gentle', 'ephemeral', 'smallness' and decoration', have often been used by critics to negatively describe art made by women; perhaps Tuttle was referring to this when he once remarked 'I am a woman'.
14 Katy Siegel, 'As Far As Language Goes', in *The Art of Richard Tuttle*, exh. cat., San Francisco Museum of Modern Art, San Francisco 2005, p.334.
15 Madeleine Grynsztejn, 'A Universe of Small Truths', in Ibid., p.30.
16 Richard Tuttle in a catalogue meeting at Tate, September 2013.

Story with Seven Characters 1965

book with 8 woodcuts, 8 leaves, binding: black paper
over board, edged with black tape, edition of 7
30.8 × 28.6 × 1
printed, bound and published by Richard Tuttle
Annemarie and Gianfranco Verna Collection, Zurich.
Courtesy Centro Galego de Arte Contemporánea
Santiago de Compostela

Type 2004 (detail, U)

portfolio of 26 drypoint etchings with tarlatan chine
collé
prints A–M: 33 × 33 each; prints N–Z 31.8 × 31.8 each
edition of 15 and 1 AP
published by Crown Point Press, San Francisco, CA

Textile Works, 1967–2014, Whitechapel Gallery

Cloth Pieces 1967

Made in 1967, these are the earliest works in the present exhibition. The title of the group emphasises the textile material, although some individual pieces have additional titles, such as *Pale Blue Canvas*, which are simple descriptions of colour and material. Others, such as *Ladder Piece*, have titles that suggest a motif. This perhaps reveals Tuttle's ambivalent attitude towards representation.

There is something ephemeral, transient, in the way that the *Cloth Pieces* are open to change. They are described by Tuttle as having 'no orientation', so their installation, up and down, even front and back, is left open. Since they are dyed rather than painted, the viewer knows what the back of the cloth looks like, even if it cannot be seen. The pieces are of different shapes: some are octagonal, others are reminiscent of letters or numbers. They are not stretched on any kind of frame but each has a seam along the edges and holes to hang them on nails from the wall. Sometimes they are placed on the floor, which emphasises the materiality of the cloth. The installer has to make choices that are more complex and less guided by convention than is the case when hanging a painting. Furthermore, the colours are subdued, blue, purple, yellow and have most probably faded since they were first shown, something Richard Tuttle accepts as part of their 'life'.

MaP

Ladder Piece 1967

dyed cut canvas
199 × 49 × 0.5
orientation variable

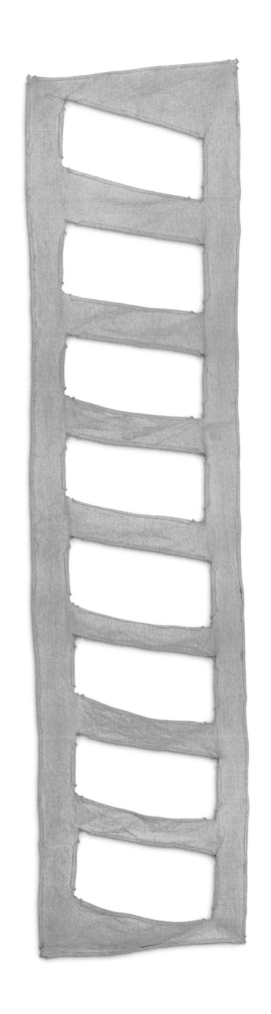

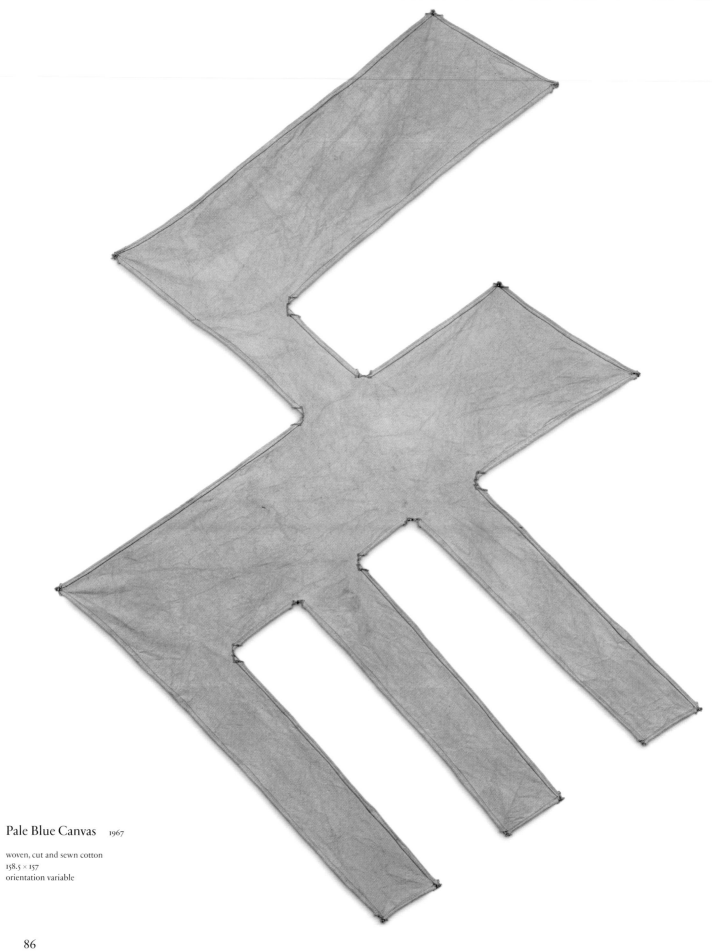

Pale Blue Canvas 1967

woven, cut and sewn cotton
158.5 × 157
orientation variable

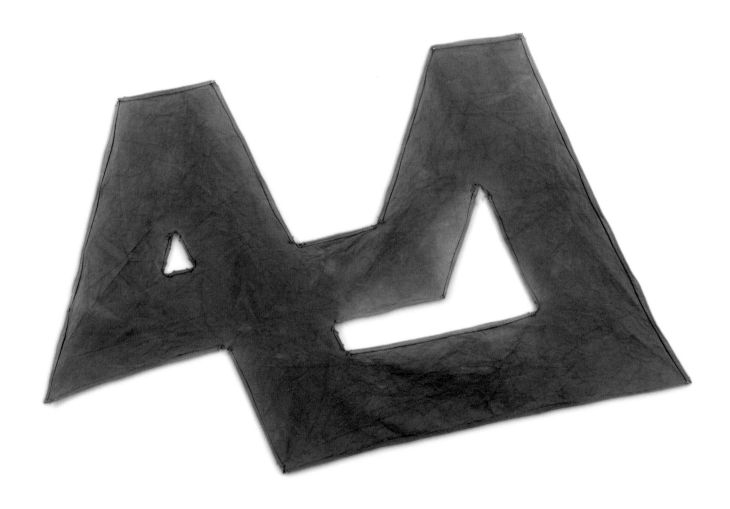

Untitled (Cloth Piece) 1967

dyed canvas and thread
97.8 × 155
orientation variable

Purple Octagonal 1967

dyed canvas
139.2 × 141
orientation variable

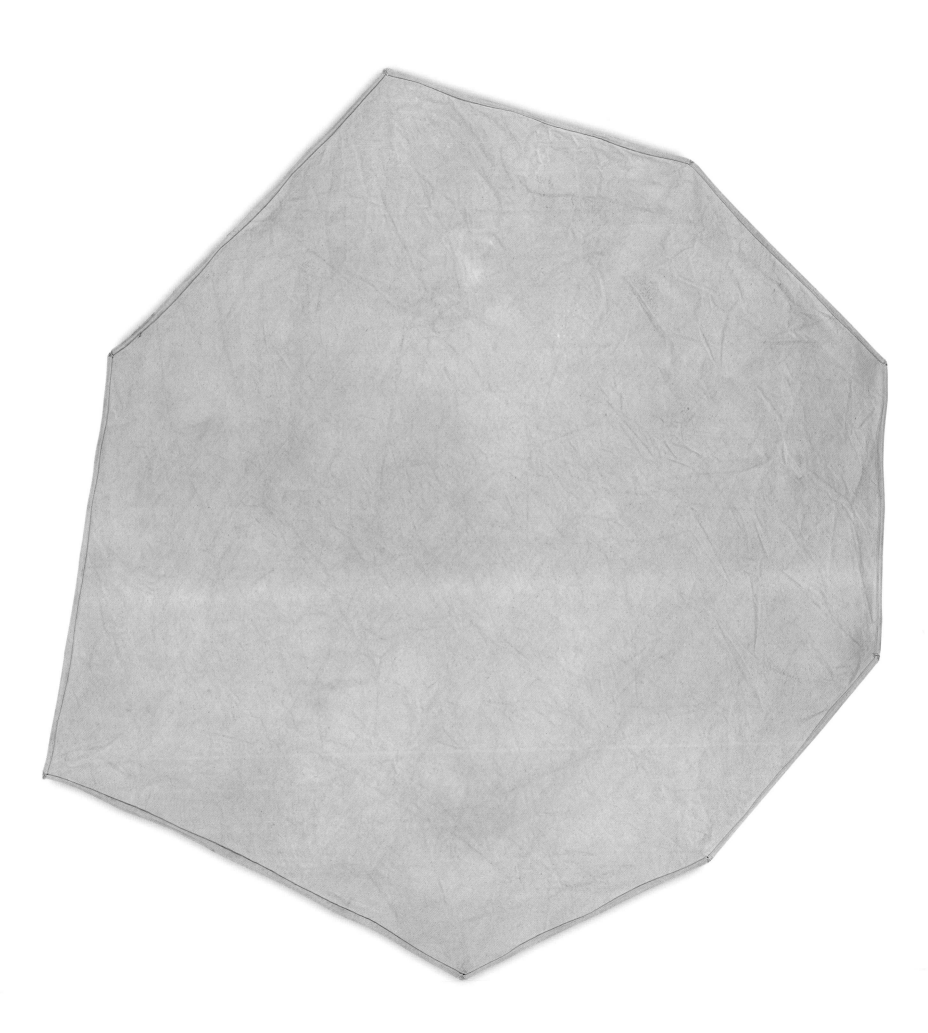

Wire Pieces 1971–2

Few works of art have pushed the limits of what constitutes art as far as the *Wire Pieces*, which invent something new in the process of both reducing and fusing drawing, sculpture and performance. Just as these are at the limits of art, they are at the limit of what may be considered as textile – the requirement for inclusion in the present exhibition. But the wire relates to the smallest constituent of a textile: a thread. The *Wire Pieces* are textiles just as a monochrome is a grid with only one square.

MᴀP

13th Wire Piece 1972, made on site

florist wire, nails and graphite
dimensions vary with installation

3rd Rope Piece 1974

rope and nails
length 7.6

4th Summer Wood Piece 1974

cloth and wood
76.2 × 50.8 × 2.5

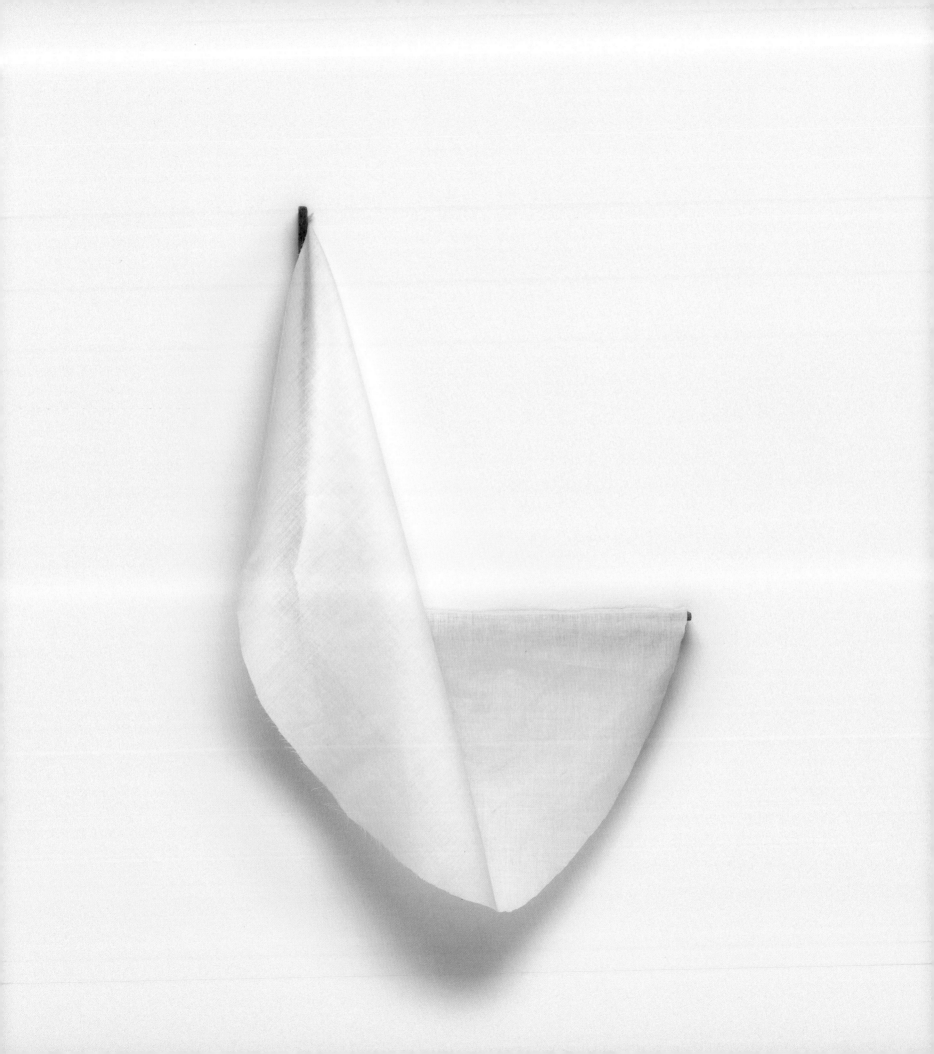

Ten Kinds of Memory
and Memory Itself 1973

This work, consisting of ten pieces of cord arranged on the floor, may be seen as something between a drawing and a group of sculptures. The piece is installed according to photographs and instructions. But rather than looking at it as a conceptual, instructional work, in the footsteps of John Cage, Yoko Ono and George Brecht, Tuttle associates it with Ryōan-ji, the Japanese gardens of sand and stone. A Ryōan-ji contains fifteen stones placed so that it is impossible to see all of them at once from inside the garden. The white sand is carefully raked to create patterns around each stone. This is a process that must be repeated at least once a day in order for the garden to stay fresh and well kept. *Ten Kinds of Memory and Memory Itself* needs to be adjusted and reinstalled, or 'refreshed', as Tuttle describes it, probably every morning after the cordage has been moved for cleaning the gallery floors. When this work was installed at the Whitney retrospective in 1975 it was used in a dance workshop, which emphasised the element of gesture that is present in much of Tuttle's work. As with the *Wire Pieces*, the movement involved in the arrangement of the work is in a way choreographed by the wire or cord and easy to see as a performance.

MaP

Ten Kinds of Memory and Memory Itself 1973, made on site

string – in several parts
dimensions variable

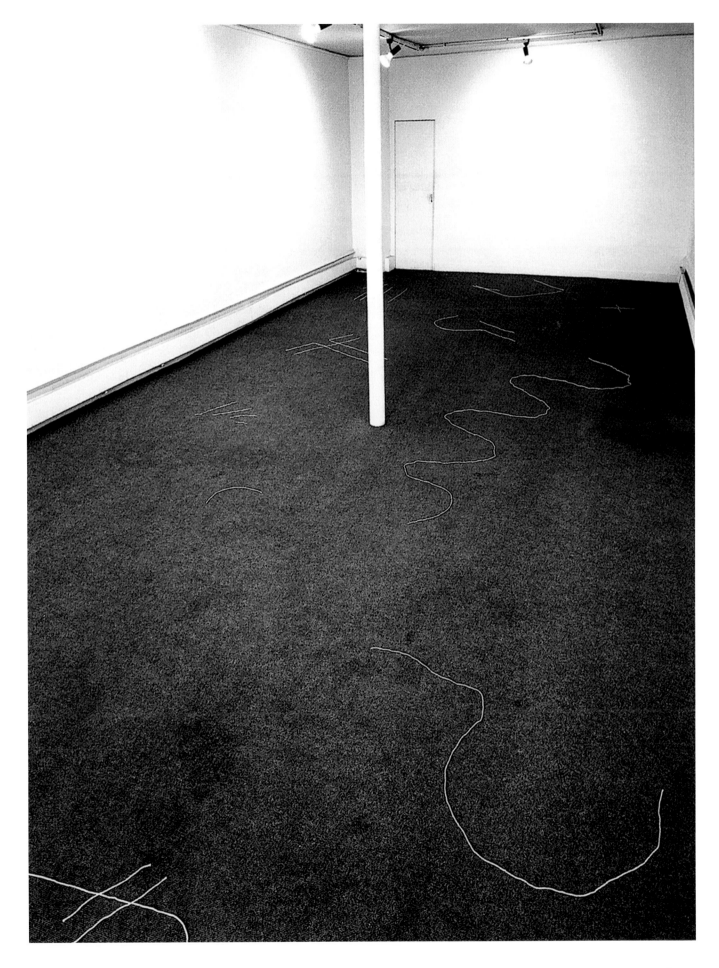

Floor Drawing #5 1987

wood, canvas, fabric, acrylic paint and linen thread
104 × 150 × 157

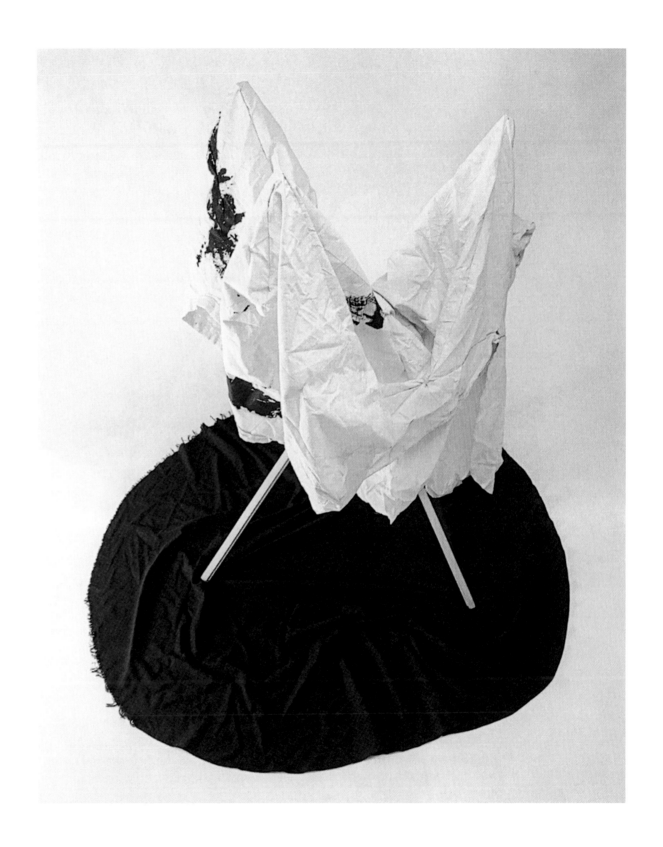

Perceived Obstacles 1991

These were made as part of a group of eighty paintings and then, in 2000, as an artist's book. The nine paintings in the exhibition are all painted with oil on linen. These are the last nine in the series of eighty and Tuttle's only paintings in oil.

The paintings are an unusually long landscape shape measuring 30 × 100 cm, each with an abstract figure that in many instances is placed somewhere close to the middle, surrounded by space. The installation of the works is always critical to Tuttle; these paintings are intended to be installed in a stack. He thinks of them as connected units and invites the viewer to 'scan' them.

Tuttle has explained that these paintings were made in a very special context and circumstance. Someone close to him was experiencing a problem, the root of which was hard to understand, and he believed that his art might help his friend to see its cause. Thus art becomes a positive energy, in the first instance making us able to see and understand; and, beyond that, possessing therapeutic qualities, helping us in the healing process.

MAP

Perceived Obstacles Nos.72–80 1991

oil and graphite on unstretched canvas
each c.33 × 97

top to bottom, p.101: 72, 73, 74
p.102: 75, 77, 79
p.103: 76, 78, 80

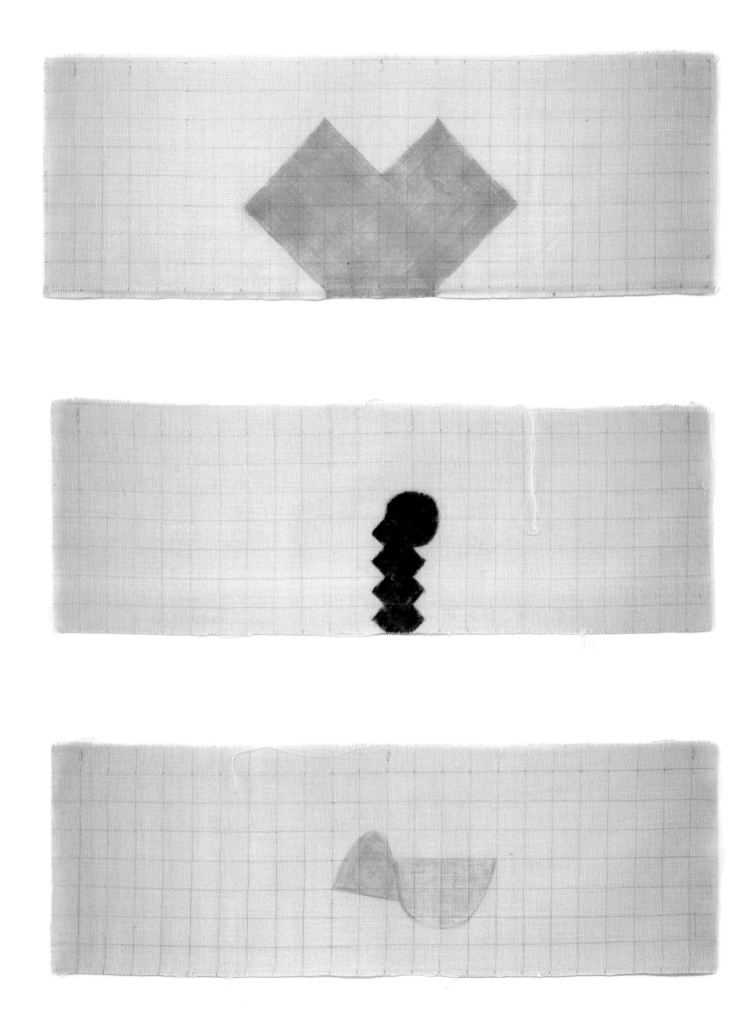

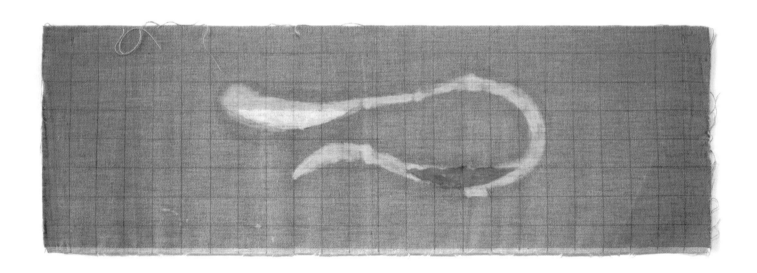

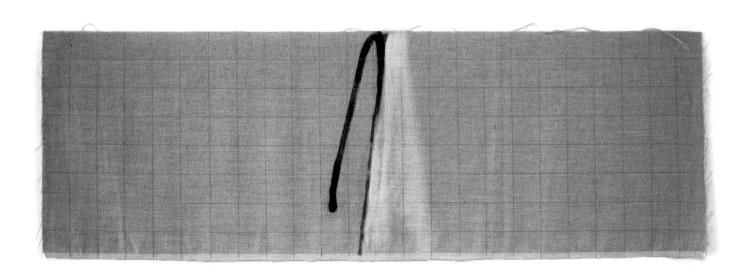

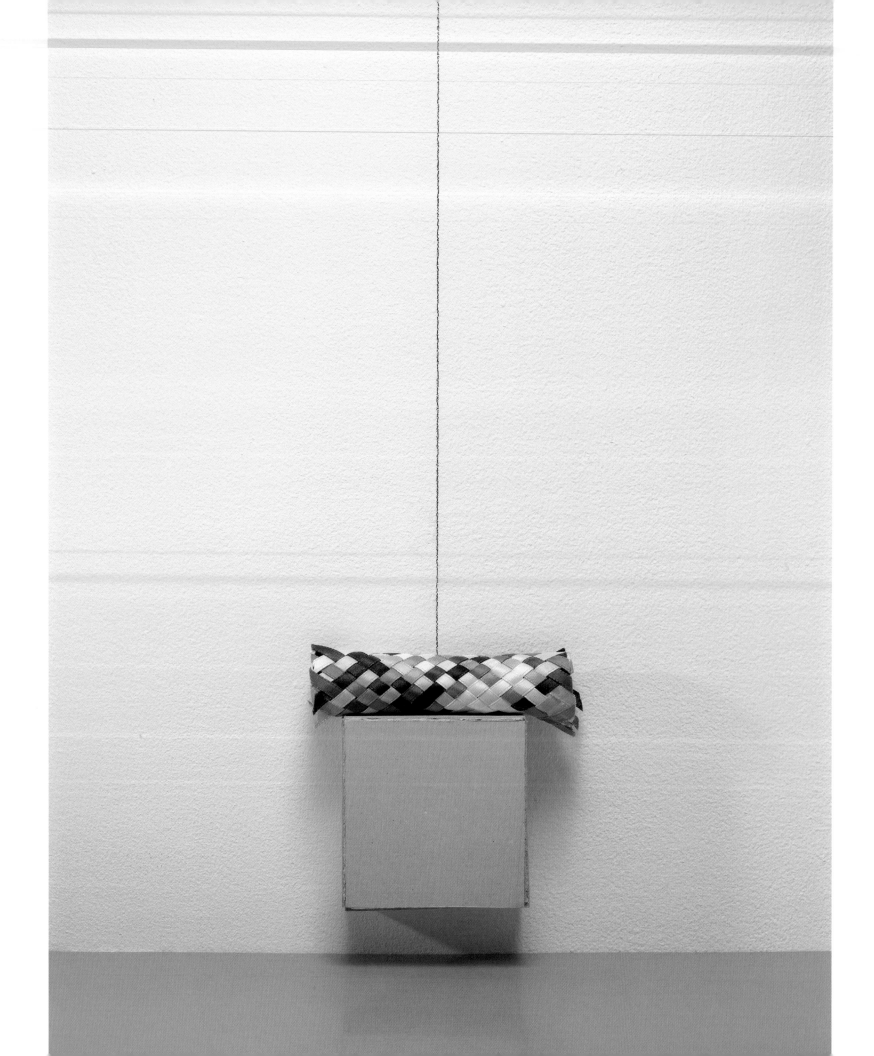

Fiction Fish 7 1992

This is part of a group of works. The starting point for the work is Tuttle's installation of sculptures by Julio González at the Institut Valencià d'Art Modern (IVAM), home of the Julio González estate. Tuttle installed a group of González's sculptures on a platform in the centre of a gallery, together with some of his own pieces. The small distance between the work of art and the floor was what he later explored in *Fiction Fish*. The example shown in the present exhibition looks like a pleated basket. Pleating is a technique similar to weaving, involving an over-under, under-over construction.

MAP

Fiction Fish 7 1992

graphite and ribbon on cardboard, graphite line
12.7 × 11.4 × 2.9 (without line)

How it Goes Around the Corner 1996

canvas, wood, thread, nails
8 parts, dimensions variable

How it Goes Around the Corner 1996

In many of Tuttle's works the wooden frame plays a
prominent role. In this group the frame is sometimes so
tight around the unstretched and unpainted cloth that the
surface inside the frame is thinner than the piece of wood
that makes up the frame. These works are installed in a line
that follows the wall and, as the title indicates, continue
around the corner.

MAP

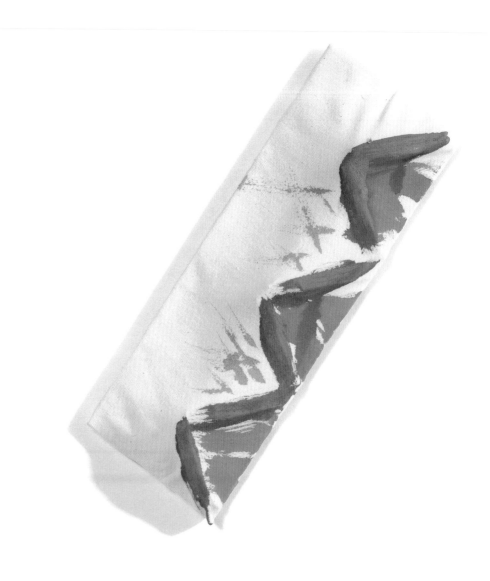

In 14 1998

acrylic, canvas, wood
22.2 × 8.3 × 3.5

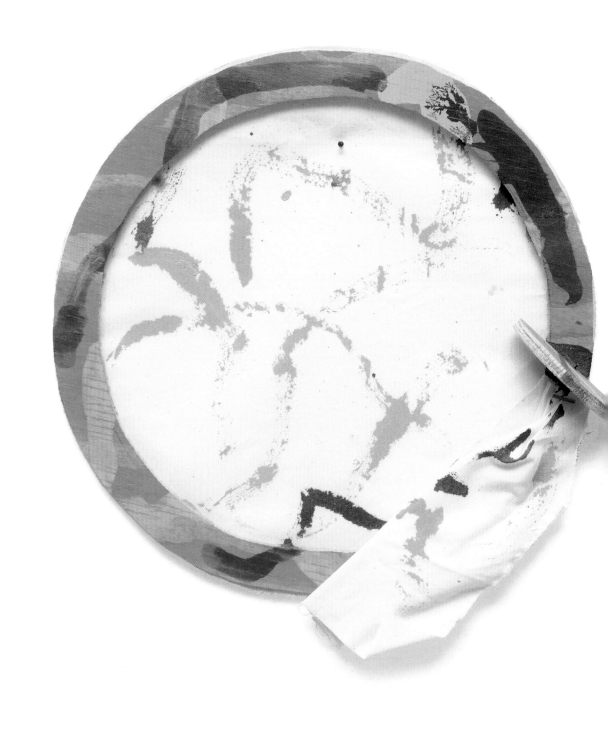

In 23 1998

acrylic, canvas, wood
33.7 × 31.8 × 5.1

Cloth (Lable 1–16) 2002–5

16 etchings with aquatint, spitbite, sugarlift,
softground, drypoint and fabric colle, published by
Brooke Alexander in edition of 25
40.6 × 40.6 each

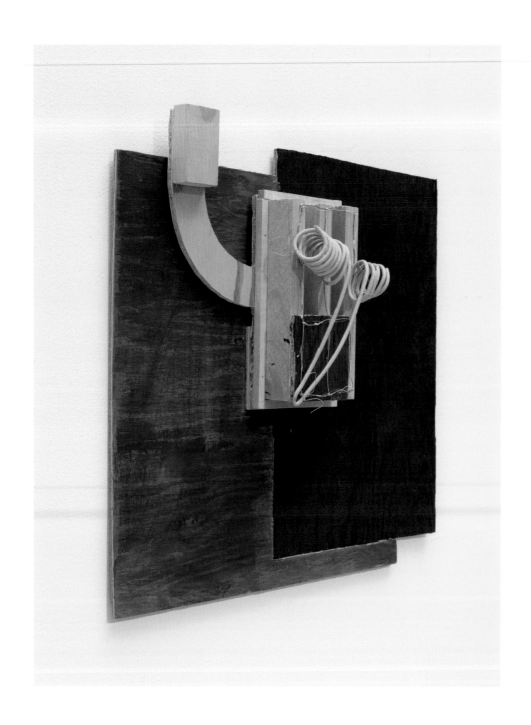

The Right Side of Summer 2003

metal, wire and wood
41.9 × 44.4 × 8.3

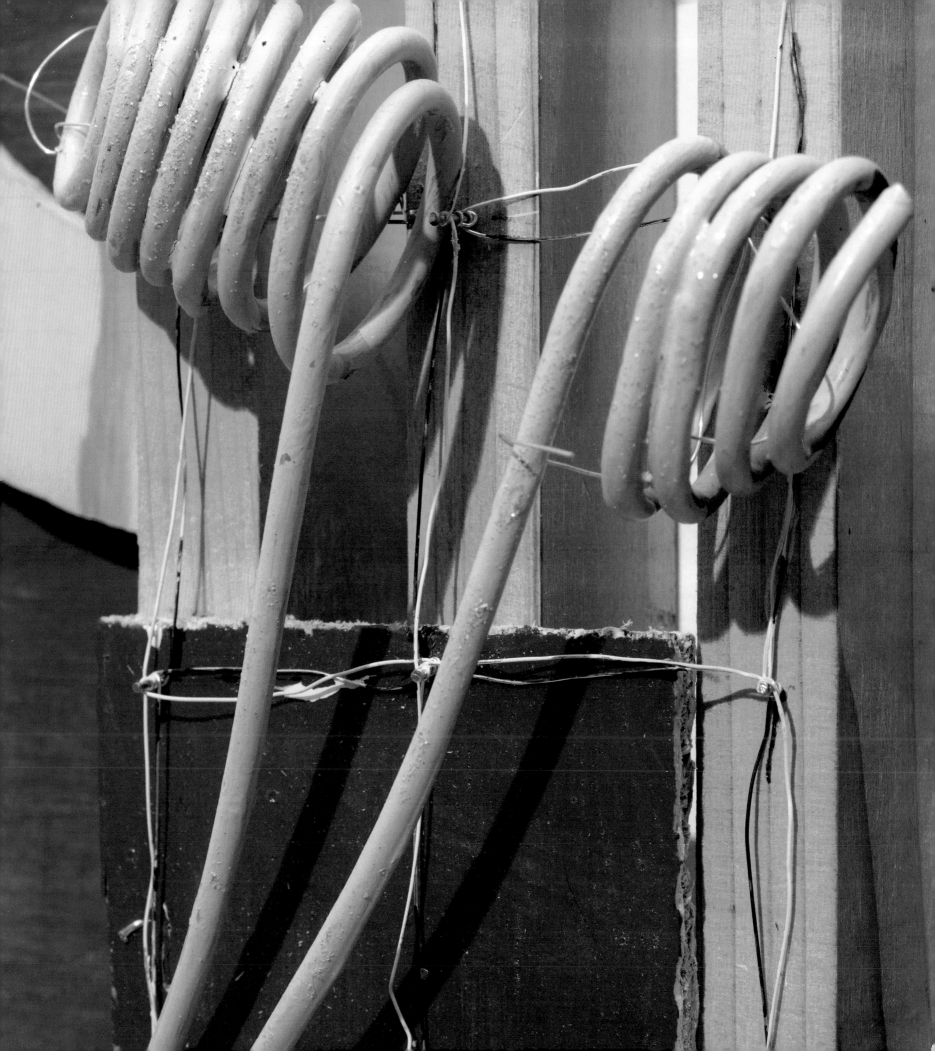

This is a series of twenty-six prints that make up an alphabet, something Tuttle did not plan when he started making the first ones: as he explains in a folder made to accompany the prints, 'It is always exciting for me to find I am making an alphabet … Paper and cloth, so common in everyday life, attain their order and harmony from their origins in chaos, like consciousness'.

In all of the prints in the series there is a very small piece of cloth attached to the paper. This is the tarlatan used to wipe ink off the copper plate used for chine collé. The cloth has a wide mesh similar to a grid. The inclusion of this textile, which is normally invisible in the end product, is typical of Richard Tuttle.

MAP

Type 2004

portfolio of 26 drypoint etchings with tarlatan chine collé
prints A–M: 33 × 33 each; prints N–Z: 31.8 × 31.8 each
edition of 15 + 1 AP
published by Crown Point Press, San Francisco, CA
illustrated here: A, K, V

A

K

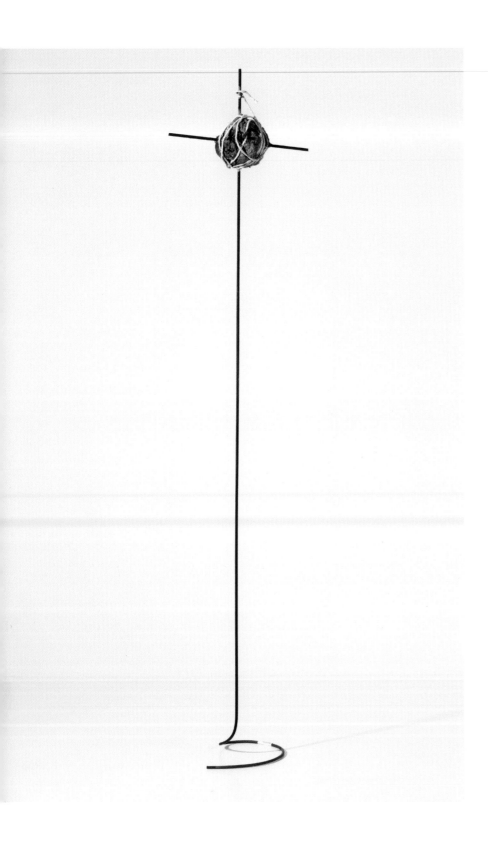

The Present 2004

metal, cloth, paper, paint, rope, with 4 coloured lamps
150 × 33 × 33 approx.

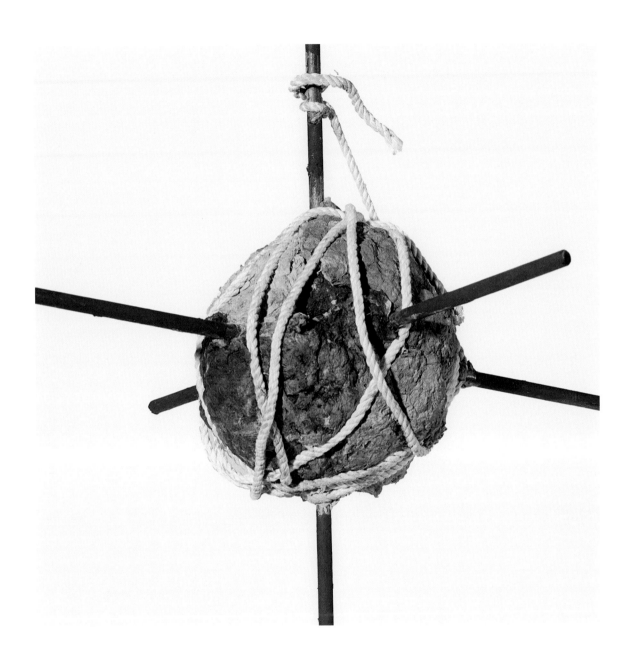

Space-is-Concrete (6) 2005

acrylic paint and graphite on spun plastic with
Golden® black gesso
61 × 50.8

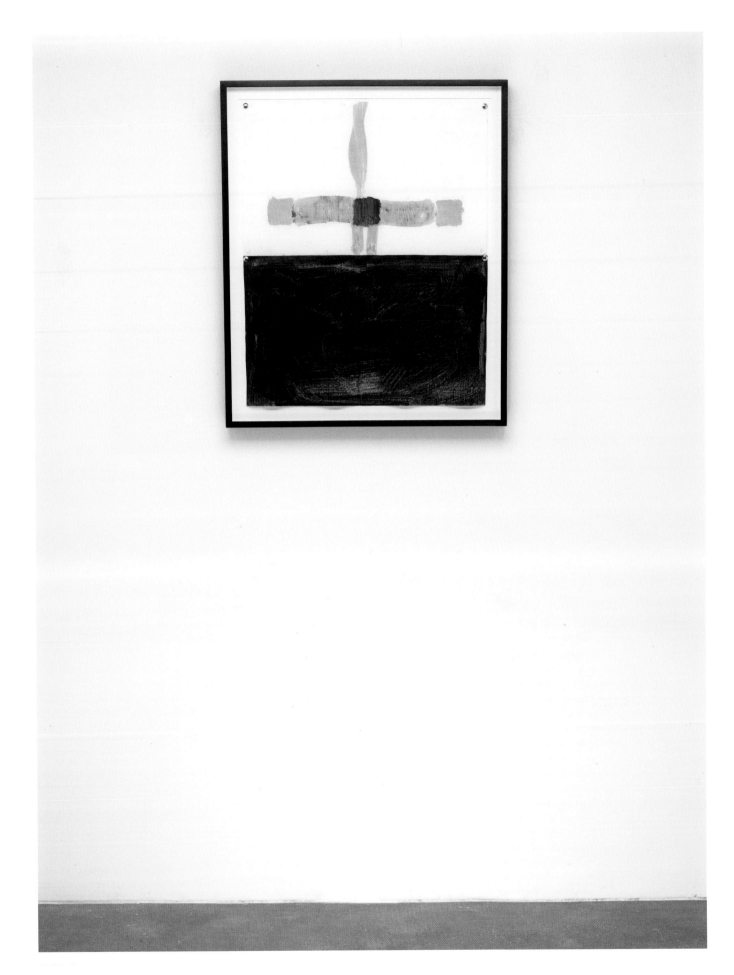

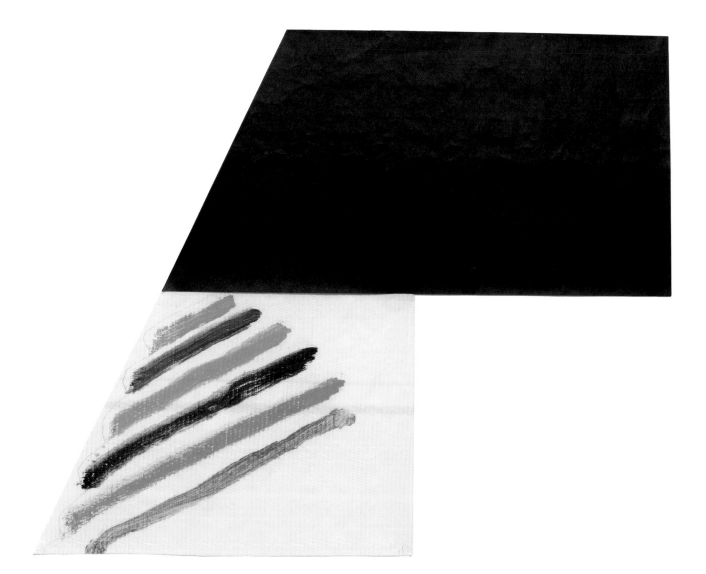

Space-is-Concrete (25) 2005

acrylic paint and graphite on spun plastic with
Golden® black gesso
61 × 76.2

Space-is-Concrete (5) 2005

acrylic paint and graphite on spun plastic with
Golden® black gesso
91.4 × 50.8

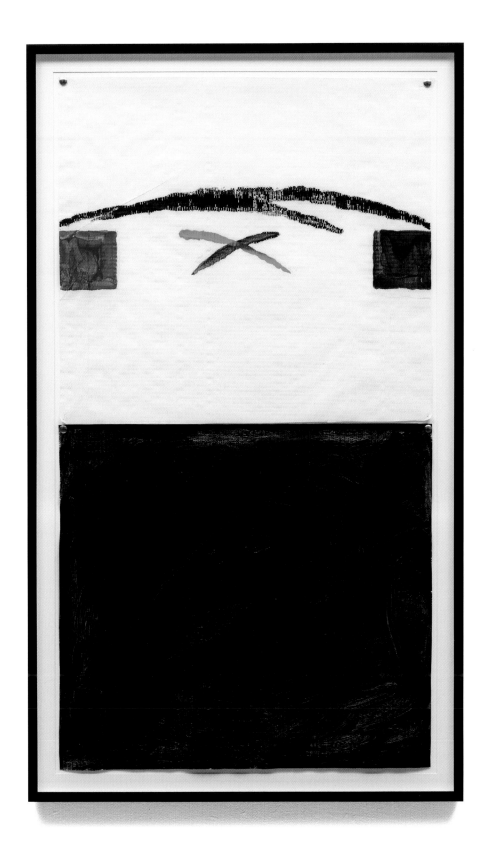

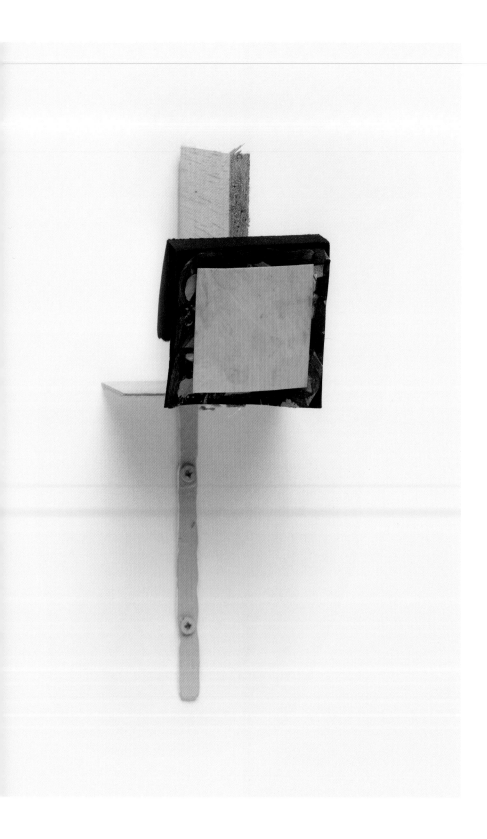

Section VII, Extension K 2007

fabric, acrylic paint, yarn, glue, wood, hammered
aluminium armature wire, screws
19 × 6.4 × 8.9

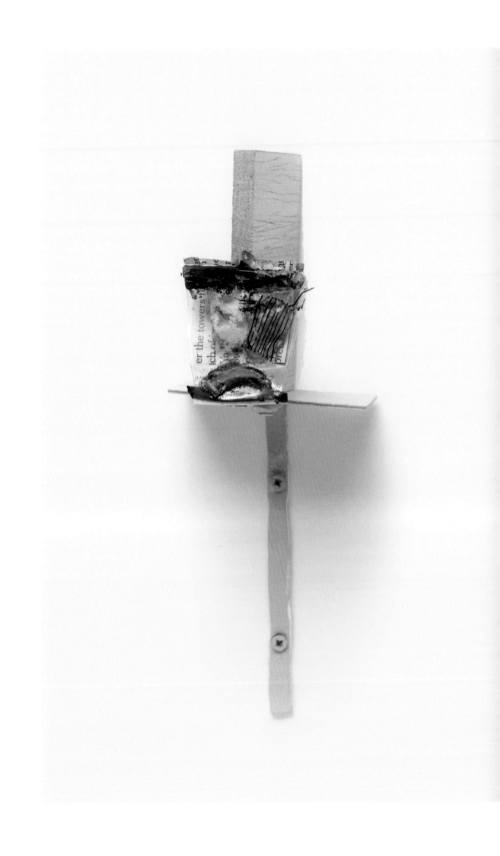

Section VII, Extension M 2007

hot glue, paper, acrylic paint, pigments, thread, wood,
hammered aluminium armature wire, screws
18.4 × 6.4 × 10.2

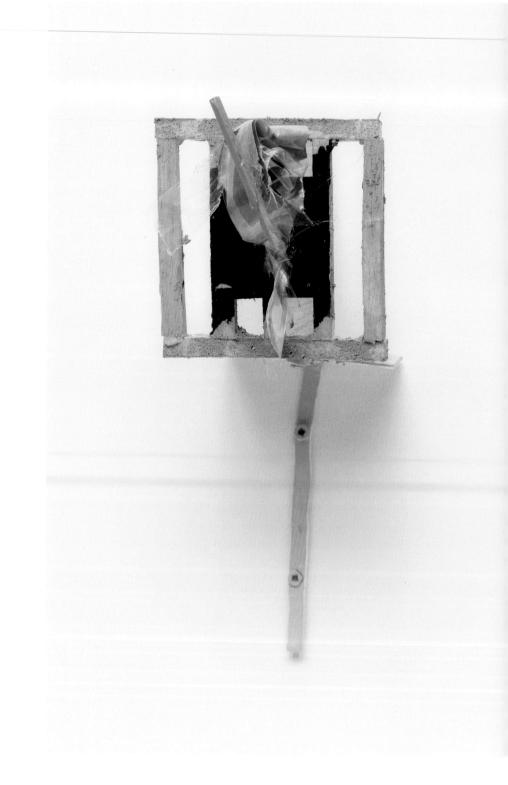

Section VII, Extension O 2007

wood, acrylic paint, screen fabric, cardboard,
hammered aluminium armature wire, screws
18.4 × 8.9 × 12.1

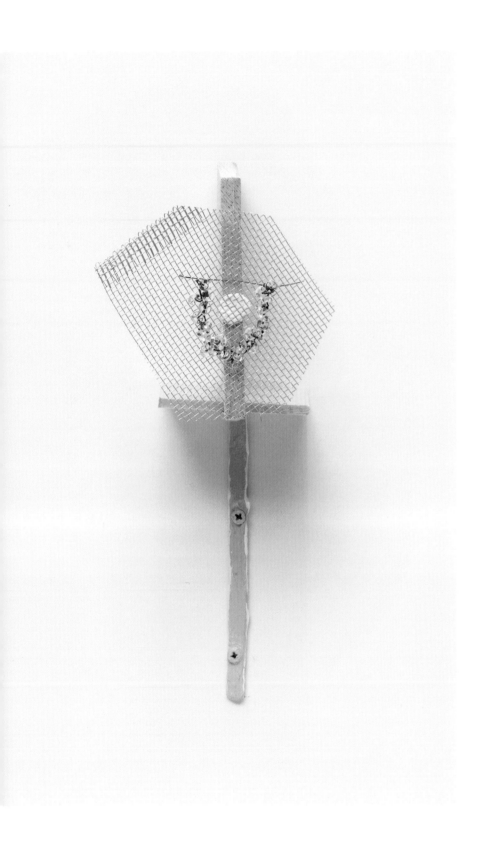

Section VIII, Extension D 2007

metal screen, yellow beads, red thread, wood,
hammered aluminium armature wire, screws
21.6 × 7.6 × 8.9

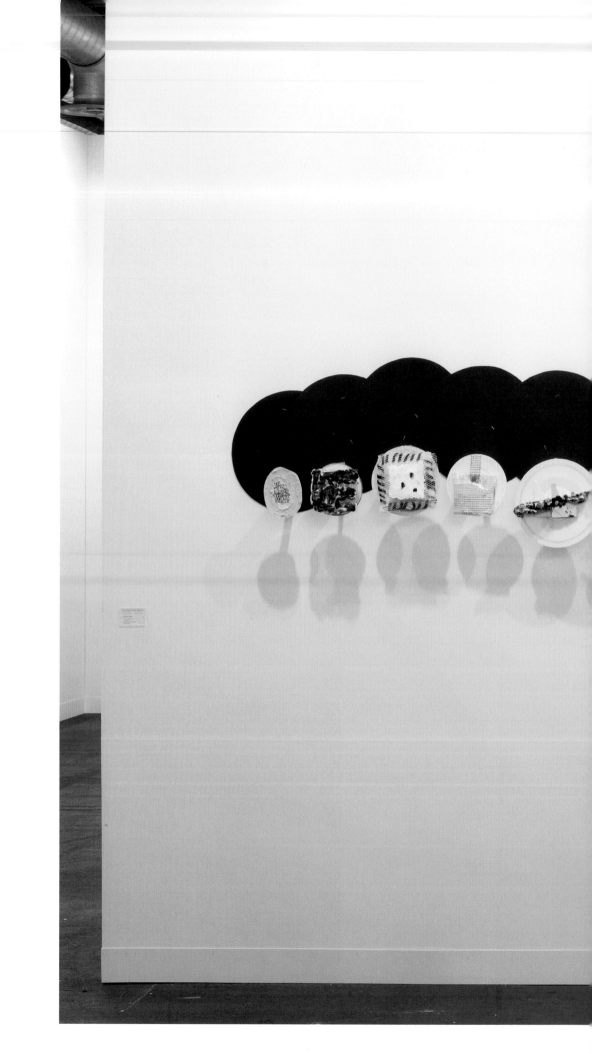

Clutter 2008–12

mixed media on painted cardboard circles, on wood,
on black cardboard circles
60 × 353 × 18

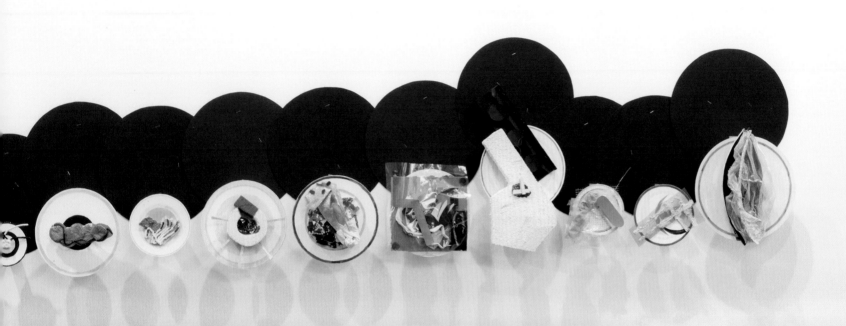

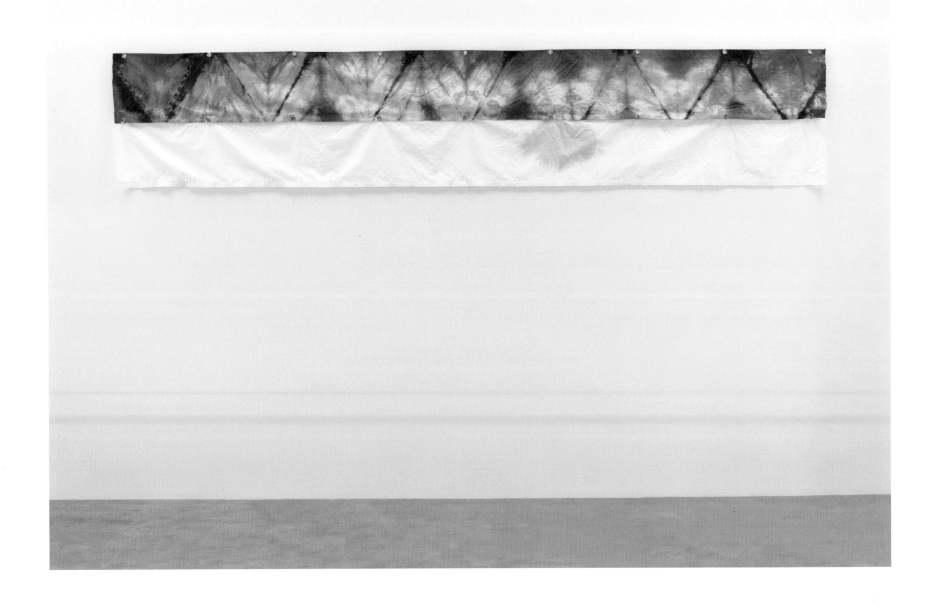

Walking on Air, C3 2009

cotton with Rit dyes, grommets, thread in
2 horizontal panels
58.4 × 316.8

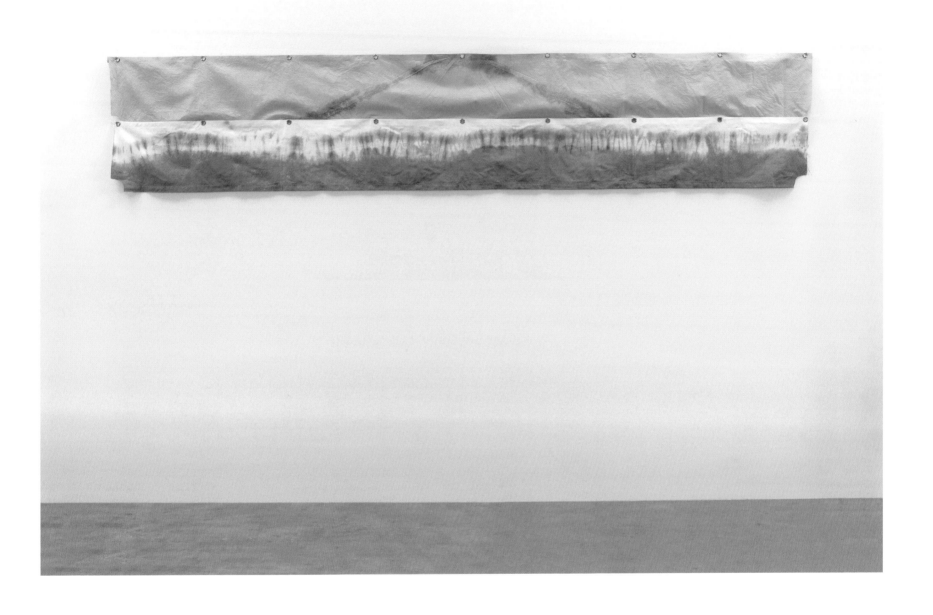

Walking on Air, C10 2009

cotton with Rit dyes, grommets, thread in
2 horizontal panels
58.4 × 312.4

Distance 2009

acrylic paint, bass wood, birch plywood, graphite
on gesso, tempera with fibres and white glue
30.8 × 30.8 × 7.6

Systems VI, White Traffic 2011

wood, fibreboard, polystyrene foam, synthetic mesh,
terracotta, halogen lamp, ceramic, vinyl-coated steel
cable, wire, foam, aluminium bolts, electrical cord,
acrylic paint, and oil paint
254 × 289.6 × 289.6

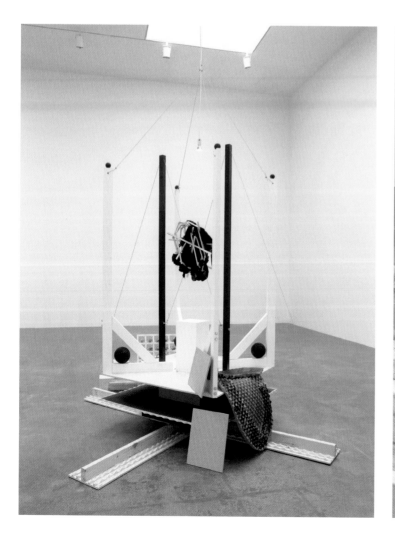

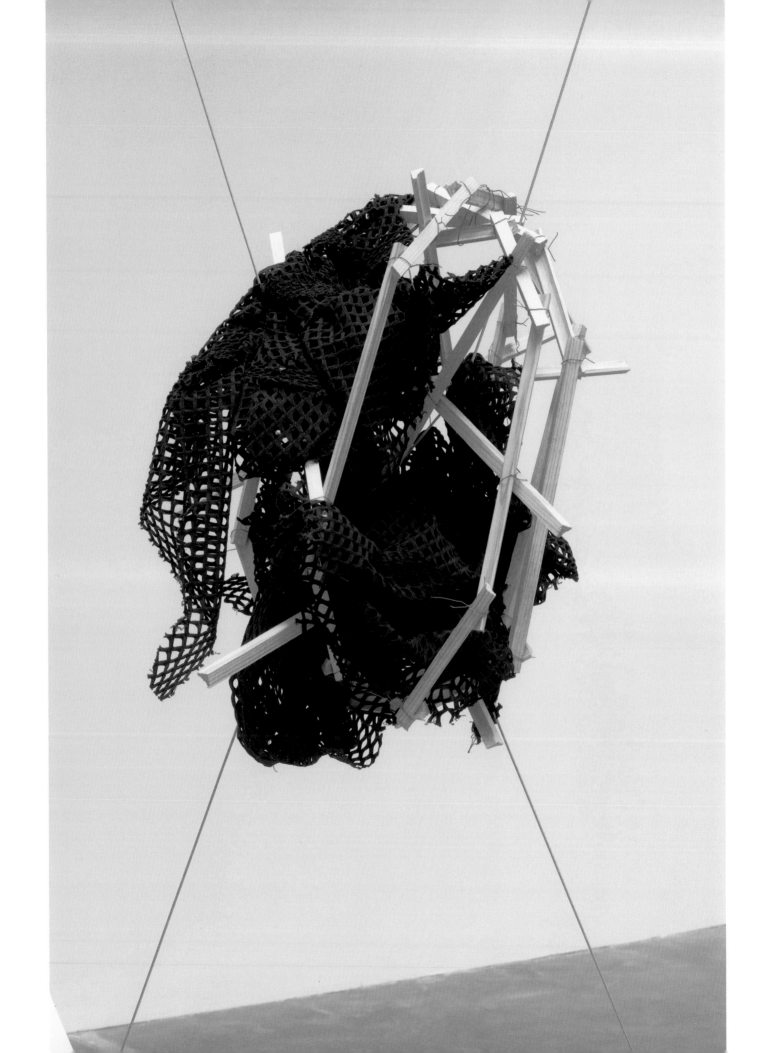

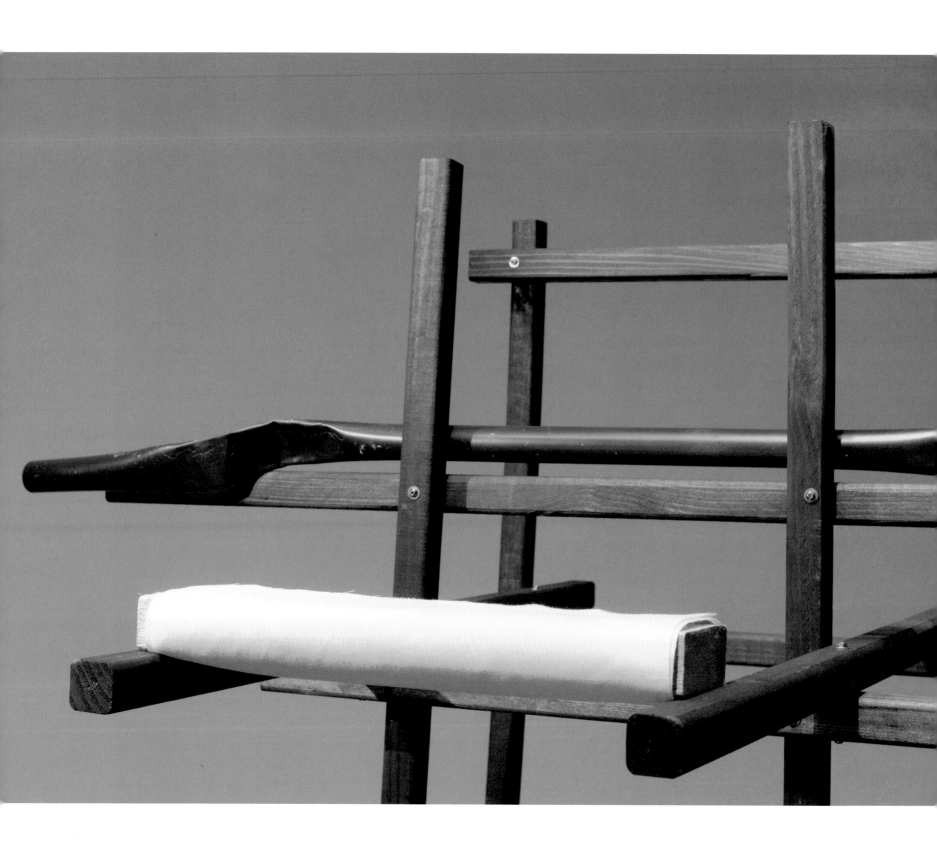

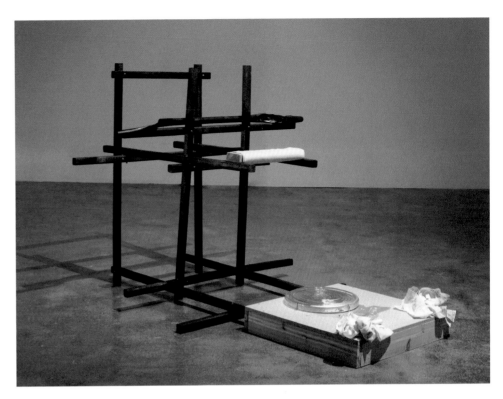

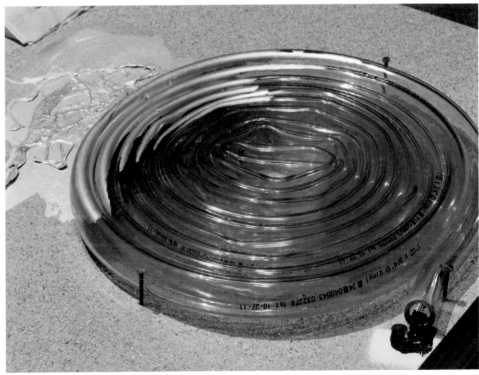

Systems, XI 2012

wood, stain, vinyl, cloth, paint, metal
106.4 × 180.3 × 116.8
overall dimensions variable

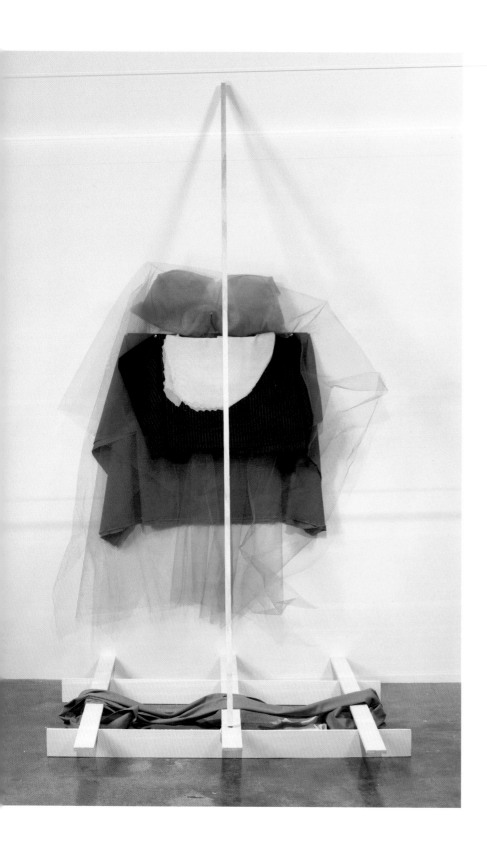

Looking for the Map 8 2013–14

fabric, wood, armature wire, foam core, push pins
and straight pins
236 × 122 × 122

Ladder Piece 1967

Dyed cut canvas
199 × 49 × 0.5; orientation variable
FNAC 2013–2009
Centre national des arts plastiques
(France). Gift of M. Yvon Lambert

Pale Blue Canvas 1967

Woven, cut and sewn cotton
158.5 × 157; orientation variable
Collection Stedelijk Museum, Amsterdam

Purple Octagonal 1967

Dyed canvas
139.2 × 141; orientation variable
Collection Museum of Contemporary Art
Chicago, gift of William J. Hokin, 1982.69

Untitled (Cloth Piece) 1967

Dyed canvas and thread
97.8 × 155; orientation variable
Collection Michalke

Wire Pieces 1971–2, made on site

Florist wire, nails and graphite
Dimensions vary with installation
Courtesy of the artist

Ten Kinds of Memory
and Memory Itself 1973, made on site

String in several parts
Dimensions variable
Courtesy of the artist

3rd Rope Piece 1974

Rope and nails
7.6 length
National Gallery of Art, Washington,
Dorothy and Herbert Vogel Collection,
2004.45.3

4th Summer Wood Piece 1974

Cloth and wood
76.2 × 50.8 × 2.5
National Gallery of Art, Washington,
Dorothy and Herbert Vogel Collection,
2004.45.2

Floor Drawing #5 1987

Wood, canvas, fabric, acrylic paint and
linen thread
104 × 150 × 157
Courtesy of the artist

Perceived Obstacle No.72
(Oil Painting #1) 1991

Oil paint and graphite on unstretched
canvas
34.9 × 97.8
Courtesy of the artist, Pace Gallery,
New York, and Stuart Shave/Modern Art,
London

Perceived Obstacle No.73
(Oil Painting #2) 1991

Oil paint and graphite on unstretched
canvas
33 × 96.5
Courtesy of the artist, Pace Gallery,
New York, and Stuart Shave/Modern Art,
London

Perceived Obstacle No.74
(Oil Painting #3) 1991

Oil paint and graphite on unstretched
canvas
32.7 × 96.5
Courtesy of the artist, Pace Gallery,
New York, and Stuart Shave/Modern Art,
London

Perceived Obstacle No.75
(Oil Painting #4) 1991

Oil paint and graphite on unstretched
canvas
32.1 × 96.2
Courtesy of the artist, Pace Gallery,
New York, and Stuart Shave/Modern Art,
London

Perceived Obstacle No.76
(Oil Painting #5) 1991

Oil paint and graphite on unstretched
canvas
32.1 × 96.5
Courtesy of the artist, Pace Gallery,
New York, and Stuart Shave/Modern Art,
London

Perceived Obstacle No.77
(Oil Painting #6) 1991

Oil paint and graphite on unstretched
canvas
31.8 × 97.8
Courtesy of the artist, Pace Gallery,
New York, and Stuart Shave/Modern Art,
London

Perceived Obstacle No.78
(Oil Painting #7) 1991

Oil paint and graphite on unstretched
canvas
31.8 × 97.2
Courtesy of the artist, Pace Gallery,
New York, and Stuart Shave/Modern Art,
London

Perceived Obstacle No.79
(Oil Painting #8) 1991

Oil paint and graphite on unstretched
canvas
31.8 × 97.2
Courtesy of the artist, Pace Gallery,
New York, and Stuart Shave/Modern Art,
London

Perceived Obstacle No.80
(Oil Painting #9) 1991

Oil paint and graphite on unstretched
canvas
31.8 × 96.5
Courtesy of the artist, Pace Gallery,
New York, and Stuart Shave/Modern Art,
London

Fiction Fish 7 1992

Graphite and ribbon on cardboard,
graphite line
12.7 × 11.4 × 2.9 (without line)
Collection of Craig Robins, Miami, FL

How it Goes Around the Corner
1996

Canvas, wood, thread and nails
8 parts, dimensions variable
Private Collection, Dallas

In 14 1998

Acrylic paint, canvas and wood
22.2 × 8.3 × 3.5
Courtesy of the artist, Pace Gallery,
New York, and Stuart Shave/Modern Art,
London

Measurements are in centimetres,
height before width and depth.

In 23 1998

Acrylic paint, canvas and wood
33.7 × 31.8 × 5.1
Courtesy of the artist, Pace Gallery,
New York, and Stuart Shave/Modern Art,
London

Cloth (Lable 1–16) 2002–5

16 etchings with aquatint, spitbite,
sugarlift, softground, drypoint and fabric
colle, published by Brooke Alexander in
edition of 25
40.6 × 40.6 each
Courtesy Brooke Alexander Inc., New
York

The Right Side of Summer 2003

Metal, wire and wood
41.9 × 44.4 × 8.3
Courtesy of the artist, Pace Gallery,
New York, and Stuart Shave/Modern Art,
London

Type 2004

Portfolio of 26 drypoint etchings, with
tarlatan chine collé
Prints A–M: 33 × 33 each; prints N–Z: 31.8
× 31.8 each
Edition of 15 + 1 AP
Published by Crown Point Press,
San Francisco, CA

The Present 2004

Metal, cloth, paper, paint, rope, with 4
coloured lamps
155 × 33 × 33 approx.
Galerie Ulrike Schmela Berlin

Space-is-Concrete (5) 2005

Acrylic paint and graphite on spun plastic
with Golden® black gesso
91.4 × 50.8
Collection of Craig Robins, Miami, FL

Space-is-Concrete (6) 2005

Acrylic paint and graphite on spun plastic
with Golden® black gesso
61 × 50.8
Collection of Craig Robins, Miami, FL

Space-is-Concrete (25) 2005

Acrylic paint and graphite on spun plastic
with Golden® black gesso
61 × 76.2
Courtesy of the artist, Pace Gallery,
New York, and Stuart Shave/Modern Art,
London

Section VII, Extension K 2007

Fabric, acrylic paint, yarn, glue, wood,
hammered aluminium armature wire,
screws
19 × 6.4 × 8.9
Courtesy of the artist, Pace Gallery,
New York, and Stuart Shave/Modern Art,
London

Section VII, Extension M 2007

Hot glue, paper, acrylic paint, pigments,
thread, wood, hammered aluminium
armature wire, screws
18.4 × 6.4 × 10.2
Courtesy of the artist, Pace Gallery,
New York, and Stuart Shave/Modern Art,
London

Section VII, Extension O 2007

Wood, acrylic paint, screen fabric,
cardboard, hammered aluminium
armature wire, screws
18.4 × 8.9 × 12.1
Verme Brothers, Lima

Section VIII, Extension D 2007

Metal screen, yellow beads, red thread,
wood, hammered aluminium armature
wire, screws
19 × 7.9 × 8.9
Verme Brothers, Lima

Clutter 2008–12

Mixed media on painted cardboard circles,
on wood, on black cardboard circles
60 × 353 × 18
Gian Enzo Sperone, Switzerland

Walking on Air, C3 2009

Cotton with Rit dyes, grommets, thread in
two horizontal panels
58.4 × 316.8
Collection of Craig Robins, Miami, FL

Walking on Air, C10 2009

Cotton with Rit dyes, grommets, thread in
two horizontal panels
58.4 × 312.4
Juan Carlos Verme

Distance 2009

Acrylic paint, bass wood, birch plywood,
graphite on gesso, tempera with fibres and
white glue
30.8 × 30.8 × 7.6
Courtesy of the artist, Pace Gallery, New
York, and Stuart Shave/Modern Art,
London

Systems VI, White Traffic 2011

Wood, fibreboard, polystyrene foam,
synthetic mesh, terracotta, halogen lamp,
ceramic, vinyl-coated steel cable, wire,
foam, aluminium bolts, electrical cord,
acrylic paint and oil paint
254 × 289.6 × 289.6
Tate: purchased with assistance from
the Karpidas Family (Tate Americas
Foundation) 2013

Systems, XI 2012

Wood, stain, vinyl, cloth, paint, metal
106.4 × 180.3 × 116.8
Overall dimensions variable
Courtesy of the artist, Pace Gallery,
New York, and Stuart Shave/Modern Art,
London

Looking for the Map 8 2013–14

Fabric, wood, armature wire, foam core,
paint, push pins and straight pins
236 × 122 × 122
Jacquelyn Soffer, Nominee

Recognition

Textiles have been part of Richard Tuttle's oeuvre since the very beginning. In the Turbine Hall of Tate Modern, Tuttle has introduced a sculpture made from coloured fabrics., creating a vast parkour that unfolds in space and time alongside the viewer.

Tuttle likes to do both big and small works. However, he is far more interested in 'making space' with objects than in the sheer dimensions of objects themselves. And 'making space' can also be achieved with such limited or minuscule materials as a nail. It should therefore come as no surprise that Tuttle uses the following words to comment on the 'bigness' of his project for the Turbine Hall: 'Scale is individual and the opposite of size. I do not view the project as about size, for no mere space is large enough for my work, though it can act as a tool to achieve its scale.'

It is not only the scale of the project but also the materiality of textiles that interests Tuttle. 'I realized that since I made the *Cloth Octagonals* in 1967, I have always been pursuing the mystery of textiles – that work showed me how mysterious – unfathomably so – the textile is. Yet I do not feel 'unfathomably' hopeless. Instead, it makes as a direction in life …'.

Just like Tuttle, at some point in my life I began to fall passionately in love with fabrics, with woven materials, with textiles of all kinds. This passion flourished when reading texts about textiles. The relationship between 'text' and 'textile' – and their common Latin root in *texere* (to weave) – is often cited. Roland Barthes described text as a 'woven fabric', a tissue of ideas.[1]

I suppose fabrics – from all around the globe – say something about my ideal museum as well. That museum of the future would be like a carpet: with multiple motifs, with many points of entry, and where everything is framed by everything else. A Persian carpet, as Italo Calvino reminds us, flies twice: first as the elevation plan of an imaginary building, and again as a magnificent piece of woven cloth.

The art of weaving and its many variations, applications and interpretations, evokes in us a strong emotional response – when looking at textiles one speaks of passion.

In the Indian state of Gujurat, I found at the Garden Silk Mills not only stacks of ancient textiles but also the vivid colours of soft, gently billowing new ones. Richard Tuttle and Achim Borchardt-Hume were equally inspired by the liveliness of these fabrics and the process of their making. It is quite correct to say, as does Richard Tuttle, that with regard to textiles, everything is necessarily connected to everything else.

If you mentioned the name 'Richard Tuttle' to experts in the field, many would probably assume you were referring to the textile scholar Richard Tuttle, since the artist

Weaving Words

CHRIS DERCON

is also, together with eminent textile historian Mary Hunt Kahlenberg, co-author of a book on Indonesian ritual textiles.[2] In commenting on the relationship between 'text' and 'textile' and their common etymological root, Tuttle observes that 'the word textile, and all its derivatives like "text" or "context", can be traced back at least as far as Sanskrit, where the meanings of weaving and construction attach themselves to the idea of over/under, under/over.'[3]

Much of Tuttle's own art addresses the question of whether or not the unique qualities of textiles have been so appropriated by art as to have been forgotten. An example of this might be the way that painted white walls have replaced decorated wallpapers, which themselves replaced older traditions of wall-hanging tapestries. As Tuttle points out, 'if you look back far enough, what appears to us a non-textile surface may in fact be a textile surface, and that, I think, would account for another huge interest in textiles at the present moment.'[4]

Indeed with textiles, everything is linked to everything else. One can imagine that in the years to come the major museums of modern and contemporary art are going to have to become ever more sensitive representatives of an art that is not simply becoming 'global', but that is also fundamental to the future of tradition and to the tradition of the future.

1 Roland Barthes, 'From Work to Text' (1971), trans. Stephen Heath, published in Roland Barthes, *Image, Music, Text*, London 1977
2 Richard Tuttle and Mary Hunt Kahlenberg, *Indonesian Textiles*, Santa Fe 2004
3 Richard Tuttle in conversation with Chris Dercon as part of Art Basel Conversations, Miami Beach, 6 December 2012
4 Richard Tuttle in conversation with Chris Dercon as part of Art Basel Conversations, Miami Beach, 6 December 2012

A Metaphorical Critique of Broad Reflection

ACHIM BORCHARDT-HUME

'Orito pictures the human mind as a loom that weaves disparate threads of belief, memory and narrative into an entity whose common name is Self, and which sometimes calls itself Perception.'
David Mitchell[1]

'In the world of software domination, it is great to be making something with other people.'
Richard Tuttle[2]

I Don't Know . The Weave of Textile Language evolves over three sites: a book conceived in close collaboration with the artist, a historic survey of Tuttle's work based around the notion of fibre, and a specially commissioned large-scale sculpture made from bountiful sways of custom-made fabric. From the outset these distinct entities were conceived as a unity to be experienced together. To circumscribe what creates this unity, Tuttle chose three words describing three cognitive manoeuvres: 'reveal, show, recognition'. Each of these manoeuvres is contingent on the other: first, something hidden or invisible is being revealed; then what has been discovered is displayed for conscious contemplation; only then can recognition occur. The dictionary defines 'recognition' as 'perception of something as identical with something already known in fact or by description'.[3] In the current context, the central object of this process of enquiry is the textile, the act of 'recognition' – the making of a new work – building on the earlier acts of 'reveal' – Tuttle's longstanding study of textiles – and 'show' – a close reading of his work from the past forty years.

The present text then is intended to share with the reader some of the experience of collaborating with Tuttle on his ambitious sculpture for Tate Modern's iconic Turbine Hall. At this point it is important to point out that far from being completed, at the time of writing we are right in the midst of this process.[4] Given Tuttle's insistence on

Richard Tuttle at work on the Turbine Hall commission, September 2014

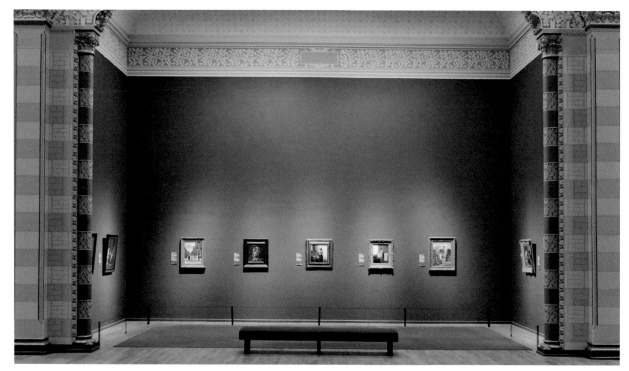
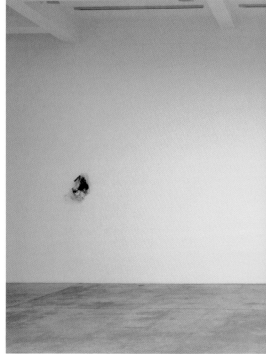

Installation view, Rijksmuseum, Amsterdam,
October 2013

Installation of *Richard Tuttle: Matter,* Marian Goodman
Gallery, Paris, 21 September – 31 October 2013

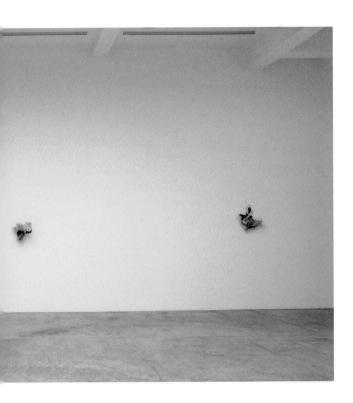

the value of actual experience as essential to art in general and his work in particular, rather than being guided by imagining a work yet to be completed I shall begin by recounting two acts of looking instead, two acts of looking which surreptitiously occurred in close succession while discussing plans for the Turbine Hall commission.

The first of these took place one Saturday morning in Amsterdam in October 2013, when I found myself in the newly opened Rijksmuseum, marvelling at a display of paintings by the seventeenth-century Dutch painter Jan Vermeer. *The Little Street* c.1658, *The Love Letter* c.1659–70, *The Milkmaid* c.1660 and *Woman Reading a Letter* c.1663 are among Vermeer's best-known paintings. One shows an alleyway adjacent to an intricately rendered brick house in Vermeer's home town of Delft, one a maid delivering a missive to her surprised-looking mistress, one a woman utterly absorbed in the mundane task of pouring milk, the white liquid glistening as it rushes from the jug, the last a woman lost to the world while reading a letter sent to her by we do not know whom. These four paintings are joined by a fifth, a street scene by Vermeer's contemporary Pieter de Hooch. Somewhat lesser known, though hardly less enchanting, de Hooch 'aside from being a painter' also happened to work for a cloth merchant – an anecdotal precedent for the historic connection between the worlds of art and textile that is so important to the understanding of Tuttle's project also.

These five paintings are displayed on a deep grey wall framed by the Rijksmuseum's neo-Gothic gilded sandstone architecture. Within the grandeur of this setting Vermeer's paintings act as four powerful vortexes, works which appear first to sideline and then to absorb the world around them, only to draw the viewer into an altogether different reality, namely the reality of art. Each is distinguished by a particular tonal range. Whereas *The Milkmaid* feeds on the tension between the protagonist's quiet concentration and the vibrancy of the contrast between the warm yellows and the cool blues, *Woman Reading a Letter* is infused with a low-key hum of subdued blues and soft beiges that is perfectly in tune with the stillness of the scene.

Later the same day I went to see an exhibition of new works by Richard Tuttle in Paris. This exhibition consisted of two discrete groups of small wall sculptures displayed across galleries on separate floors of the same elegant eighteenth-century town house in the Marais area. The first of these, made during Tuttle's recent residency at the Getty Research Centre in Los Angeles, comprised seven sculptures, all titled *The Place in the Window, #2*, made from variably bent pieces of wire mesh and coloured cotton pulp. The works were displayed at regular intervals across three walls flanking the French windows offering a view onto the courtyard garden. In the basement gallery a second series was arranged in a similarly evenly paced manner, but this set took a metal wire coat-hanger as its systemic point of departure. Collectively titled *An Other Set of Shoes*, each work was affixed to the wall by virtue of the coat-hanger's hooks being bent and looped over a simple nail. While this may sound straightforward enough, what is difficult to capture in words is the exquisite playfulness with which the fusion of wire hook and nail was explored and the degree to which the specifics

of their encounter informed the tectonics of each individual sculpture. At times the hook seemed to command the rising of a piece of wood, at others it made sure that the work pressed itself firmly against the wall. Both upstairs and downstairs, colour, form, structure, support and the relationship of object to wall entered into a complex symbiosis that seemed without precedent in the everyday world – the commonness of the wire hangers notwithstanding. Instead, as in so much of Tuttle's work – and here I include the commission for the Turbine Hall – both their appearance and, as a result, their meaning appeared to be generated by the way one material related to the other, the specifics of each one, the (material) connection of the work to its surroundings and the insistence with which each work appeared to say 'I am art; nothing more, nothing less. I did not exist until the artist made me. I am real but I am separate. I am.'

When looking at Tuttle's new works I could not help but be reminded of the Vermeers I had seen in the morning and how the works of both artists, so intensely different and rooted in two such different cultural moments, shared a similar momentum of drawing in the viewer by the sheer force with which they mobilise the vocabulary of colour, structure and form; and how both, by virtue of their presence, insisted on the reality of art. I described this synergy to Tuttle a few days later, and here is his reply:

> Colors are real
> The body is real
> The spirit is real
> Mythology is real
> Mythology feeds the brain
> The soul is not real
> Truth is not real
> Truth feeds the soul
> Art is real

> The self includes the real and not real. We have to negotiate constantly, and looking at art helps.

> Yours, Richard [5]

This quote from our ongoing email conversation is a telling example of the high ambitions Tuttle has for (his) art, from which we should not allow ourselves to be distracted by the frequently remarked upon humility of his materials, a topic to which we shall return. For the moment, let us stay with the question of looking and the degree to which looking, unprejudiced looking, is at the very root of *I Don't Know . The Weave of Textile Language.*

Every aspect of this project is infused with Tuttle's invitation to look at textiles by

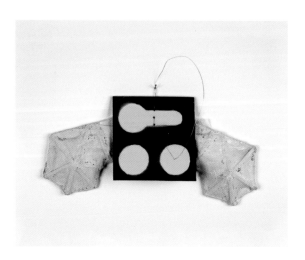

An Other Set of Shoes (6) 2013

mixed media, 17.8 × 40.6 × 10.2
Marian Goodman Gallery

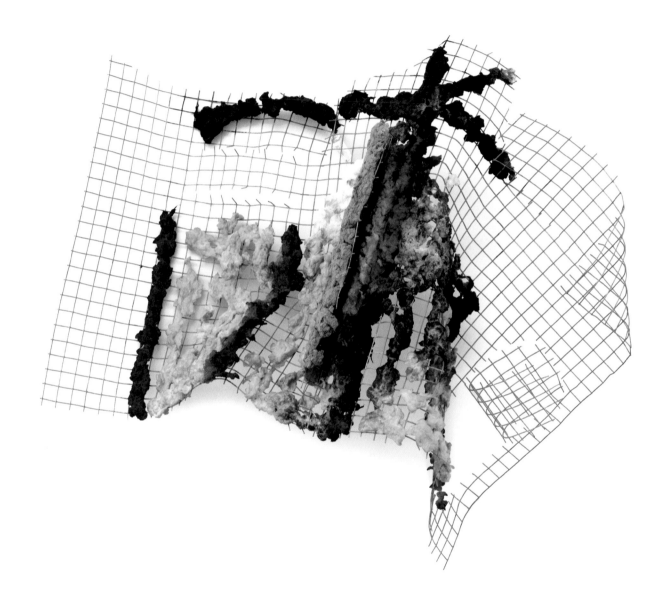

The Place in the Window, #2 2013

wire, mesh wall sculpture, 43 × 51 × 20
Marian Goodman Gallery

way of understanding better what defines the textile, the seminal position it occupies in the evolution of culture – together with text with which it shares its etymological route – and the potential its close consideration holds for sharpening our sense of place in the world. This is no easy task, as Tuttle is first to acknowledge: 'There is part of the textile that is so common, it's hard to identify, much less research.'[6] It is for this reason that the present book begins with an anthology of photographs and texts mining the full plethora of the world of textiles, including a nineteenth-century North American wedding dress incorporating French or Italian lace, a Navaho saddle blanket, a fragment from a several thousand-year-old Peruvian summer tunic, modern-day West African trousers, a flecked industrial dust sheet, a contemporary boy's shirt in polyester from Bangladesh and an eighteenth-century Belgian cravat, to name but some. All of these form part of Tuttle's personal collection, a collection that is characterised by its openness to consider textiles in all their variety, historically and geographically, whether made from natural or man-made fibre, hand-woven or industrially produced, and that resists the wilfully imposed categorisations of museological display. Macro and micro shots of these fabrics are accompanied by texts selected by Tuttle to circle around the idea of the textile, pausing on such divergent vantage points as anthropology, economic and social history, trade literature, and so on. The aim is not to come to a universal definition but to enter into this vast topic by allowing eye and mind to roam like Baudelaire's proverbial flâneur wandering the streets of the city.

Simultaneously, the first part of this book recaptures a crucial moment in the project's initial germination. For no sooner had the idea for both commission and exhibition been uttered than Tuttle encouraged us to consider five exceptional moments in the history of textiles. To do so, guided by the Victoria and Albert Museum's expert curators Clare Browne and Rosemary Crill, we pored over the airy intricacies of Venetian sixteenth- and seventeenth-century lace, the mind-boggling virtuosity of Indonesian ikat, the animated geometry of Berber fabrics, the liquid delicacy of Chinese and Indian silks and the singular achievements of sixteenth-century Elizabethan embroidery. Tuttle identified these five areas for us jointly to reflect on the question how textile is central to almost any culture in the world, yet how specific modes of textile production occur in one place and one moment in time only. Lace, for instance, is particular to Europe and hardly practised elsewhere, whereas ikat weaving is virtually unknown outside South East Asia. We learned that so besotted was King Charles II with Venetian lace that he made its wearing a royal privilege, risking bankruptcy – his own and that of the country – in the course. Who could blame him? Holding this lace is like being caressed by the merest hint of a physical object, with so many threads extracted from the original linen weave that one wonders whether its makers were consciously courting its collapse into nothingness.

In a magnificent exhibition at the Metropolitan Museum of Art of textiles made for trade export we considered the evolution and display of taste and the creation of desire for what is not yours, which has been so successfully exploited by textile

Needle lace collar, Italian (Venetian), c.1660–80
Victoria and Albert Museum, London

Waist sash (patka), pashmina made in Kashmir, first half of the eighteenth century, Tapi Collection, Surat

merchants across the ages and around the globe. We admired one of the most complex surviving examples of Indian ikat produced for the Indonesian export market, every single thread meticulously wrapped and resistance dyed in advance of the weaving process, the overlay of warp and weft calculated to form the image of four elephants. While the blurriness of the animals' contours beautifully conveys a sense of motion, the complexity of the equation necessary to achieve this result was not wasted on its first wearers, who had to be of high rank and with an income to match.

In the Gujarati town of Surat in West India, Praful Shah, a collector passionately dedicated to preserving the history of Indian textiles and an indispensable collaborator in this project, allowed us access to some of the most extraordinary objects from his Tapi Textile Collection, named after the majestic river crossing the city. These ranged from luxurious Kashmir shawls woven with the rarest materials in the most subtle colour schemes for the Mughal Emperors to their self-consciously exotic descendants made to be wrapped around the shoulders of the high bourgeoisie of Napoleonic France. Having enjoyed but a mere glimpse at the riches of Indian textiles of the past, we visited the factories and markets of Surat with their veritable deluge of fabrics, these days mostly made from man-made fibre, principally polyester. To the ignorant Western eye these seemed at first to be aesthetically inferior, a perception that rapidly changed when we were told that during their production and lifecycle these garments consume but a fraction of the amount of water needed for traditional cotton, a great asset for a country populated by billions where water is a precious resource.

What does all of this have to do with a US artist making a large sculpture for a museum in London dedicated to modern and contemporary art, you may well wonder. If the pursuit of this question is expected to result in identifying clear-cut causalities, I fear that the answer may disappoint. None of these experiences has fed in an immediate way into Tuttle's new work, at least not in one that would mean that the work looks

Patalou (silk cloth). India (Gujarat for the Indonesian market), late eighteenth century. The Metropolitan Museum of Art, New York

a particular way because we looked at *x*, *y* or *z*, or because it was made by *a* in place *b*. And then again, the work is imbued with the network of connections that informed its conception and making. No element shows this better than the three fabrics that so strongly determine its appearance.

In autumn 2012 Tuttle first shared a simple maquette of his plans for the Turbine Hall. Made from coloured plywood, this was diminutive in scale and, while giving a first impression of the overall shape of the sculpture, provided little clue as to its material appearance or execution. All that was apparent was that there would be a central vertical body, not entirely unlike a question mark, to which a series of discs would be attached with a group of what for convenience's sake came to be called 'airfoils' suspended to create a horizontal cross-beam. Soon after the presentation of this model, Tuttle proposed to produce three fabrics. He specified the colours – deep red with diamond-shaped holes, bright orange and a saturated midnight blue – and indicated the mix of materials and the quantities he thought he might require. For neither of these specifications did there exist an obvious prompt. Instead, they seemed to spring entirely from Tuttle's imagination or were, as he would say, 'what the work required'. As much as any textile is the outcome of a number of design decisions, fabric here was conceived as an artistic medium, 'woven paint' if you will, eventually to be applied to a substructure whose exact make-up was yet to be determined.

The details Tuttle had specified were forwarded to Praful Shah, Chairman and Managing Director of Garden Silk Mills Ltd, and his nephew, Sanjay Shah, who oversees the Mills' weaving operation. Both great experts in traditional and contemporary textile production – Praful Shah transformed the small factory he inherited from his father, who was originally an eye surgeon, into a large business specialising in the manufacture of artificial silks – they generously offered their help and expertise. Drawing on his extensive experience in long-distance collaboration with designers not based in India, Sanjay Shah asked Tuttle to quantify the characteristics of each fabric according to the four categories of 'feel, drape, fall and aesthetics', going on to elaborate:

> I presume feel is not important.
> By drape I need an idea of how the fabric should hang. Simplify this as a creaseless
> hang of an elegant curtain to a formless type like a tarpaulin.
> By fall I mean stiff or limpy.
> By aesthetics I mean weave, colour and lustre.

Anticipating further conversations about the idiosyncrasies of particular materials and the complex relationship between colour as perceived visually and thread and dye as its material chromatic carriers, he continued:

Maquette for the Turbine Hall

Richard Tuttle's specification notes

TEXTILE ORDER
FOR INDIA

I. AMOUNT

PIECE A ~~78 square meters~~
200' × 20' → feet?

PIECE B 80' × 20'

PIECE C 30' × 20'

II. STRUCTURE

PIECE A see drawing p. 2
warp: silk + rayon
weft: rayon

PIECE B silk crepe
warp: silk + cotton
weft: cotton

PIECE C satin
warp: rayon
weft: silk

III. COLOR

PIECE A see drawing

PIECE B

PIECE C warp: black
weft: midnight blue

The use of viscose, cotton and silk in shirting – apart from comfort factors – is to impart sober dull to mild bright lustres. These fibres dye in much more vivid colours as compared with polyester. Their only disadvantage against polyester is that you cannot get a glittery or shimmery look.

It is also possible to blend bits of shimmery polyester threads in a natural fabric to get a reduced sparkle in an overall sober fabric.

Please describe based on the above discussion what kind of look you need so that I can elucidate this matter further.[7]

Making good use of Shah's proposal of how to put into words what generally is experienced in a non-linguistic way, Tuttle replied as follows:

Fabric A: drape: 40% (between elegant curtain, 0%, and tarpaulin, 100%)
fall: 50% (between stiff, 0%, and limpy, 100%)
aesthetics: can we do 40% silk, 60% viscose for warp and 100% for filler?

Fabric B: drape: 60%
fall: 70%
aesthetics: do you know One Hundred Denier Crepe? Could lycra be blended with something and used as a filler as in wool crepe?

Fabric C: drape: 10%
fall: 70%
aesthetics: shot fabric with black viscose warp and midnight blue silk weft.[8]

Based on this exchange, Shah and his team embarked on producing a series of samples. Eventually it was decided that the deep red fabric A would be woven on a shuttle loom from a silk and rayon warp combined with a rayon weft, the bright orange fabric B on a shuttle loom equipped with a Dobby for additional surface texture from a modal warp shot through with a high twist rayon weft, and fabric C once more on a shuttle loom from a black rayon warp and a midnight blue silk weft.[9]

In early April 2013 Tuttle and I arrived in Surat to inspect the final samples. As soon as we arrived at Garden Vareli we were presented with rolls of fabric in subtly differing shades of red, orange and midnight blue. Tuttle immediately selected the orange and dark fabrics he deemed closest to his design, asking solely for the red fabric to be made one shade darker, something Garden Vareli's expert craftsmen achieved literally overnight. Everybody was ecstatic at the apparent simplicity of the process, all the more so as, while Tuttle mostly works on his own in the studio, it involved fourteen different trades:

Fabrics designed by Richard Tuttle

1 Silk fibre preparation and supply
2 Procurement of Micro Modal Fibre
3 Blow room mix by Birla Cellulose
4 Single yarn by Surat textiles
5 Doubling of this yarn … this is the warp of fabric A
6 Modal weft for A is brought out
7 Same modal for warp of fabric B
8 Viscose fibre by Birla Cellulose in prepared form
9 Spinning by Surat textile mills
10 High twist and doubling by same producer as in 5 … this is the weft of fabric B
11 Modal warp dyed black
12 All fabric warped and woven by Garden Silk Mills
13 Final dyeing and finishing of all fabric by Garden Silk Mills
14 Cutting diamond pattern with lasers by outside supplier[10]

One much-posed question concerns the correlation between the place where the textiles were produced, Surat, and how this informs the meaning of the work of which they form part. There can be no suggestion that the design of the fabrics was inspired by Tuttle's visit to India, as all his significant design decisions occurred long in advance: colour, texture, pattern, weight, lustre, and so on. In this regard the sculpture for the Turbine Hall is markedly different from, for instance, Robert Rauschenberg's *Jammers* 1975–6, which were famously inspired by the visit of a textile merchant to the Le Corbusier house of Rauschenberg's hosts in Ahmedabad, the Sarabhai family, and Rauschenberg's spontaneous enthusiasm for the contrast between the stridently colourful silks on offer and the sun-baked dustiness of a city on the edge of the Thar desert. At some level, the fact that the fabrics Tuttle uses in his sculpture were produced in Southern Asia is utterly coincidental to the surreptitious outcome of a constellation of personal and institutional relationships paired with technical expertise and production capacity. Yet to say that the fabrics had nothing to do with the people who made them would also be misleading.

There are two principal industries in Surat: the polishing of precious stones, imported and immediately re-exported at this singular moment on their journey from mineral to jewel; and the production and distribution of textiles. The sound of the looms in the countless factories, easily mistaken for the whirring song of cicadas on a hot summer day, forms the constant background hum to life in the city. Silence is dreaded, as the looms falling quiet would mean an end to many a family's livelihood. Much of the time in Surat, at Tuttle's instigation, was spent in the factories of Garden Vareli Mills to witness every step of modern-day textile production first hand, from the white peaks of polyester fibre being spun into even thread to the thread being dubbled and spooled ready for the Japanese looms, from the weaving of the Jacquard patterns to the final fabrics being dyed in a seemingly limitless palette of colours. We watched

water jet looms expelling water at such speed that a single drop would pull the weft with it when being shot across the warp, the patterns catering to domestic and export markets such as Burma or China carefully encrypted in the punched strips directing the looms. With their noise and heat, Surat's factories and markets seemed a far cry from Gandhi's vision of hand-spun khali cotton and villagers collectively engaged in pre-industrial textile production to recover their sense of nationhood. Rather, they gave a sense of being at the heart of mass production and global trade. As Banerjee and Miller observed in their study about the enduring appeal of the sari as a popular item of clothing on the Indian subcontinent: 'The romantic image of the artist-craftsmen working a handloom is misleading, because much of Indian weaving has for centuries been geared towards mass export for China, East Africa and South-East Asia.'[11]

Divergent modes of textile production are, of course, emblematic in demarcating the watershed between pre-industrial and industrial societies (and post-industrial societies in that most of the textiles we often carelessly consume today are produced elsewhere). It was the invention of the steam engine and of machines that enabled the spinning and weaving of cotton on a large scale in the mills of England during the second half of the eighteenth century that brought in the Industrial Revolution. (Ironically, within the current context, it was this very production of English cotton on an industrial scale that, coupled with the protectionist politics of the British government, led to the demise of the Indian cotton calico production.) It was in the factories of the midlands that synchronised time was conceived, with all workers having to arrive and leave at the same hour as the looms were set into motion. It was also here, in Manchester, that Friedrich Engels observed the plight of a new class, the industrial proletariat, which he vividly described in *Die Lage der arbeitenden Klasse in England* (1845, published in English as *The Condition of the Working Class in England* in 1847). His observation of their hardship compelled him three years later to co-author, together with Karl Marx, *The Communist Manifesto* (1848). Some forty-five years later the German dramaturge Gerhard Hauptmann staged the uprising of the textile workers in his play *Die Weber* (*The Weavers*, 1892), revolutionising theatre by making a group – the insurgent mob – the protagonist, rather than an individual character.

Garden Silk Mills, Surat, April 2013

Some form of collectivism does indeed appear to be common to many forms of textile production, whether this takes the form of a group of like-minded individuals meeting by their own volition to infuse a manual task with social pleasure, of streamlined manufacture in organised work shops or of industrial labour tightly regimented on a grand scale.[12] As a consequence, most textiles are produced anonymously, with little awareness by the end user as to whose hands were physically responsible for the making of a specific fabric. However, nonetheless a particular value distinction is commonly made – a distinction that extends right through to the aesthetic realm – between the hand-made, perceived as inherently of superior quality, and the machine-made, deemed to be unavoidably inferior as 'mass-produced'. Reflecting on this common view and its limitations, Tuttle has observed:

An interesting thing happened at the commencement of the Industrial Revolution – something rare and costly became abundant and cheap. We are still in the glow of that, but some say a real textile is not a commercial textile. One thing, therefore, which interests me, is what the commercial textile can do that the hand-made, pre-revolution textile could not do in terms of what the textile is. And, of course, the man-made fibre world comes out of the same revolution.… Even today, instead of seeing the machine made imitating the hand made, you can see the machine made as completely different, with different aesthetics. To see or make these distinctions when they are … invisible is especially hard, though I'd like to try, for it could create a metaphorical critique of broad reflection.[13]

What if we think of Tuttle's work for the Turbine Hall as part of such 'a metaphorical critique of broad reflection', and do so by paying close attention to the strategies involved in its making? The fabrics combine both natural and man-made fibres and are, of course, machine made, with the diamond pattern in the red fabric laser-cut. Yet it is important to bear in mind that these machines do not work themselves and that the human hand remains integral to all types of textile production. To enable machine production the yarn first has to be prepared and meticulously threaded into the eyes of the shuttle looms, spools have to be controlled, fibre to be loosened, machines to be supervised. One of my most memorable impressions of our visit to the factories of Surat was that of a man and a woman working in perfect synchronicity, using both their hands and feet to separate and thread hair-thin polyester yarn through what looked like metal combs ready for transfer to the looms. Watching this scene, I had to guard against my post-industrial squeamishness at the sight of industrial production so as not to denigrate or deny the fact that beneath the repetitiveness of the couple's every movement lay an extraordinary dexterity and hard-won skill. Watching them, it was impossible to ignore that there was a direct, if complex, lineage from the precious historic hand-made fabrics we had admired in the specialist departments of museums in London and New York and the textiles we saw being produced in front of our eyes, which filled the markets of Surat and were worn by millions of people in the streets. Yet the way in which these fabrics were valued, aesthetically and economically, was very different, epitomised by the fact that one was preserved and exhibited alongside 'works of art' in a museum, while the other was doomed to the ephemeral cycle of consumption. The fabrics for Tuttle's work upset this dichotomy, being, as they are, woven on the looms ordinarily producing large quantities of fabric for garment production, yet made for the sole purpose of becoming part of a unique work of art – and one that will only exist in this shape for a limited period of time at that.

Textiles and art have much shared history, never more so than over the past hundred years or so, as evidenced by the recent explosion of exhibitions on the subject. Whether it be the cross-pollination of textile design and abstraction in the early parts of the

twentieth century – from famous Bauhaus weavers such as Anni Albers to artists otherwise as diverse as Sonia Delaunay, Natalia Goncharova, Hannah Höch or Sophie Täuber, to name but a few – or the reflection on the canvas as a 'woven' ground, as in the work of Agnes Martin and Richard Tuttle himself, art and textile have engaged in a long and highly productive dialogue. (The first time I met Tuttle he was ironing one of his works, *Walking on Air* 2009, for an exhibition to open a few days later in London.) Within this conversation, the boundary at which art and textile meet or even overlap has offered fertile ground for speculation about such issues as gender or sexuality and, by osmosis, the value hierarchy implied in the distinction between art and craft, or 'high' and 'applied' art.

It is interesting to observe at this juncture that some of the key concepts that inform our understanding of art today came into being at exactly the same time as the emergence of the textile mills marked the transition from a pre-industrial to an industrial age. For it was then, in the thick-set smoke of Enlightenment, that Immanuel Kant in his *Kritik der Urteilskraft* (*Critique of Judgement*) of 1790 first articulated an idea of art that set it free from any kind of utilitarian agenda, be it the demands of religion, wealthy clients or princely commissioners, all of whom had been so instrumental in shaping the history of art until then. For Kant argued that art was to exist on its own terms, to develop by its own rules and to justify its existence on its own merits alone. Essentially unnatural – that is, not part of nature – in order to be successful it had to appear entirely natural to the viewer, as if it could not be otherwise. Put simply, art was intended to be autonomous, free and, most importantly, 'useless'.

This notion of art as 'useless', having no value in serving the interests of others or, indeed, hard capitalist gain, became central to the early romantics' conception of art that in turn fed directly into the birth of modernism. Where religion and political ideology had failed, it was the radical aesthetic experiments of the artistic avant-garde that were to act as dowsing rods pointing the way towards a brighter and better future. Whenever textile and art came into contact along this somewhat treacherous path, it was the idea of the former as 'useful' and the latter as 'useless' which made them such uneasy bedfellows. In his seminal article 'Culture and Administration', the philosopher Theodor Adorno observed the following of the contradictory relationship between 'useful' and 'useless':

> In bourgeois society … a terribly complex relation prevails between the useful and the useless … Culture is looked upon as thoroughly useless and for that reason as something beyond the planning and administrative methods of material production; this results in a much sharper definition of the profile upon which the claim to validity of both the useful and the useless is based. One factor of actuality has manifested itself within this ideology: the separation of culture from the material processes of life and finally – the social hiatus between physical and intellectual work.[14]

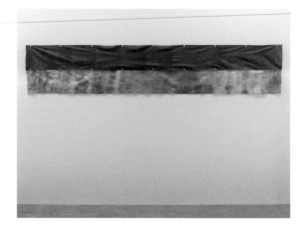

Walking on Air, C9 2009

cotton with Rit dyes, grommets, thread
58.4 × 315.6, 2 panels, overall installed
courtesy the artist, Stuart Shave/Modern Art and
Pace Gallery

Anni Albers (1899–1983) and Stölzl workshop
Wallhanging Black-White (detail)
design by Anni Albers 1927, replica woven 1964 in the
workshops of Gunta Stölzl, Zurich, to specifications
and under supervision of Anni Albers
double weave, cotton and artificial silk in black
and white
Bauhaus-Archiv, Berlin

Agnes Martin (1912–2004)
Morning 1965
acrylic paint and graphite on canvas
182.6 × 181.9
Tate. Purchased 1974

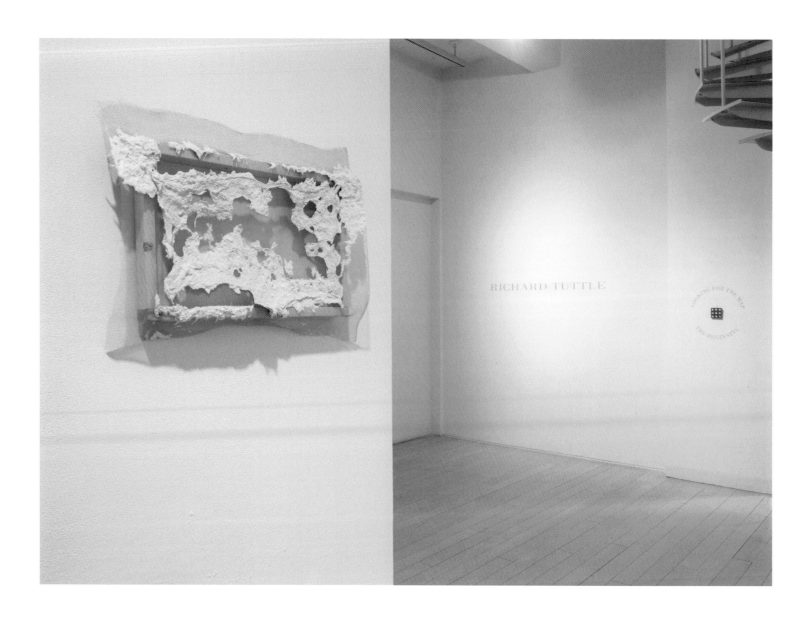

PlusMinus – 9 2013–14

installation view, *Looking for the Map*, Pace Gallery,
New York, 7 February – 15 March 2014
courtesy the artist and Pace Gallery

What then happens if Tuttle, an artist, fuses the 'useful' – the machine-made textile – and the 'useless' – the work of art he constructs from it? Would it be possible to think of this act as an allegorical bridging of the social rift between physical and intellectual work, the worlds of textile production and art-making? Do the Turbine Hall sculpture's monumental scale and its precarious suspension in space, both of which stand in such marked contrast to the utilitarian potential of the plywood, steel and fabric from which it is constructed, serve to underscore its final status as 'pure' art? In his statement to accompany the commission Tuttle makes it abundantly clear that the work's formal logic is entirely driven from within itself and from the way it responds to and inhabits the vast volume of the Turbine Hall:

> Scale is individual and the opposite of size. I do not view the project as about size, for no mere space is large enough for my work, though it can act as a tool to achieve its scale. I view the hall, ambiguous whether indoors or outdoors, as one actor on the stage. Like an actor it has a job to do, one part, alone, one part, with others. Both parts together offer a lens though which I hope to penetrate the levels of my work more deeply. I am very excited to see something in something I know so well, I have never seen before, for the magnification has never been great enough, nor as useful.[15]

What Tuttle describes here is an act of recognition, of measuring a new experience against one of familiarity and seeming comprehension, all by virtue of making a work for the Turbine Hall. Throughout the process of making this work he has nurtured its autonomy, rejecting the logic of efficiency-thinking and resource-maximising to which we have become so accustomed in our neo-liberal society. Instead, he has consistently upheld the standard and logic of art. Rather than make a model – or prototype – to be enlarged by a fabricator, he produced a whole new series of works which he conceived as studies and drawings for the Turbine Hall, that were shown under the collective title *Looking for the Map*. Far from being drawings that bore any semblance to the Turbine Hall work, this was a series of sculptures made from all kinds of textiles bunched, bundled or draped over different-sized wooden frames and poles, some of them precariously leaning against the gallery's walls, others firmly attached. To the nervous calls for technical sketches and defining production details Tuttle responded by making more art, insisting that it is only experience – the experience of making and of looking – that can provide guidance, and that experience alone will dictate what questions can be answered at any given moment in time and which may have to wait longer.

Ever since the battle cry of the avant-garde a century ago, the call for life to come into art and art into life has become part of the common rhetoric surrounding modern and contemporary art, to legitimise what might otherwise be deemed as hard 'to get', if not outright frivolous or incomprehensible. In sharp contrast, Tuttle, while continually using materials that bear an immediate relationship to the world beyond art – fabrics,

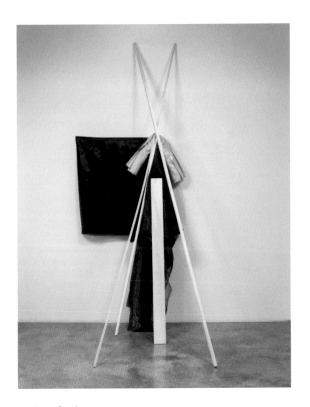

Looking for the Map 9 2013–14

fabric, wood, PVC, pushpin and straight pins
215.9 × 105.4 × 105.4
installation view, Pace Gallery, New York,
7 February – 15 March 2014
courtesy the artist and Pace Gallery

rope, nails, coat-hangers, pins, wooden poles with their barcodes from the DIY shop still visible – passionately pleads to keep art and life separate:

> I believe strongly art and life are not one. Almost any work I have ever done is posited on this distinction … I could simply list hundreds of reasons, I do not think art and life are one.[16]

By using factories, drawing on large-scale production and technical expertise to produce his art for the Turbine Hall, Tuttle makes the useful subservient to the logic of the useless. Thus he gives back dignity and value to the shared human endeavour of all of those involved in the making of this sculpture, from the weavers in Surat to the installation team in London, whether they self-consciously participate in this process or do so surreptitiously. When asked about the need for art and artists, and his repeated demand to raise the respect for either, Tuttle states:

> One thing is, to get better art; another is to have an authority outside those verily used to suppress the artist. For when they do their work, we can see all the good things in life – the truth, beauty, humanity, love, etc. otherwise obscured by the agendas, value structures of the other authorities. And through heightened respect, we contribute to an even better art.[17]

Perhaps it is here that we move closest to Tuttle's hoped-for 'critique of broad reflection': for what is at the heart of the creation of Tuttle's work for the Turbine Hall is not a series of technocratic production steps but a shared ethos of how to be and how to make:

> Creation never ceased on the sixth evening, it occurs to the young man. Creation unfolds around us, despite us and through us, at the speed of days and nights, and we like to call it 'Love'.[18]

1 David Mitchell, *The Thousand Autumns of Jacob de Zoet*, London 2010, p. 277.
2 Email to the author, 11 February 2014.
3 *Longman Dictionary of the English Language*, Harmondsworth 1991, p.1344.
4 This essay was written in Spring 2014, at a time when the fabrics were in the process of production while the solid sub-structure was still in development and the actual installation several months off.
5 Email to the author, 20 October 2013.
6 Email to Magnus af Petersens, 5 July 2013.
7 Email from Sanjay Shah to Richard Tuttle, 15 February 2013.
8 Email from Richard Tuttle to Sanjay Shah, 18 February 2013.
9 Rayon is made from purified cellulose, primarily from wood pulp, which is chemically converted into a soluble compound to produce filaments that are chemically solidified, resulting in synthetic fibers of almost pure cellulose. Because rayon is manufactured from naturally occurring polymers, it is considered a semi-synthetic fibre. Modal is a type of rayon. It is smooth and soft, highly water-absorbent and takes dye like cotton.
10 Email from Sanjay Shah to the author, 4 March 2013.
11 Mukulika Banerjee and Daniel Miller, *The Sari*, Oxford 2008, p.196.
12 In Surat it is a tradition among members of the weaving community to conclude the day by sharing a light meal. Everybody, from the proprietor to the technical, design and marketing staff, comes together after work to have a small but proper meal. Tuttle and I were kindly invited along to these occasions during our stay.
13 Email to Magnus af Petersens, 5 July 2013.
14 Theodor Adorno, *The Culture Industry*, London 1991, pp.114–15.
15 Richard Tuttle, statement for the Turbine Hall, October 2013.
16 Email to Marko Daniel, 23 October 2013.
17 Email to Marko Daniel, 24 September 2013.
18 David Mitchell, *The Thousand Autumns of Jacob de Zoet*, London 2010, p.146.

Turbine Hall Commission, Tate Modern

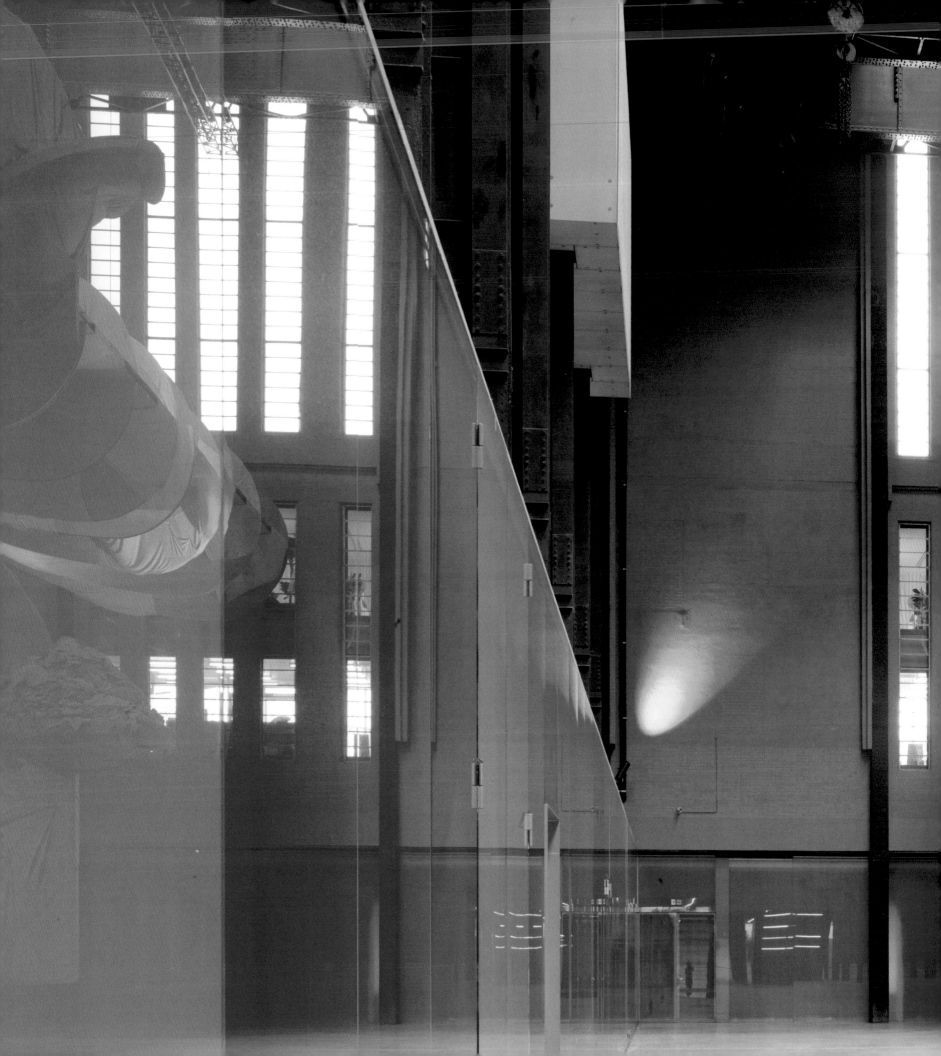

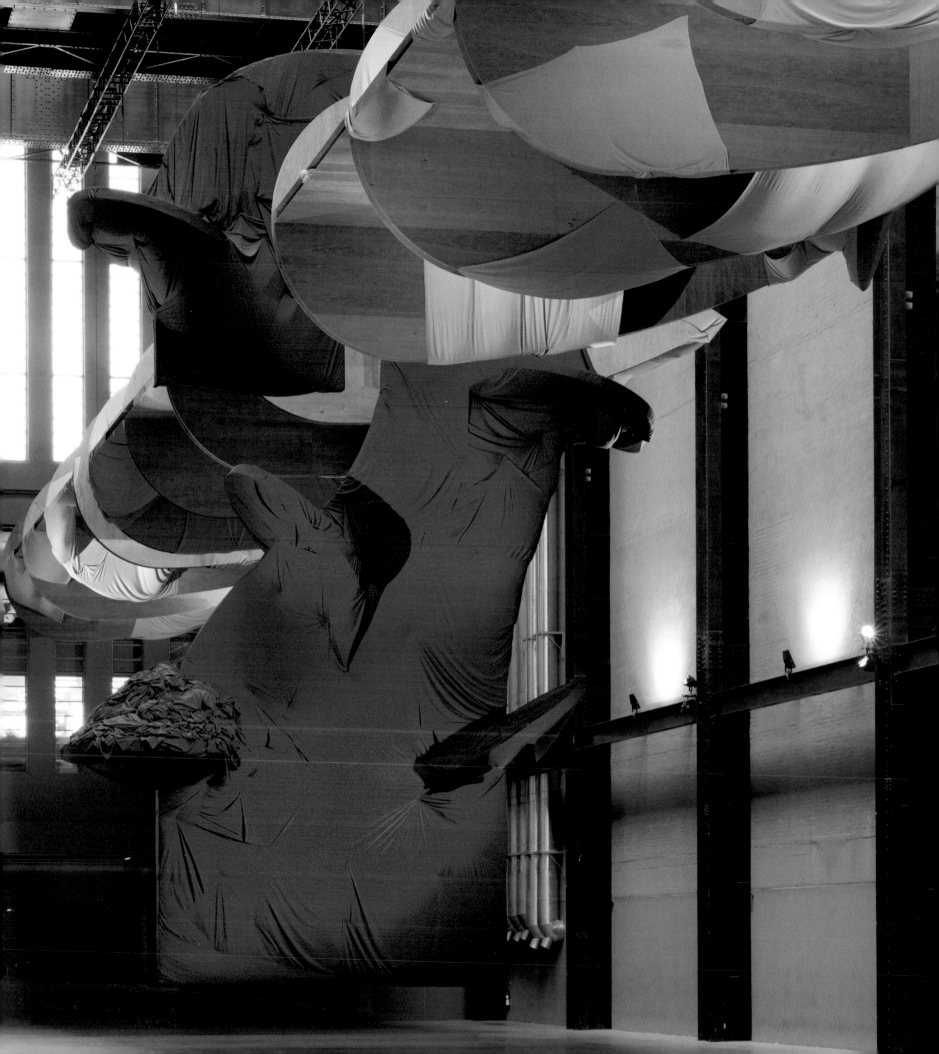

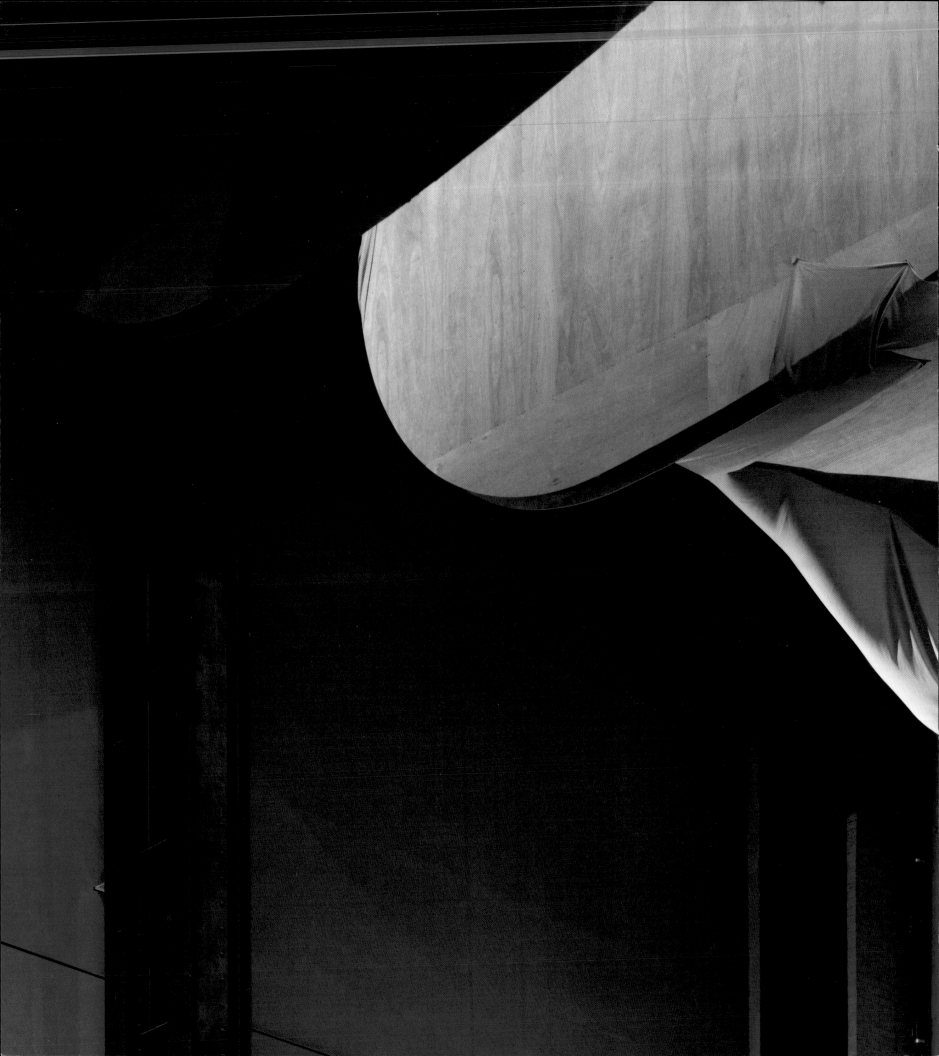

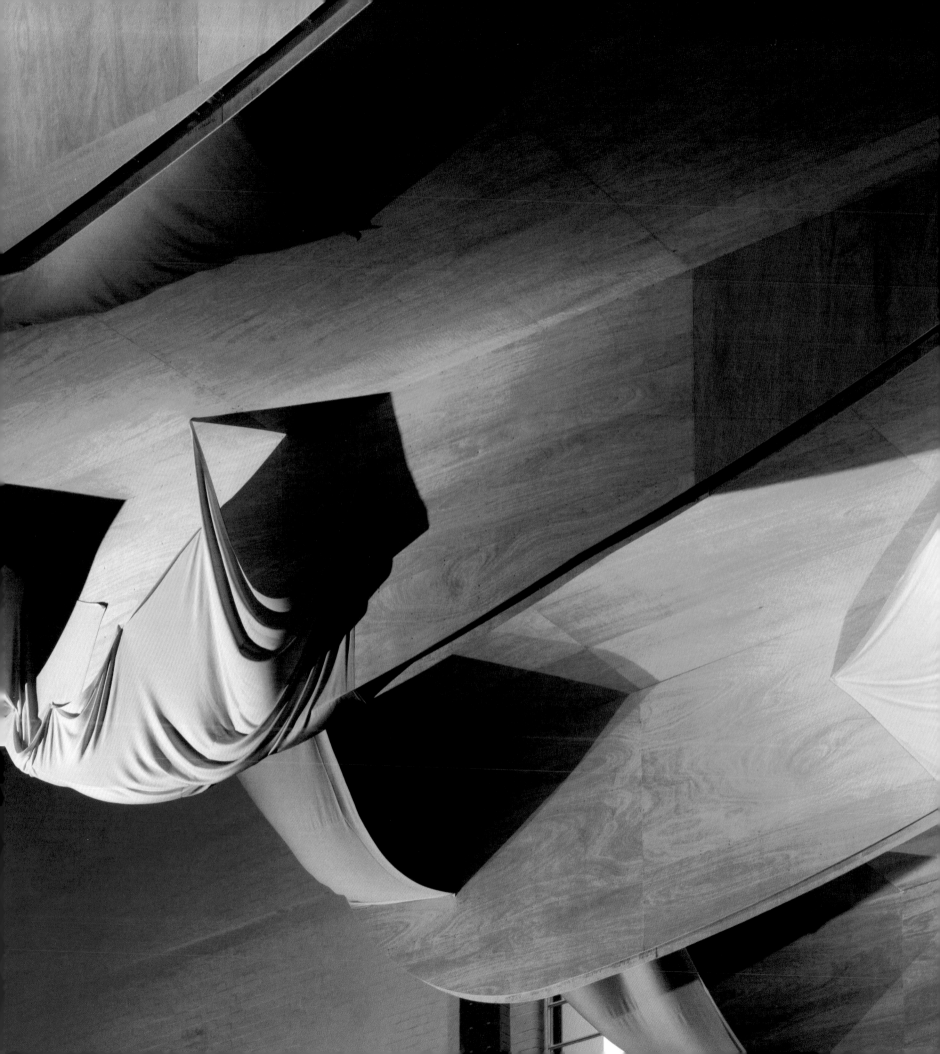

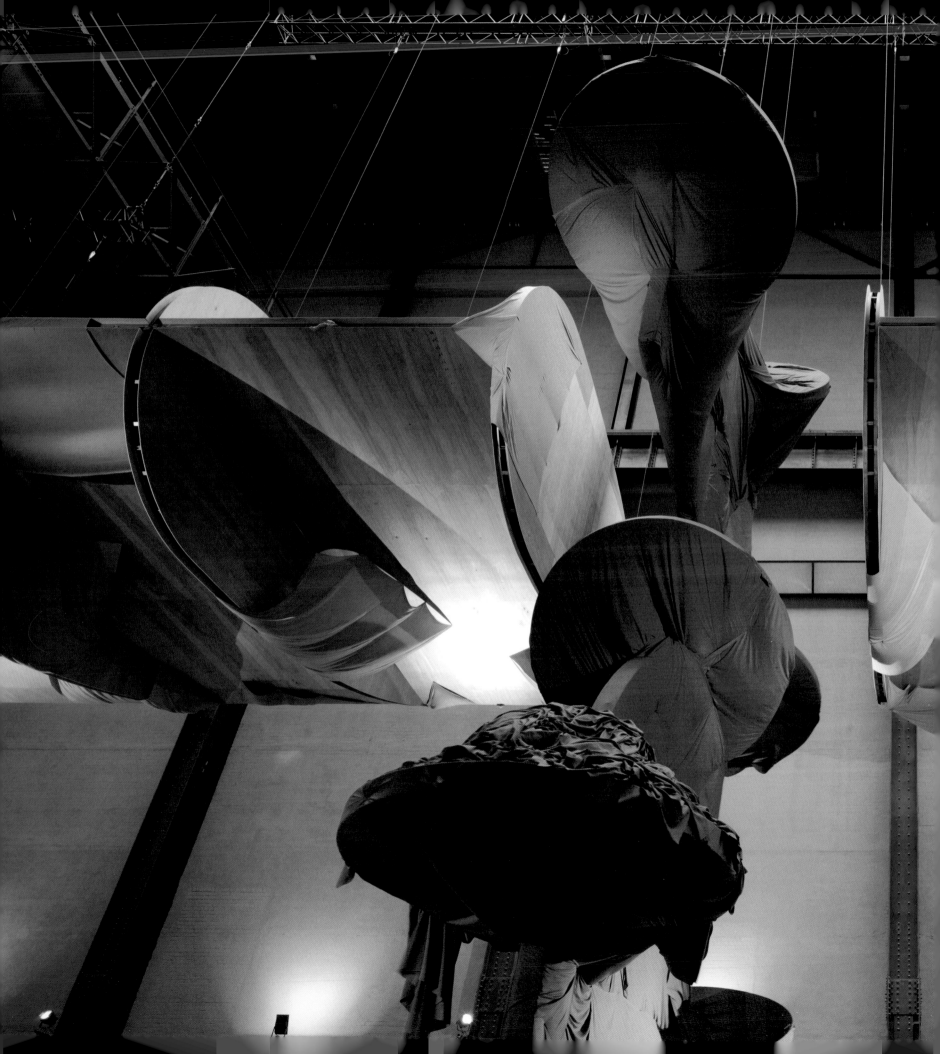

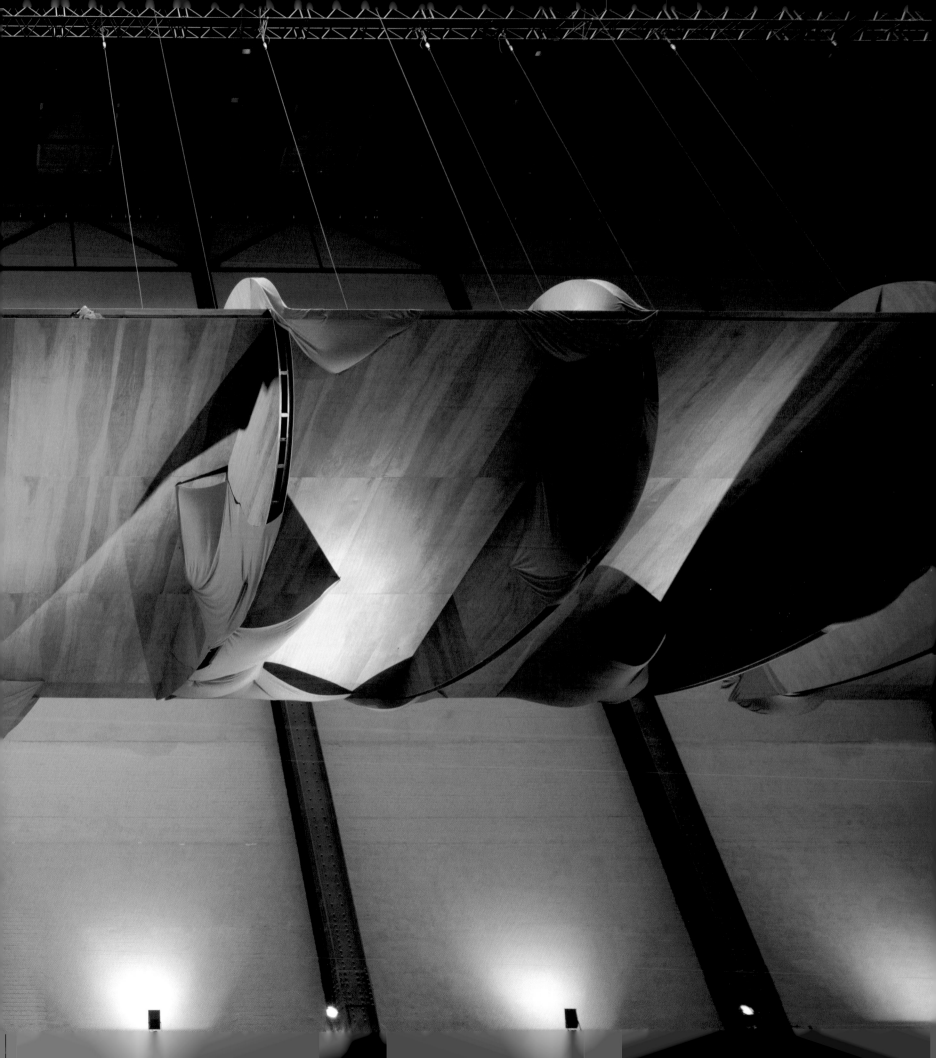

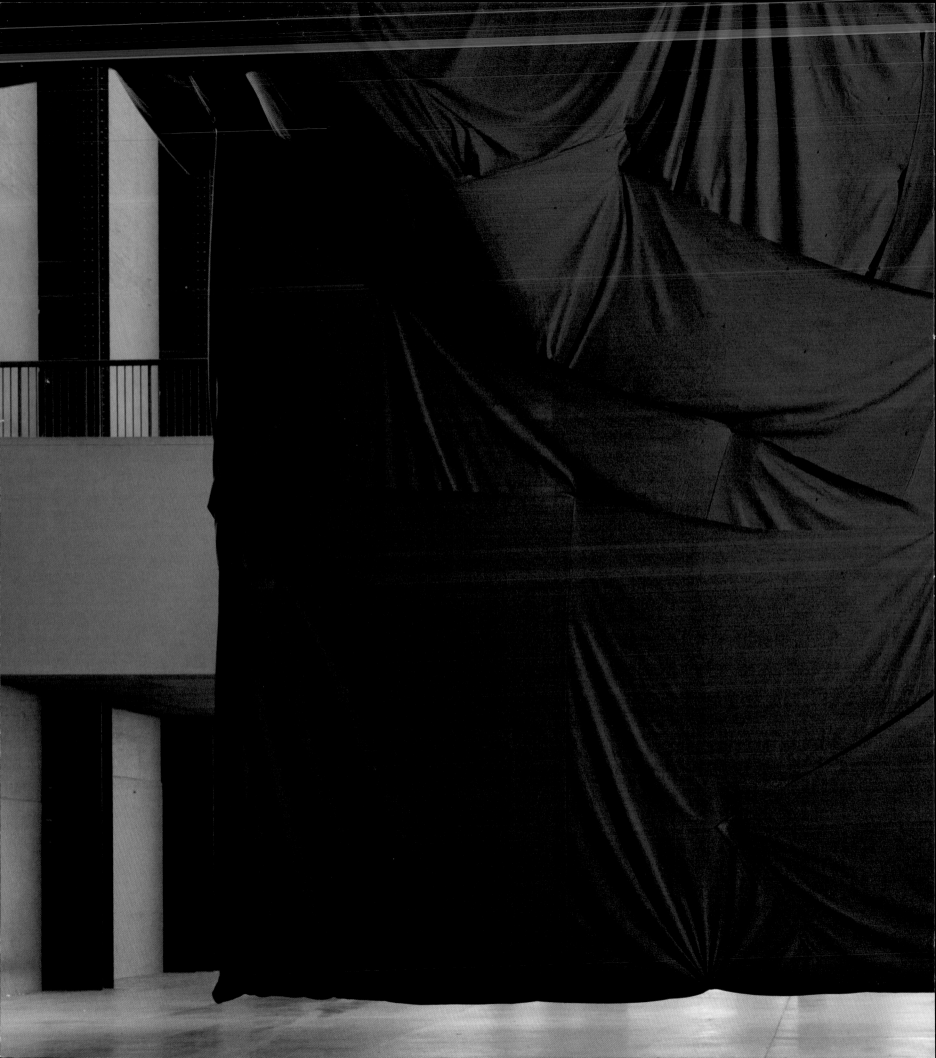

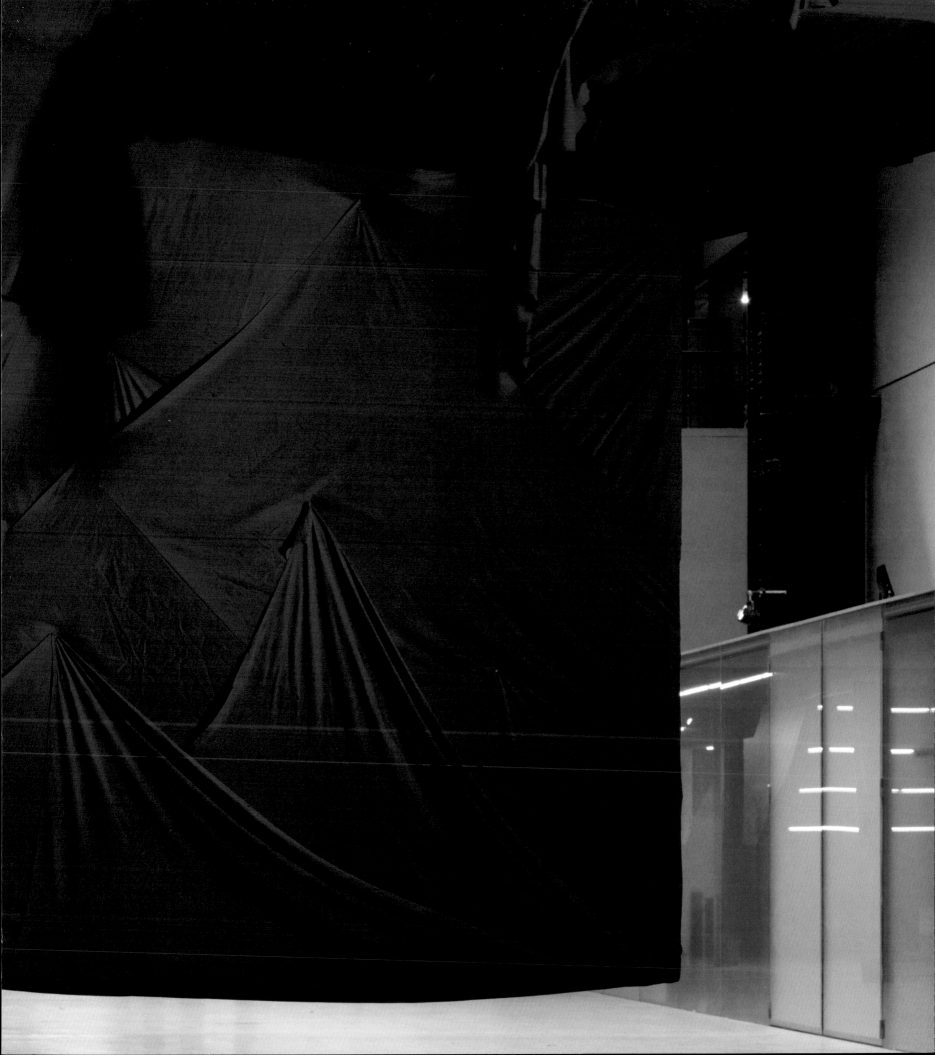

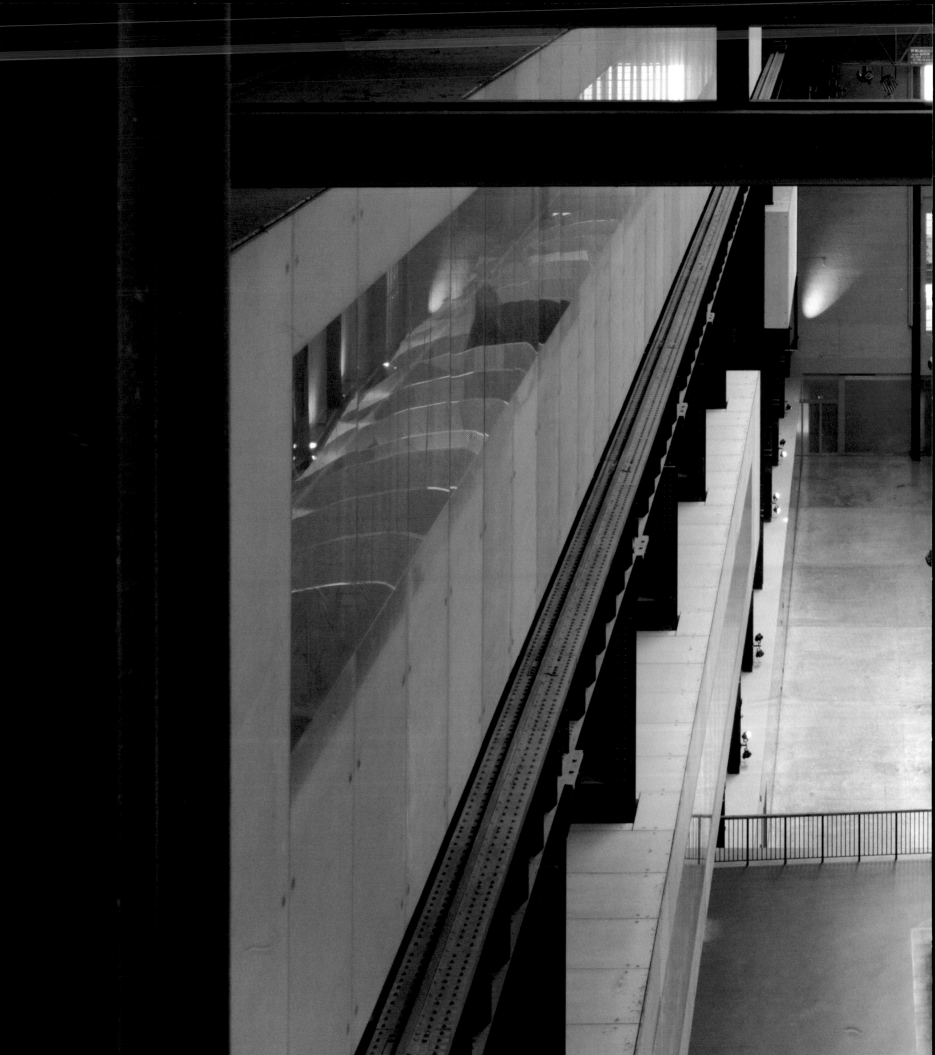

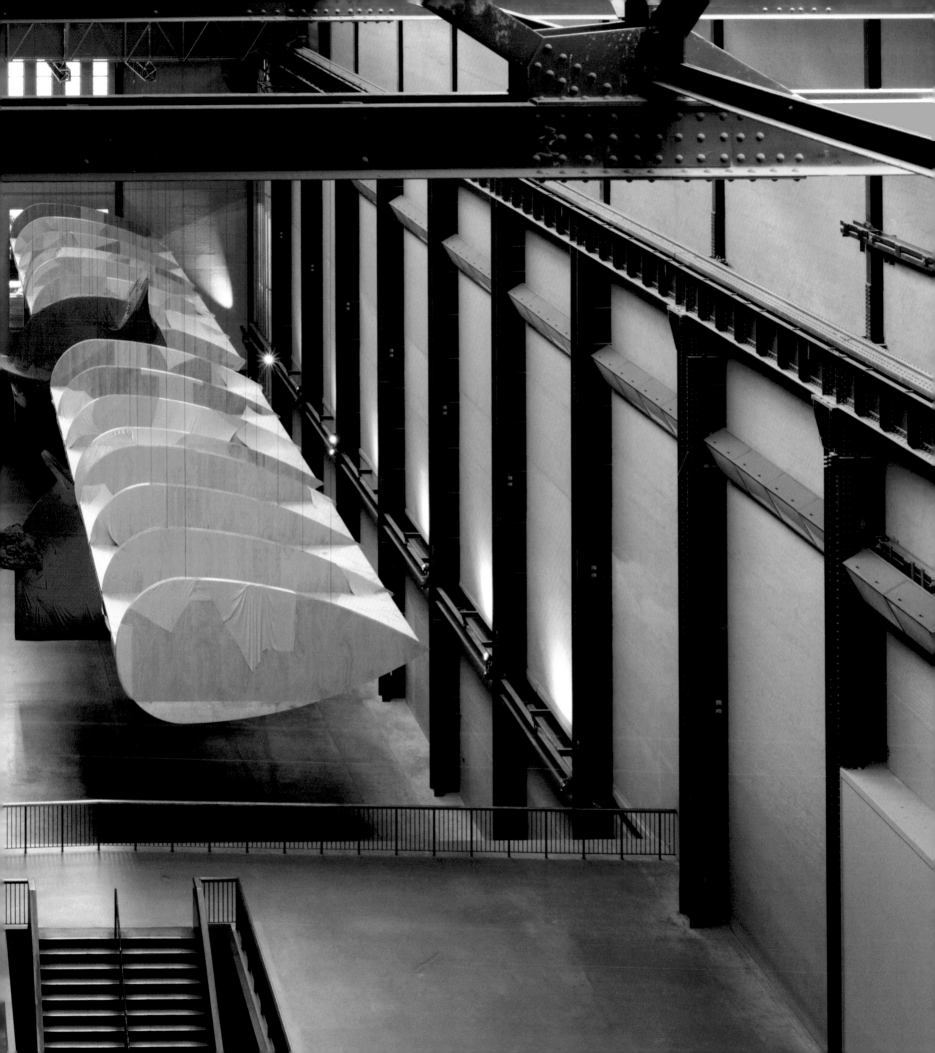

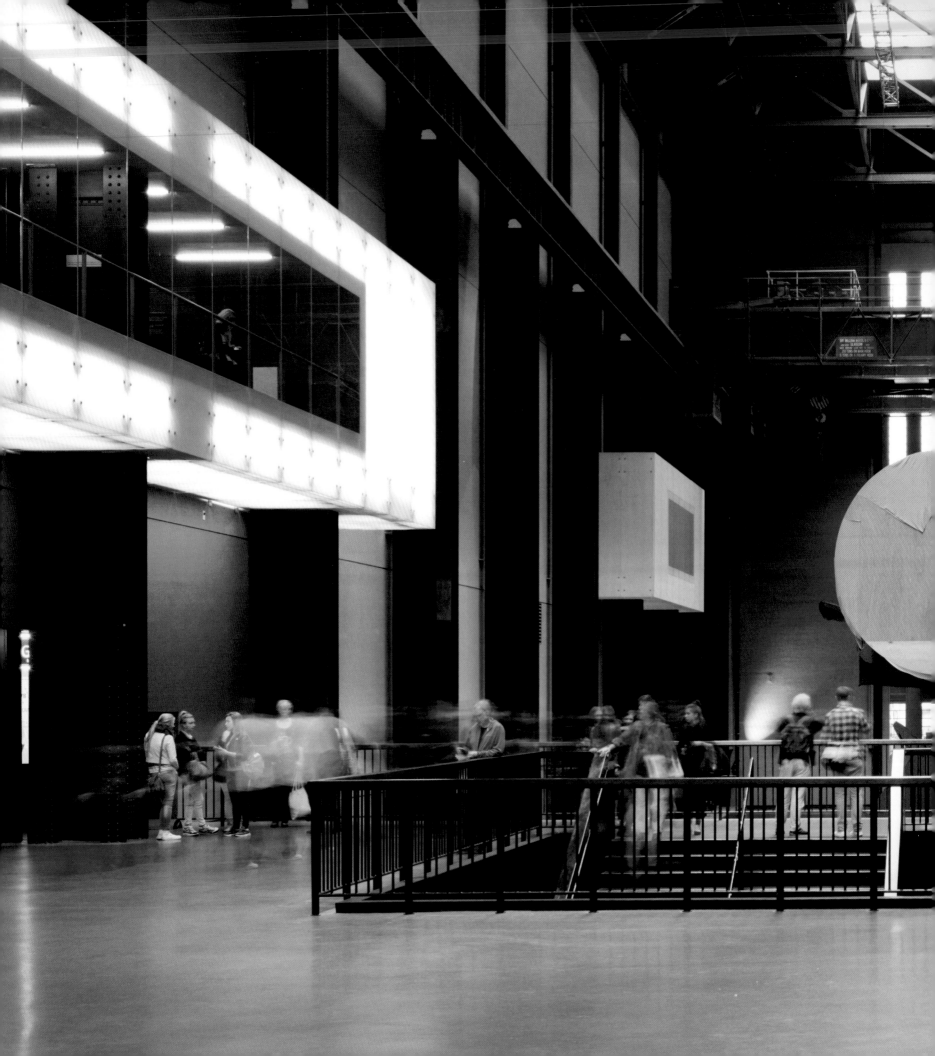

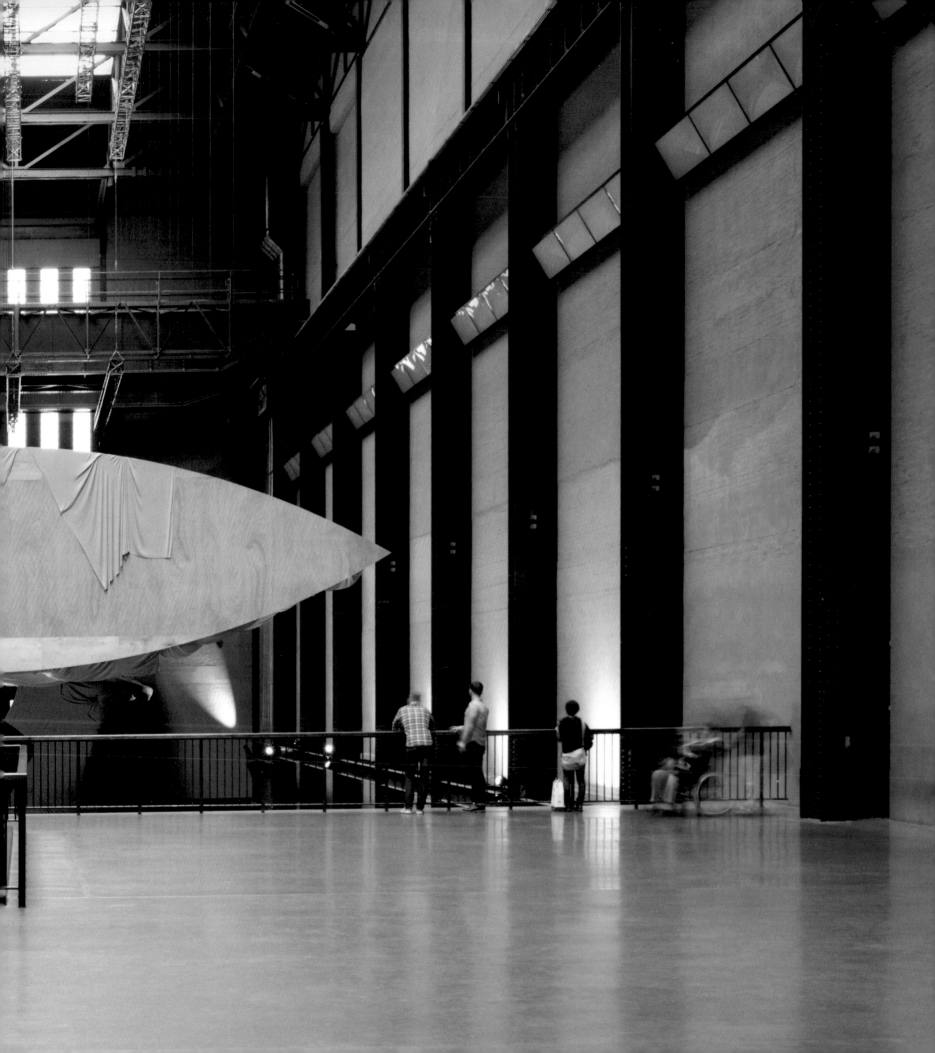

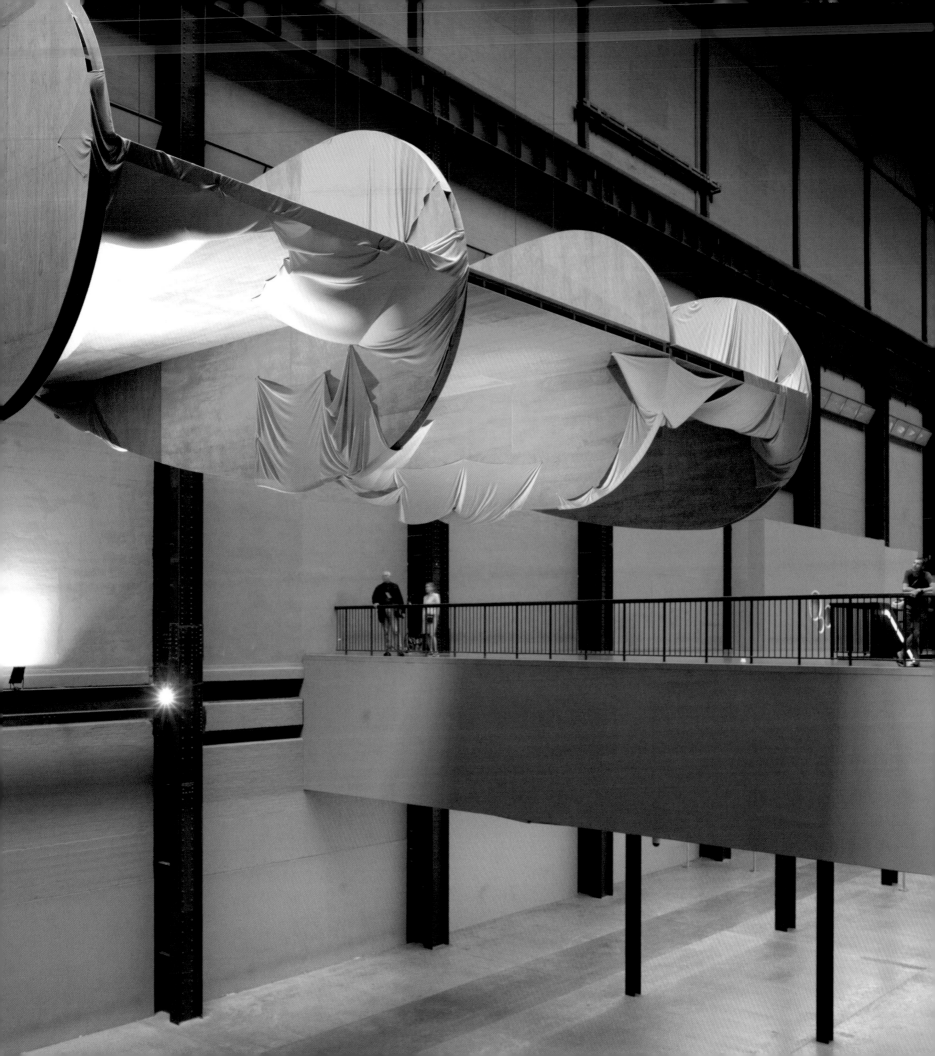

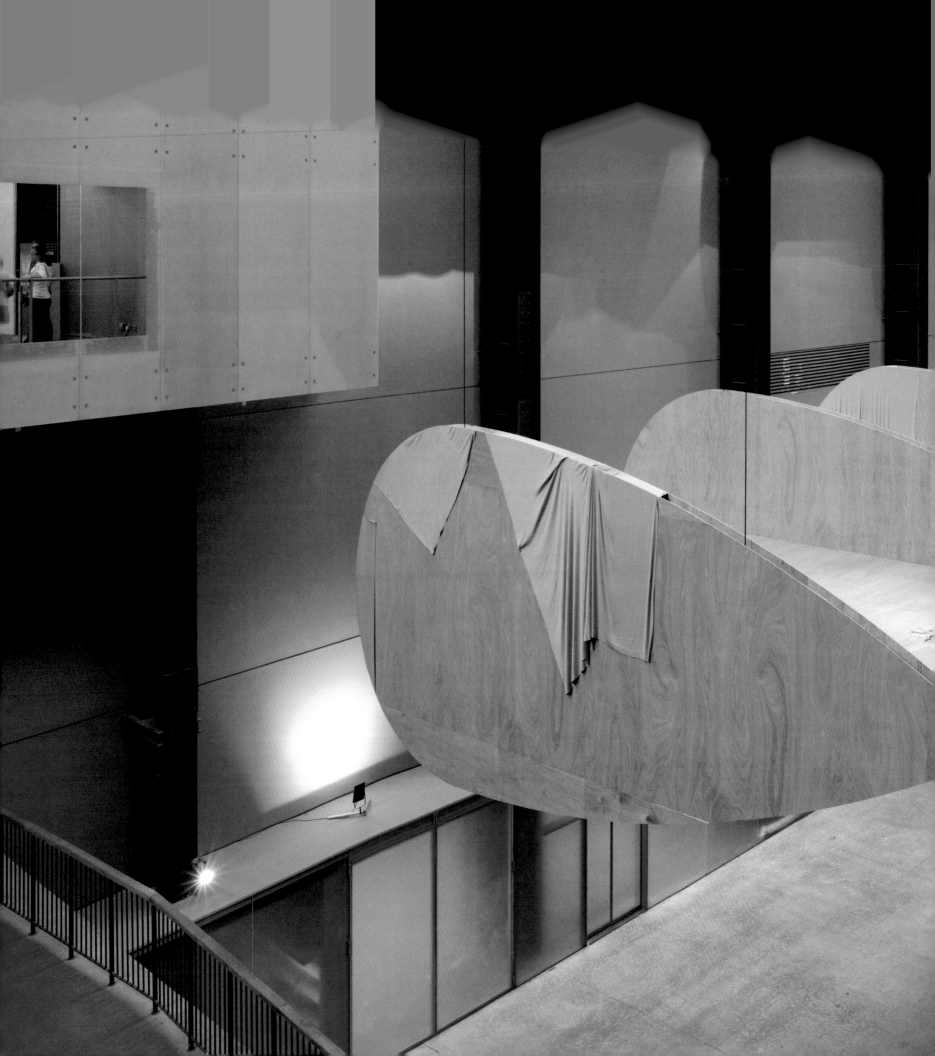

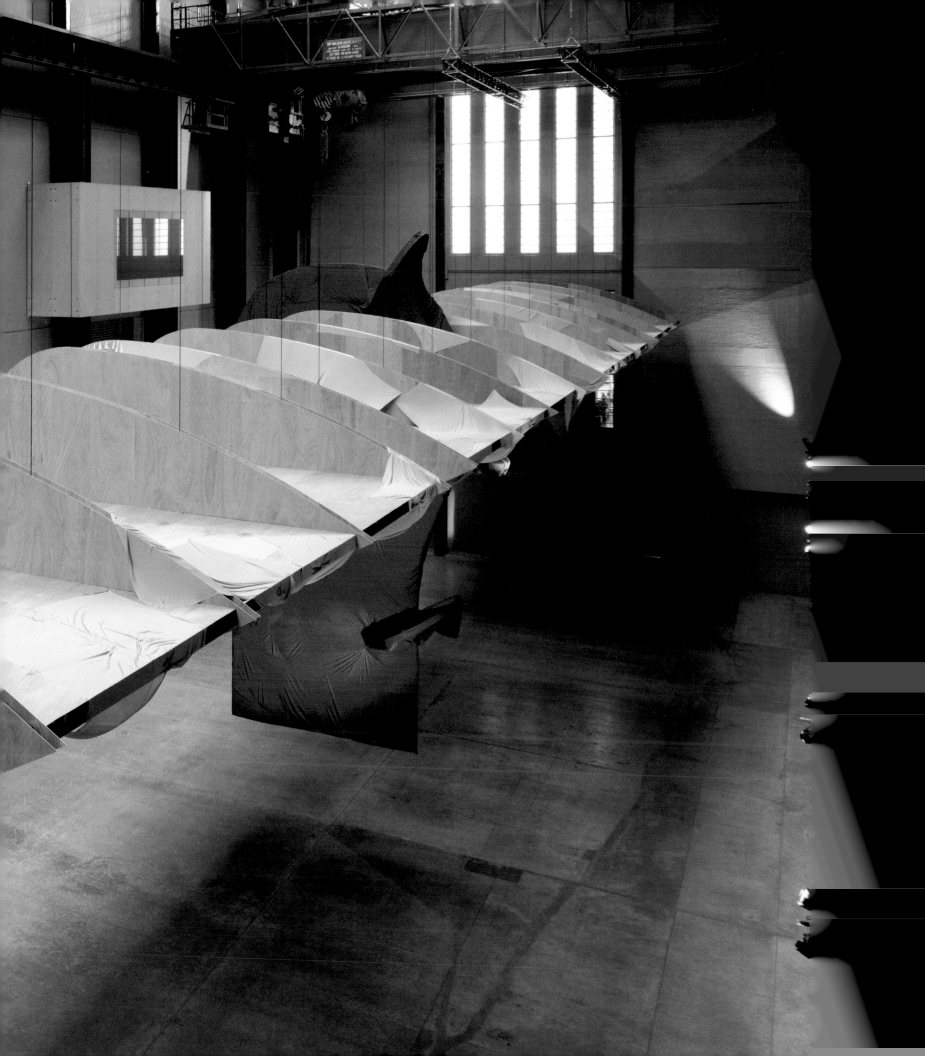

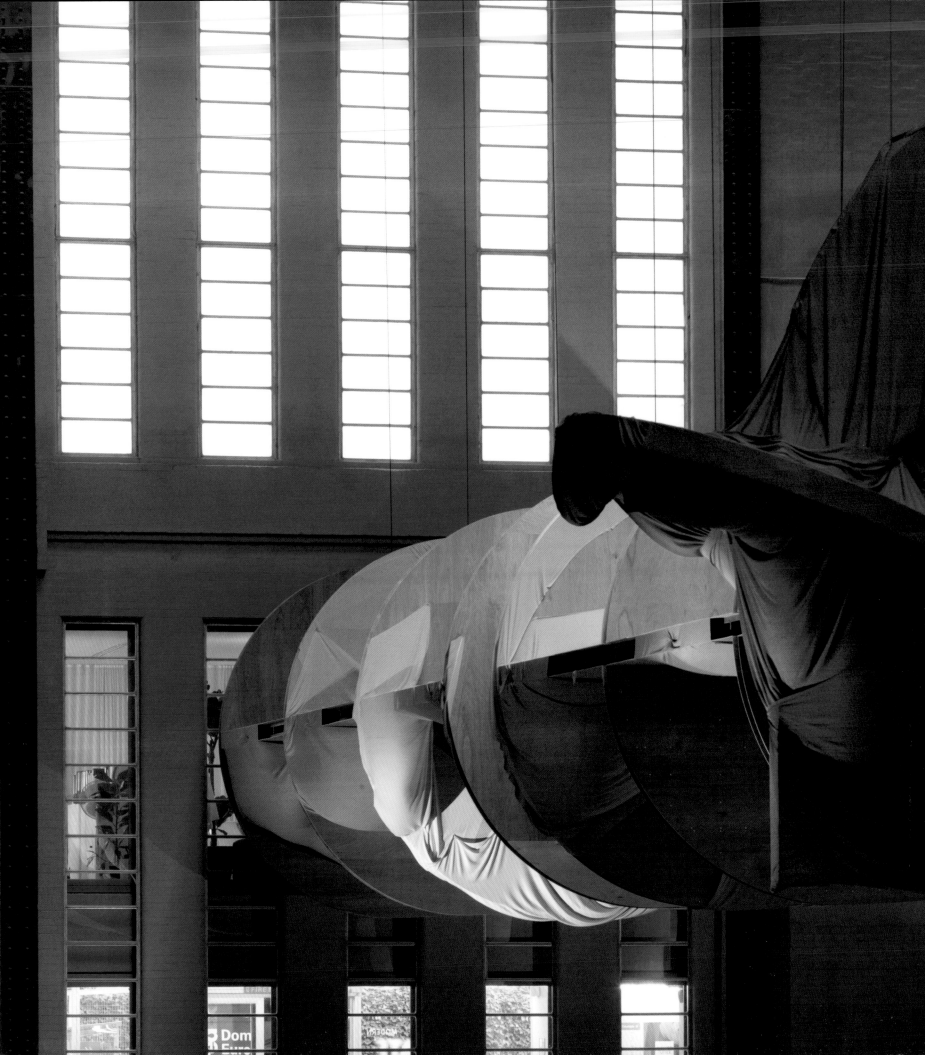

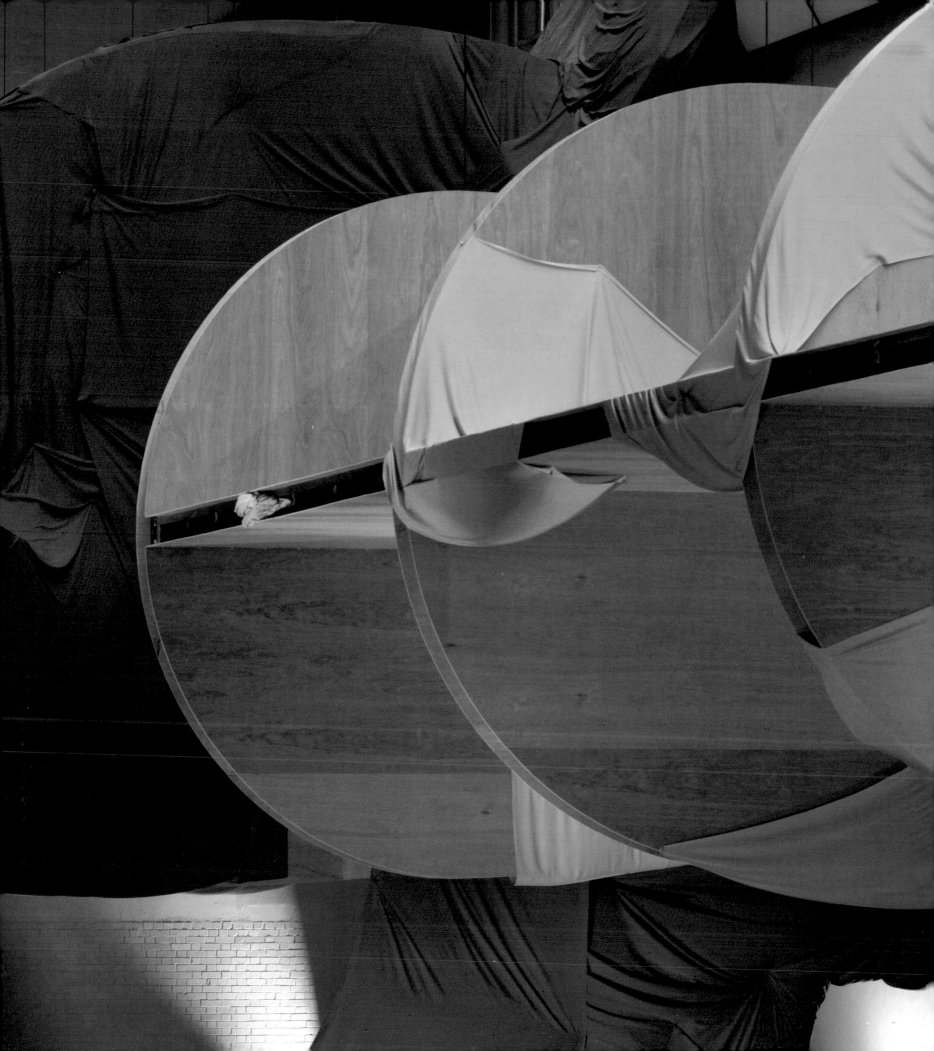

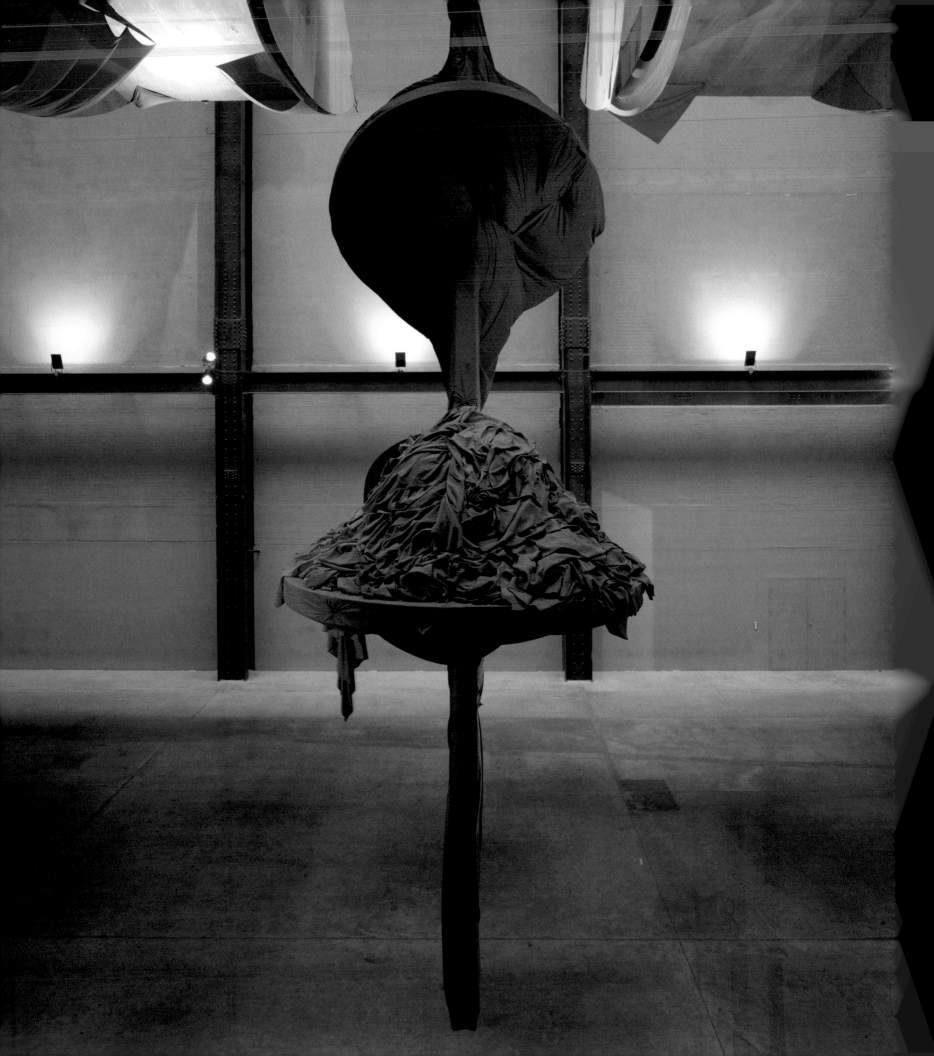

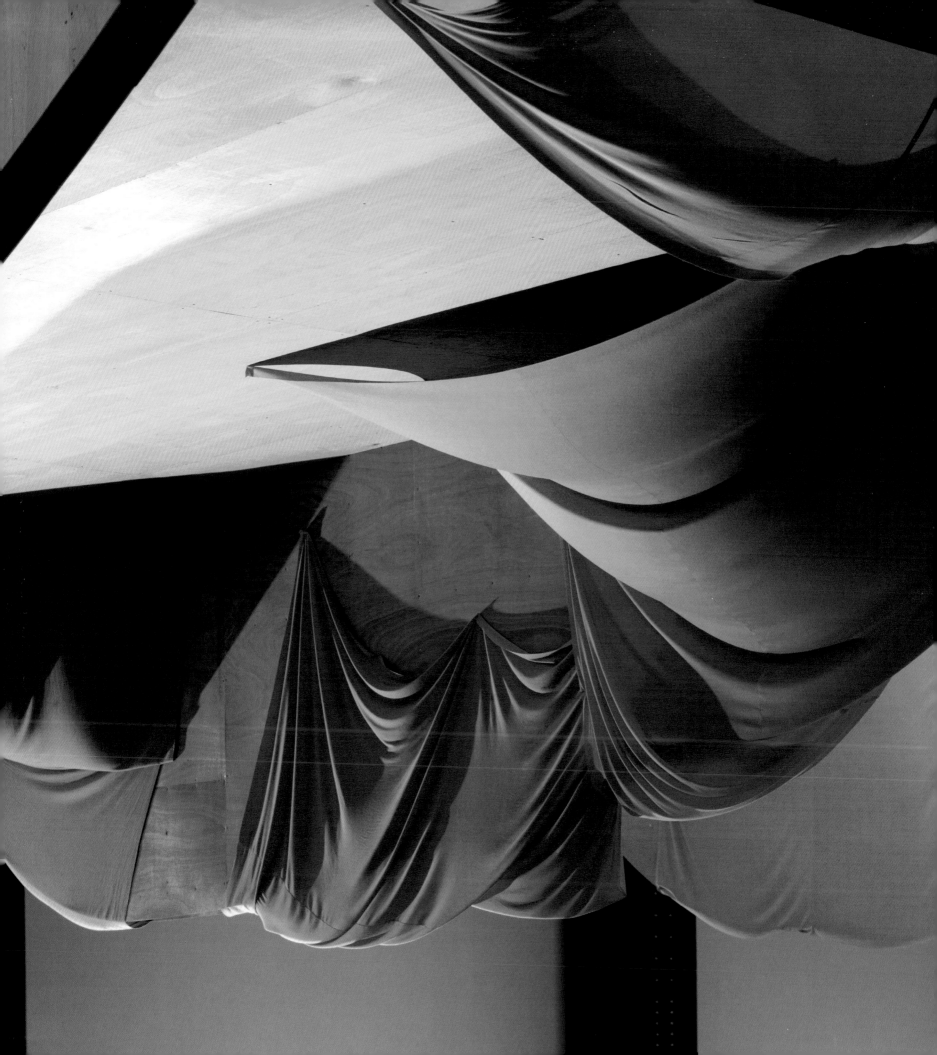

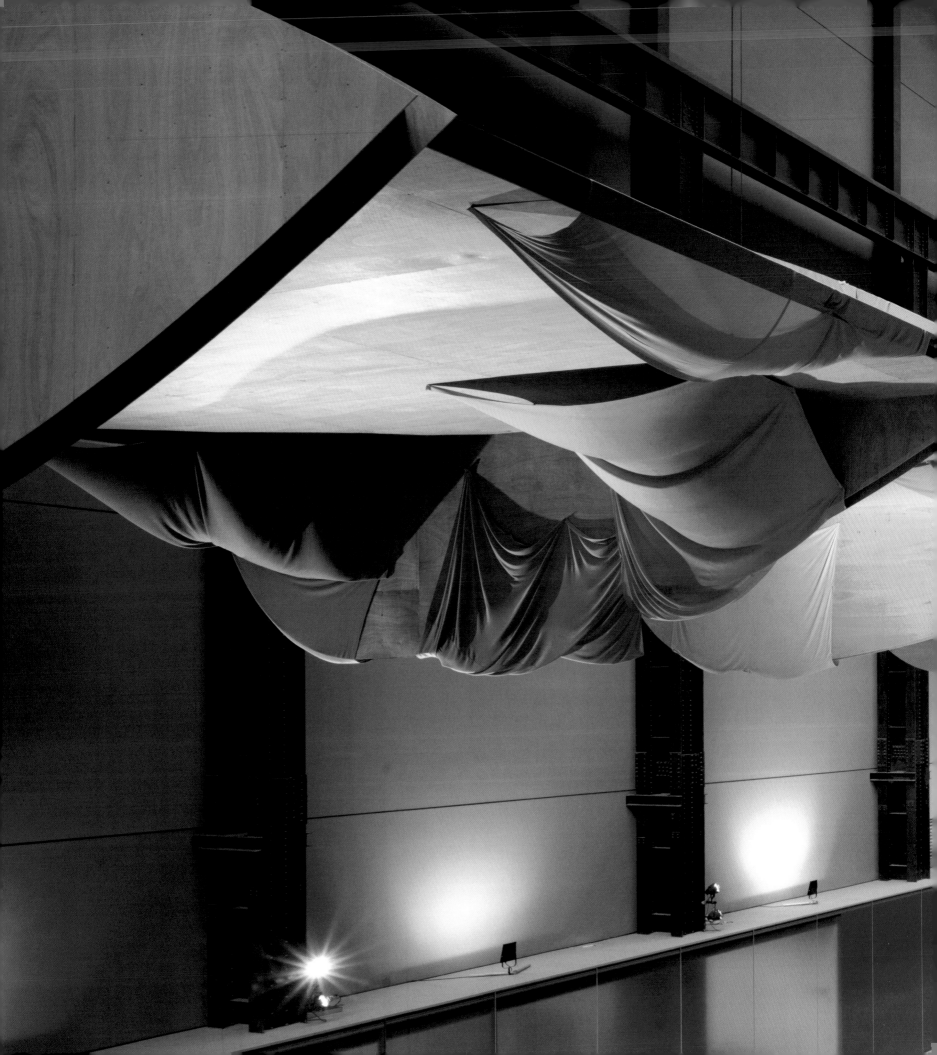

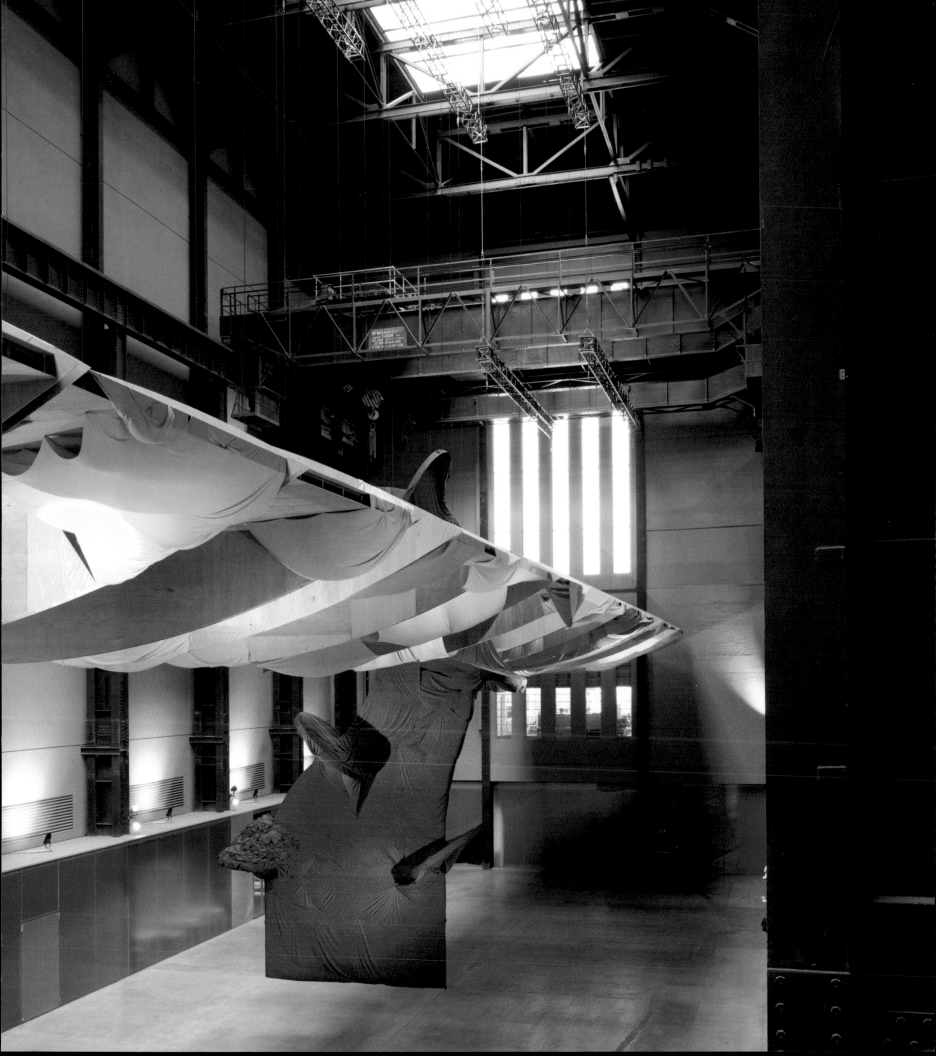

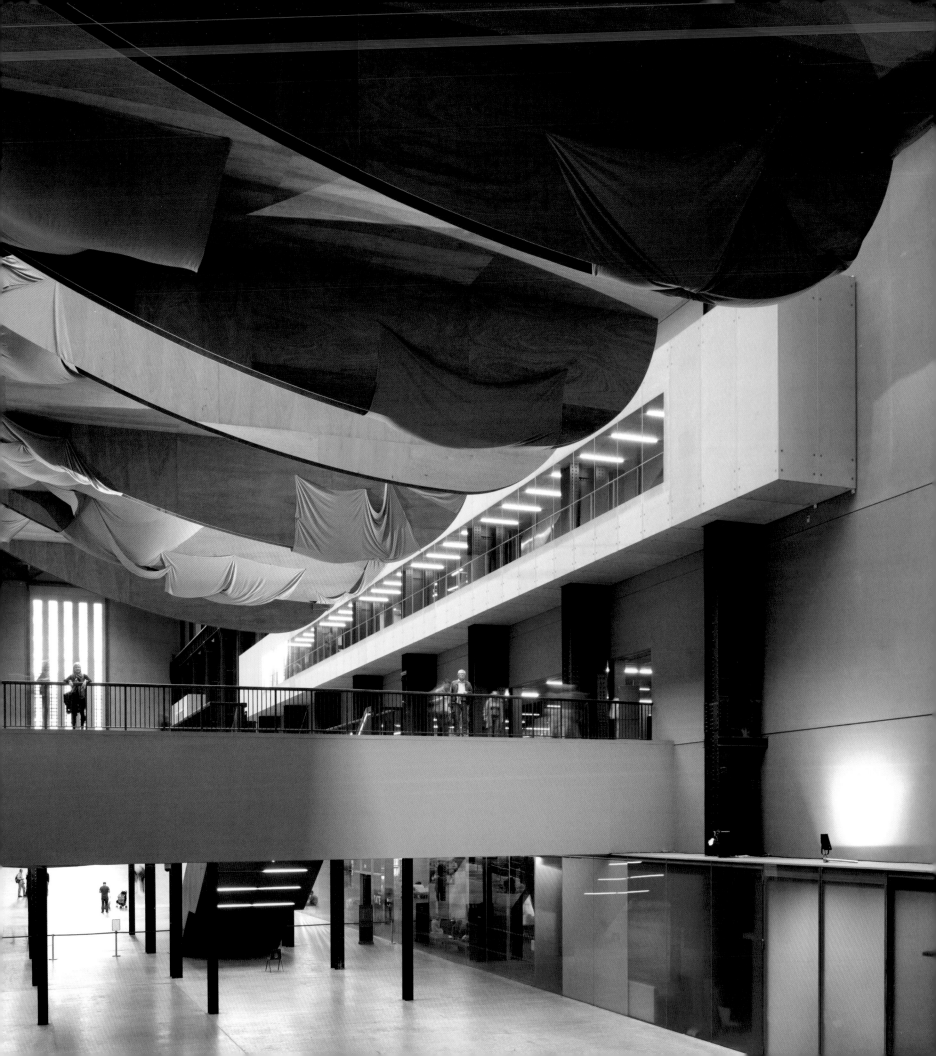

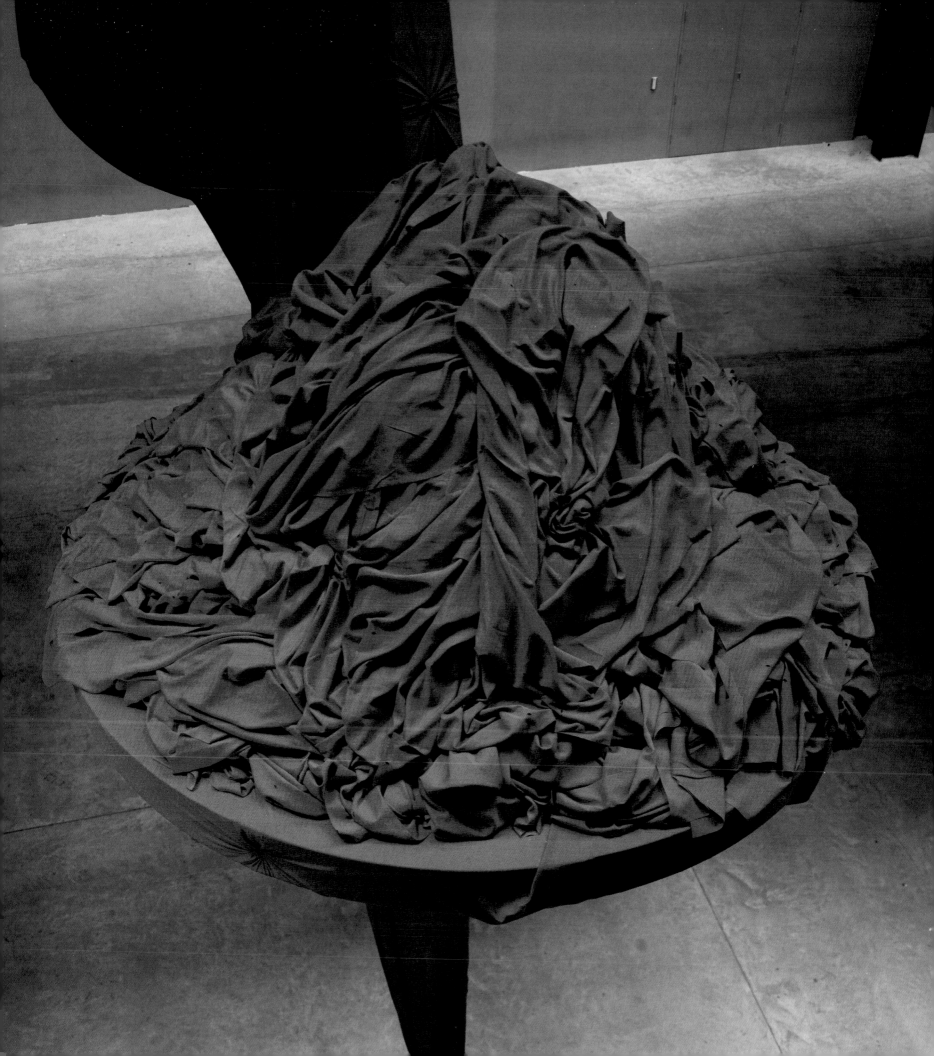

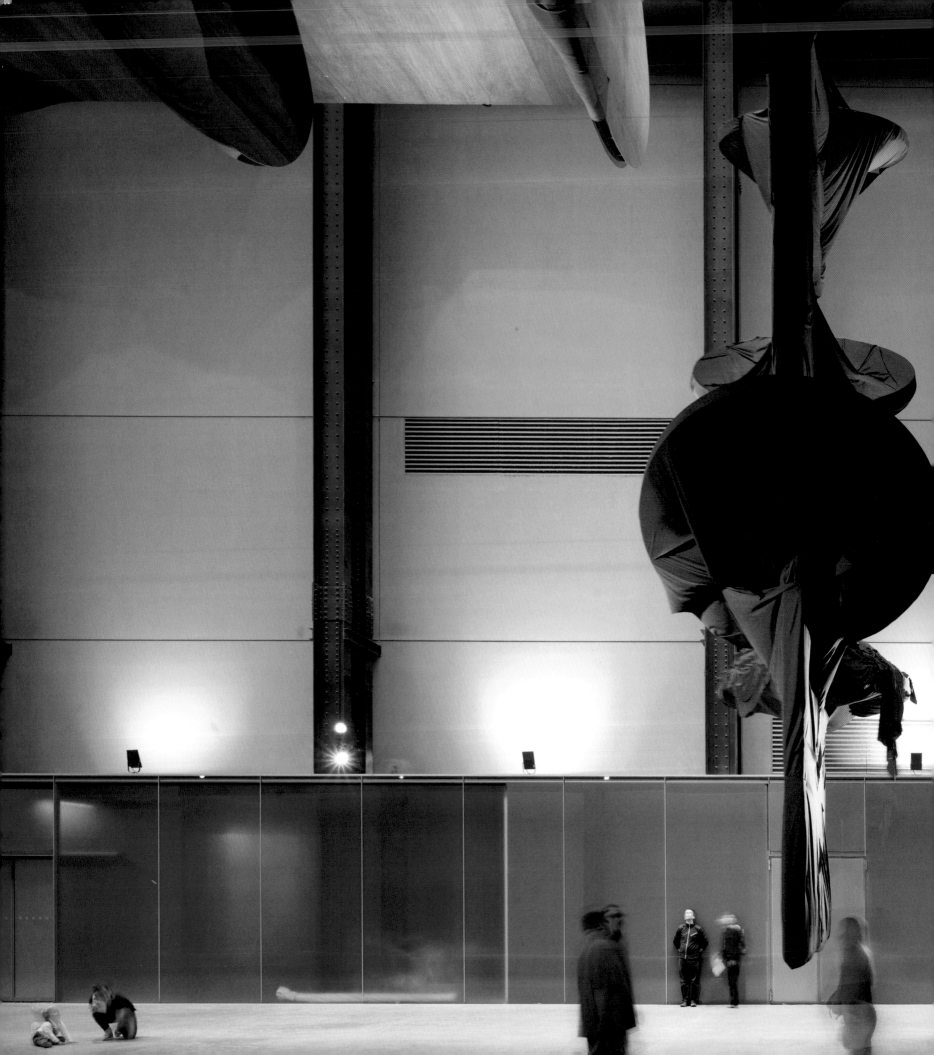

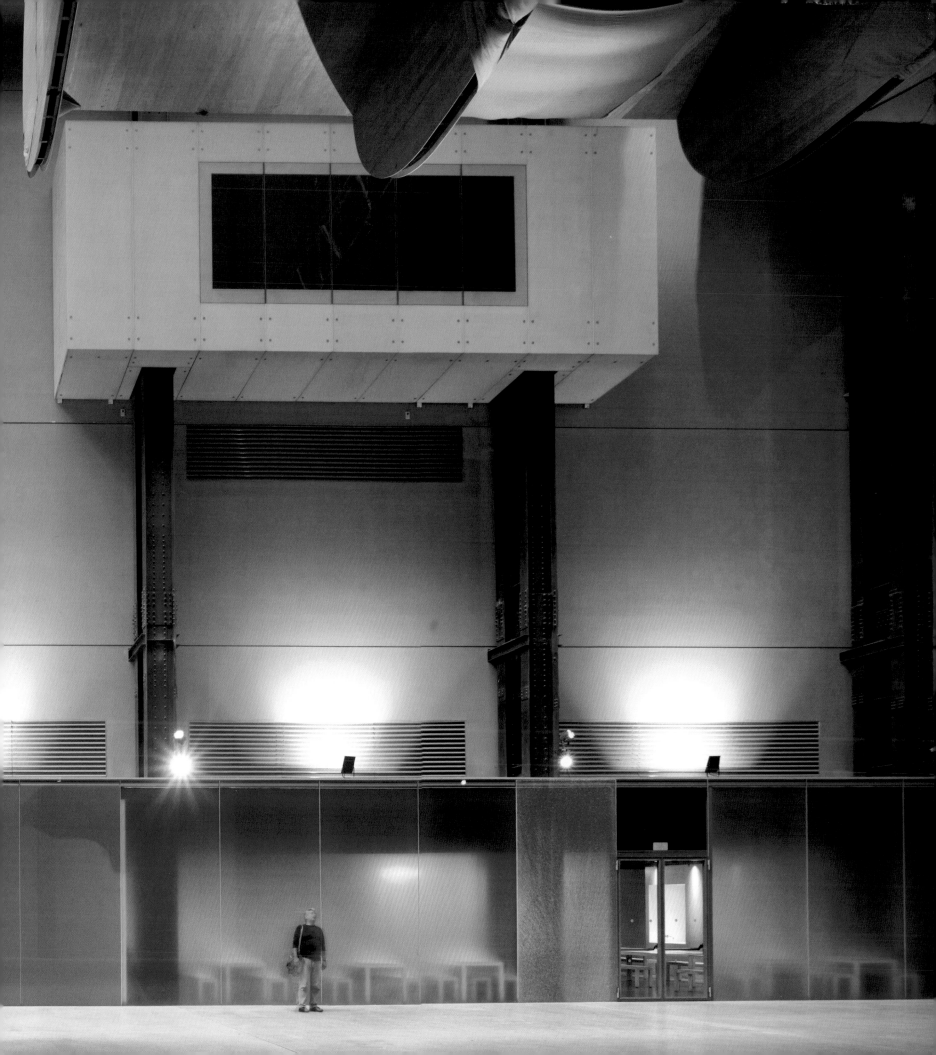

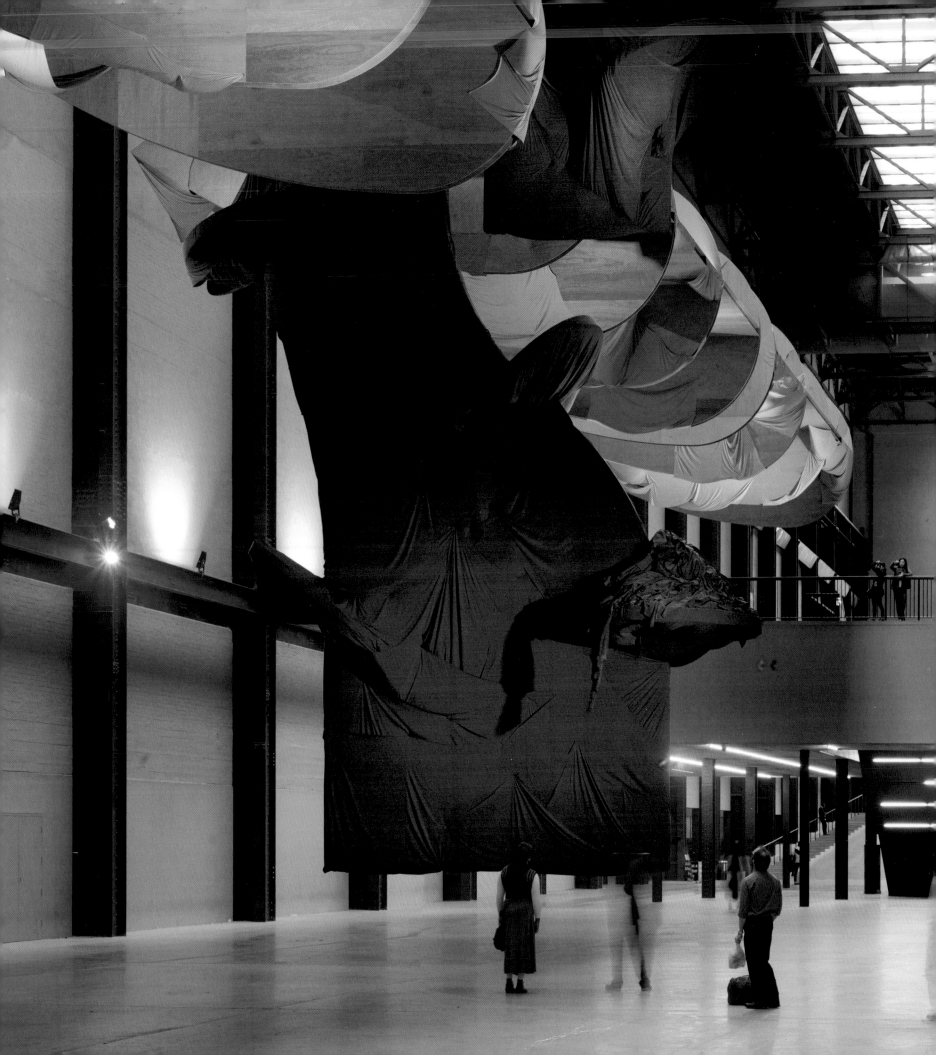

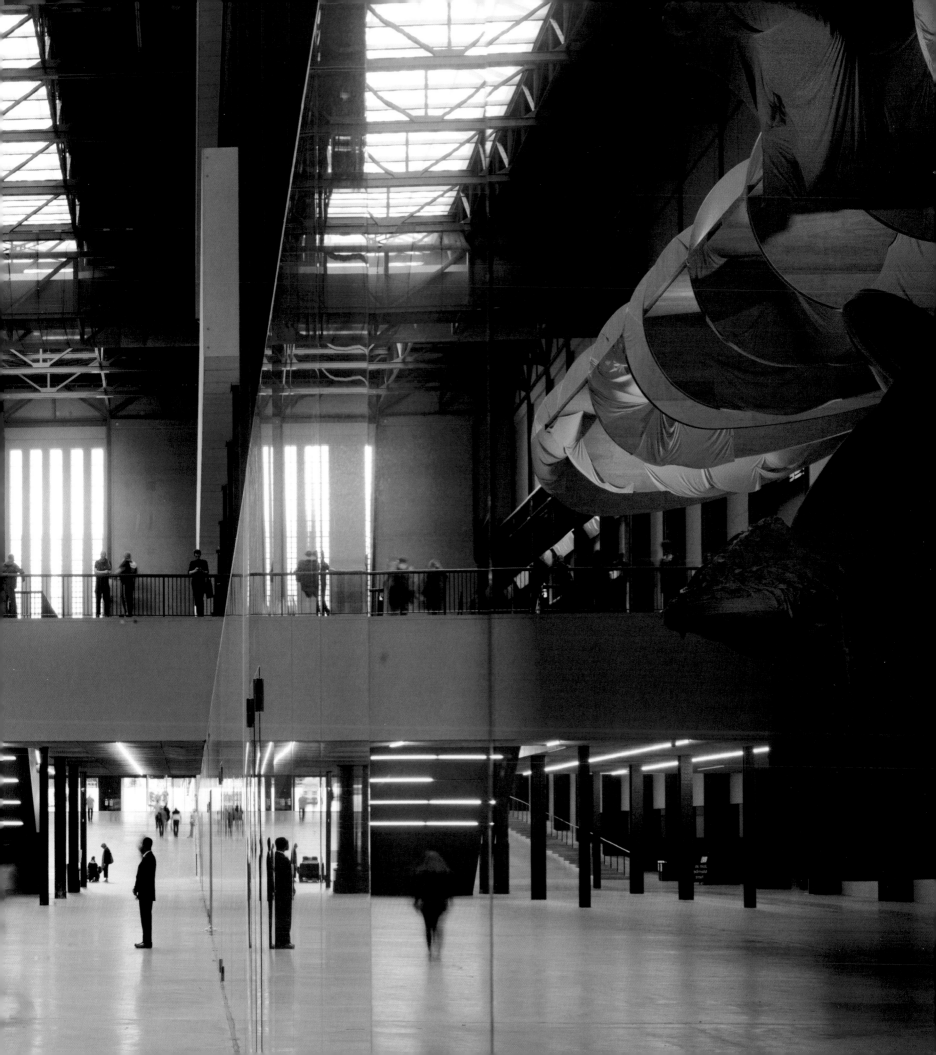

Select Biography

Born Rahway, New Jersey, USA, 1941
BA, Trinity College, Hartford, Connecticut,
USA, 1963

Selected solo exhibitions

1965
Richard Tuttle: Constructed Paintings,
Betty Parsons Gallery, New York (booklet)

1968
Ten works by Richard Tuttle, Betty Parsons
Gallery, New York
Galerie Schmela, Düsseldorf

1971
Dallas Museum of Fine Arts (catalogue)

1972
Projects: Richard Tuttle and David Novros,
The Museum of Modern Art, New York

1973
Clocktower Gallery, Institute for Art and Urban
Resources, New York
*Richard Tuttle: Das 11. Papierachteck und
Wandmalereien/The 11th Paper Octagonal and
Paintings for the Wall*, Kunstraum München,
Munich (catalogue)
*Richard Tuttle: Ten Kinds of Memory and Memory
Itself*, Daniel Weinberg Gallery, San Francisco

1974
*A Group of Very Small Coloured Metal Plates
Set at Various Distances from the Wall in the
Different Rooms of the Gallery*, Barbara Cusack
Gallery, Houston
Forty October Drawings + Interlude, Nigel
Greenwood Inc. Ltd, London

1975
Matrix 10: Richard Tuttle, Wadsworth Atheneum,
Hartford, Connecticut (booklet)
Whitney Museum of American Art, New York,
USA. Travelled to Otis Art Institute Gallery of
Los Angeles County (catalogue)

1976
Richard Tuttle: Books and Prints, 1964–1976,
Brooke Alexander, New York
Richard Tuttle: The Cincinnati Pieces, Julian Pretto,
New York
Graeme Murray Gallery, Edinburgh
McIntosh Gallery, London and University of
Western Ontario (booklet)
*Grafiek – Typologische Symmetrieen. Richard Tuttle
en Maria Van Elk*, Galerie Swart, Amsterdam

1977
*Richard Tuttle, New York, Zeichnungen und
Aquarelle, 1968–1976. 140 Werke*, Kunsthalle
Basle (catalogue)
Richard Tuttle: Zwei mit Zwei/Two with Any Two,
Kunstraum München, Munich
Richard Tuttle: Maine Works, Two with Any Two,
Nigel Greenwood Inc. Ltd, London

1978
An Exhibition of the Work of Richard Tuttle,
College of Creative Studies, University of
California, Santa Barbara
Museum Van Hedendaagse Kunst, Ghent
(catalogue)

1979
*Richard Tuttle: Title 1–6, Title I–IV, Title A–N,
Title 11–16, Titre 1–8, Titolo 1–8*, Stedelijk
Museum, Amsterdam (catalogue)
*Presentation of the Book: List of Drawing Material
of Richard Tuttle and Appendices*, G. & A. Verna,
R. Krauhammer, A. Gutzwiller, Zurich
CAPC Centre d'Arts Plastiques Contemporaine,
Bordeaux

1980
Richard Tuttle: Pairs, 1973, Centre d'art
contemporain, Geneva
*Richard Tuttle: 12 Drahtoktogonale, 1971, und 25
Wasserfarbenblätter, 1980*, Museum Haus Lange,
Krefeld
Richard Tuttle: From 210 Collage-Drawings,
Georgia State University Art Gallery, Atlanta;
Baxter Art Gallery, California Institute of
Technology, Pasadena (catalogue)

1982
Nigel Greenwood Gallery, London
Richard Tuttle: Pairs, Musée de Calais (catalogue)

1983
Richard Tuttle: Zeichnungen 1968–1974,
Städtisches Museum Abteiberg,
Mönchengladbach

1984
Richard Tuttle: 16 Works from India 1980,
Galleriet, Lund
Richard Tuttle: Engineer, Portland Centre for the
Visual Arts, Oregon (booklet)

1985
*Richard Tuttle: Vienna Works, Indonesian Works,
Monkey's Recovery for a Darkened Room*,
Galerie Schmela, Düsseldorf
Richard Tuttle: Works 1964–84, Institute of
Contemporary Art, London; Fruitmarket
Gallery, Edinburgh (artist book/catalogue)

1986
Richard Tuttle: Wire Pieces, CAPC Musée d'art
contemporain, Bordeaux (catalogue)
Richard Tuttle: I See in France, ARC Musée d'art
moderne de la ville de Paris (artist book/
catalogue)

1987
*Richard Tuttle: The Baroque and Color/Das Barocke
und die Farbe*, Neue Galerie am Landesmuseum
Joanneum, Graz (artist book/catalogue)

1988
Richard Tuttle: Space in Finland, Galerie
Schmela, Düsseldorf (catalogue)
Richard Tuttle: Portland Works, Galerie Karsten
Greve, Cologne, Germany; Thomas Segal
Gallery, Boston (catalogue)
XX Blocks, Galleria Marilena Bonomo, Bari
(catalogue)

1990
Richard Tuttle: 70s Drawings, Brooke Alexander,
New York
Richard Tuttle: In Memory of Writing, Sprengel
Museum Hanover (artist book/catalogue)
The Nature of the Gun: Richard Tuttle,
A/D Gallery, New York

1991
Richard Tuttle: Crickets, Sala d'exposiciones de
la Fundació 'La Caixa', Carrer de Montcada,
Barcelona
Twenty Floor Drawings, Institute of Contem-
porary Art, Amsterdam; as *Time to Do
Everything – Floor Drawings and Recent Work*,
Kunstmuseum Winterthur; as *The Poetry of
Form: Richard Tuttle, Drawings from the Vogel
Collection*, Institut Valencià d'Art Modern,
Valencia; *Twenty Floor Drawings*, Indianapolis
Museum of Art, Indiana; Museum of Fine
Arts, Santa Fe, New Mexico (catalogue)
Richard Tuttle: Oboes and Clarinets, Feuerle,
Cologne

1992
Oxyderood/Red Oxide, Museum Boymans-van
Beuningen, Rotterdam (artist book/catalogue)

1993
Richard Tuttle: Chaos, the Form, Staatliche
Kunsthalle Baden-Baden
Matrix: Richard Tuttle, Space/Sculpture,
University Art Museum, University of
California, Berkeley (booklet)

1994
*Richard Tuttle: A Lamp, a Chair, a Chandelier:
A Work in Process*, A/D Gallery, New York
Discontinuous Space, Burnett Miller Gallery,
Santa Monica, California

1995
Richard Tuttle: Verbal Windows, Galleria
Marilena Bonomo, Bari
North/South Axis, Museum of Fine Arts, Santa
Fe, New Mexico (artist book)
Richard Tuttle, Selected Works: 1964–1994, Sezon
Museum of Art, Tokyo (catalogue)
*Richard Tuttle: Warm Brown, 1–67 and Mesa
Pieces*, Kunsthalle Ritter, Klangenfurt (artist
book/catalogue)

1996
Retrospektiv II: Sol LeWitt und Richard Tuttle,
Annemarie Verna Galerie, Zurich
A Chair, a Table, a Book: Richard Tuttle, Brian
Kish Office for Architecture & Art, New York
(booklet)
Richard Tuttle: Renaissance Unframed 1–26,
Contemporary Art Museum, University
of South Florida, Tampa; University Art
Museum, California State University (booklet)
Richard Tuttle: Replace the Abstract Picture Plane,
Kunsthaus Zug (catalogue)
Richard Tuttle: Books and Prints, Widener Gallery,
Trinity College, Hartford, Connecticut; New
York Public Library (booklet)
Mies van der Rohe Haus, Berlin (catalogue)
Richard Tuttle: Grey Walls Work, Camden Arts
Centre, London; Douglas Hyde Gallery,
Dublin; Inverleith House, Royal Botanical
Garden, Edinburgh (catalogue)

1997
*Projekt Sammlung: Richard Tuttle, Replace the
Abstract Picture Plane, Works 1964–1996*,
Kunsthaus Zug, Switzerland (catalogue as part
of four exhibitions at Kunsthaus Zug)

1998
Richard Tuttle: The Thinking Cap, Fabric
Workshop and Museum, Philadelphia
Agnes Martin/Richard Tuttle, Modern Art
Museum of Fort Worth, Texas; SITE, Santa Fe,
New Mexico (catalogue)
*Richard Tuttle: Replace the Abstract Picture Plane,
Books and New Works, The Kamm Collection
of the Kunsthaus: A Selection by the Artist*,
Kunsthaus Zug (catalogue as part of four
exhibitions at Kunsthaus Zug)
Here and Now: Richard Tuttle, Church of
Saint Paulinus, Brough Park, Catterick,
in collaboration with the Henry Moore
Sculpture Trust
Richard Tuttle: Die Konjunktion der Farbe,
Ludwig Forum für Internationale Kunst,
Aachen

1999
Richard Tuttle: Community, Arts Club of
Chicago, Illinois, USA (artist book/catalogue)
*Projekt Sammlung: Richard Tuttle: Replace the
Abstract Picture Plane (1996–1999)*, Kunsthaus
Zug (catalogue as part of four exhibitions at
Kunsthaus Zug)

2000
Richard Tuttle: Perceived Obstacles, Stiftung
Schleswig-Holsteinische Landesmuseum,
Schloss Gottorf, Schleswig; Westfälisches
Landesmuseum für Kunst und
Kulturgeschichte, Münster; Akademie der
Künste, Berlin (catalogue)
Richard Tuttle: Reservations, BAWAG
Foundation, Vienna (artist book/catalogue)

2001
*Richard Tuttle: Werken op Papier uit de
Verzameling van Museum Overholland/Works
from the Museum Overholland Collection*,
Kabinet Overholland, Stedelijk Museum,
Amsterdam
Richard Tuttle: In Parts, 1998–2001, Institute
of Contemporary Art, University of
Pennsylvania, Philadelphia, USA (artist book/
catalogue)

2002
Richard Tuttle: cENTER, Centro Galego de Arte
Contemporánea, Santiago de Compostela
(catalogue)
Richard Tuttle: Memento, Museu Serralves de
Arte Contemporánea, Porto (catalogue)

2003
Richard Tuttle: Costume, Crown Point Press,
San Francisco (booklet)

2004
Richard Tuttle: Type, Crown Point Press,
San Francisco (booklet)
Richard Tuttle: Dogs in a Hurry, De Kanselarij
(organized by Foundation VHDG),
Leewarden (artist book/catalogue)

Richard Tuttle: It's a Room for 3 People, Drawing
 Center, New York; Aspen Art Museum,
 Colorado (artist book/catalogue)
Beauty-in-Advertising, installation and exhibition
 curated by Richard Tuttle, Wolfsonian-Florida
 International University, Miami

2005
The Art of Richard Tuttle, San Francisco Museum
 of Modern Art, California, USA; Whitney
 Museum of American Art, New York; Des
 Moines Art Center, Indiana; Dallas Museum
 of Art, Texas; Museum of Contemporary Art,
 Chicago; Museum of Contemporary Art, Los
 Angeles (catalogue)
Richard Tuttle: Wire Pieces, CAPC Musée d'art
 contemporain, Bordeaux (catalogue)

2006
Unfold, FRAC, Auvergne; Domaine de
 Kerguehennec, Bignan; FRAC, Haute
 Normandie, Sotteville les Rouen (catalogue)
Richard Tuttle: Half-Light Alphabet, Galerie
 Ulrike Schmela, Düsseldorf, Germany and
 Galerie Lena Bruning, Berlin, Germany
 (catalogue)

2008
Richard Tuttle: The Use of Time, Kunsthaus Zug
Richard Tuttle: Craft, Annemarie Verna Gallery,
 Zurich

2009
Richard Tuttle: Walking on Air, Pace Wildenstein,
 New York
Richard Tuttle: L'nger than Life, Stuart Shave/
 Modern Art, London

2010
Richard Tuttle: Triumphs, Dublin City Gallery,
 The Hugh Lane (catalogue)

2012
Richard Tuttle: Systems, VIII–XII, Pace Gallery,
 New York (catalogue)
Hello The Roses, with Mei-mei Berssenbrugge,
 Kunstverein Munich
*Richard Tuttle: Werke aus Münchner
 Privatsammlungen*, Pinakothek Munich
Richard Tuttle: Slide, Bergen Kunsthall

2013
*The Thrill of the Ideal: Richard Tuttle; The
 Reinhart Project*, Pocket Utopia, New York
Walking in Air: An Exhibition by Richard Tuttle,
 TAI Gallery, Santa Fe, New Mexico
Richard Tuttle: Matter, Marian Goodman
 Gallery, Paris

2014
Richard Tuttle: Looking for the Map, Pace Gallery,
 New York
Richard Tuttle: A Print Retrospective, Bowdoin
 College Museum of Art, Brunswick, ME

Selected group exhibitions

1965
*The Seventh Selection of the Society for the
 Encouragement of Contemporary Art: A New
 York Collector Selects*, San Francisco Museum
 of Arts

1966
2e Salon International de Galeries Pilates, Musée
 cantonal des Beaux-Arts, Palais de Rumine,
 Lausanne (catalogue)
Twentieth Anniversary, 1946–1966: Pattern Art,
 Betty Parsons Gallery, New York (booklet)

1968
Painting: Out from the Wall, Des Moines Art
 Center, Indiana (catalogue)
Anti-Form, John Gibson Gallery, New York
Some Younger American Painters and Sculptors,
 organised by the American Federation of the
 Arts, New York

1969
*When Attitudes Become Form: Works–Concepts–
 Processes–Situations–Information*, Kunsthalle
 Bern; Museum Haus Lange, Krefeld; Institute
 of Contemporary Arts, London (catalogue)
Anti-Illusion: Procedures/Materials, Whitney
 Museum of American Art, New York
 (catalogue)
Other Ideas, Detroit Institute of the Arts, MI

1970
Using Walls (Indoors), Jewish Museum, New York
 (catalogue)
Paperworks, Art Lending Services, Penthouse
 Gallery, The Museum of Modern Art,
 New York

1972
Amerikanische Graphik seit 1960, Bünder
 Kunsthaus, Chur; Kunstverein Solothurn;
 Musée d'art et d'historie, Geneva; Kunsthaus
 Aarau; Kunsthalle Basel (catalogue)
*Documenta 5: Befragung der Realität, Bildwelten
 heute*, Museum Fridericianum, Kassel
 (catalogue)
Book as Artwork 1960/72, Nigel Greenwood Inc.
 Ltd, London (catalogue)
[Drawing], The Museum of Modern Art, Oxford
 (booklet)

1973
Bilder, Objekte, Filme, Konzepte, Städtische
 Galerie im Lenbachhaus, Munich (catalogue)
*Options and Alternatives: Some Directions in
 Recent Art*, Yale University Art Gallery, New
 Haven, Connecticut (catalogue)

1974
Line as Language: Six Artists Draw, Art Museum,
 Princeton University, New Jersey (catalogue)
Printed, Cut, Folded and Torn, Museum of
 Modern Art, New York
Painting and Sculpture Today, 1974,
 Contemporary Art Society of the Indianapolis
 Museum of Art, Indiana; Contemporary
 Arts Center and Taft Museum, Cincinnati
 (catalogue)

1975
*Mel Bochner, Barry Le Va, Dorothea Rockburne,
 Richard Tuttle*, Contemporary Arts Center,
 Cincinnati (catalogue)
Color, organised by the International Council
 of The Museum of Modern Art, New York;
 Museo de Arte Moderno, Bogotá; Museo de
 Arte de São Paulo; Museu de Arte Moderna,
 Rio de Janeiro; Museo de Bellas Artes,
 Caracas; Museo de Arte Moderno, Mexico
 City
The Small Scale in Contemporary Art, Society for
 Contemporary Art and the Art Institute of
 Chicago, Illinois
*Painting, Drawing, and Sculpture of the '60s
 and '70s from the Dorothy and Herbert Vogel
 Collection*, Institute of Contemporary Art,
 University of Pennsylvania; Contemporary
 Arts Center, Cincinnati (catalogue)

1976
The Book as Art, Fendrick Gallery, Washington,
 DC (booklet)
Drawing Now, Museum of Modern Art,
 New York; Kunsthalle Basel; Kunsthaus
 Zurich; Staatliche Kunsthalle Baden-Baden;
 Graphische Sammlung Albertina, Vienna;
 Sonja Henie-Niels Onstad Museum, Oslo;
 Tel Aviv Museum (catalogue)
Line, Visual Arts Museum, New York;
 Philadelphia College of Art, Pennsylvania
 (booklet)
Critical Perspectives in American Art, Fine Arts
 Center Gallery, University of Massachusetts,
 Amherst; *37th La Biennale di Venezia*, United
 States Pavilion, Venice
Rooms, P.S. 1, Institute for Art and Urban
 Resources, Long Island City, New York
 (catalogue)
American Artists: A New Decade, Detroit Institute
 of Arts, Michigan; Fort Worth Art Museum,
 Texas; Grand Rapids Art Museum, Michigan
 (catalogue)
Artists' Books, organised by the Arts Council of
 Great Britain (catalogue)

1977
1977 Biennial Exhibition, Whitney Museum of
 American Art, New York (catalogue)
Documenta 6, Orangerie, Kassel (catalogue)
A View of a Decade, Museum of Contemporary
 Art, Chicago (catalogue)
Small Objects, Whitney Museum of American
 Art, Downtown Branch, New York

1978
Sol LeWitt, Richard Long, Richard Tuttle,
 Yale School of Art, New Haven, CT
Door beeldhouwer gemaakt/Made by Sculptors,
 Stedelijk Museum, Amsterdam (catalogue)

1979
Material Pleasures: The Fabric Workshop at ICA,
 Institute of Contemporary Art, University of
 Pennsylvania (catalogue)
*American Abstract Artists: The Language of
 Abstraction*, Betty Parsons Gallery and Marilyn
 Pearl Gallery, New York (catalogue)

1980
Art/Book/Art, organised by Detroit Institute of
 Arts, Michigan; Slusser Gallery, University
 of Michigan, Ann Arbor, Michigan; Mid-
 Michigan Community College, Harrison,
 Michigan; Urban Institute for Contemporary
 Art, Grand Rapids, Michigan; Willard Library,
 Battle Creek, Michigan; Ella Sharp Museum,
 Jackson, Michigan (catalogue)
Printed Art: A View of Two Decades, Museum of
 Modern Art, New York (catalogue)
*Pier + Ocean: Construction in the Art of the
 Seventies*, Hayward Gallery, London;
*Maximum Coverage: Wearables by Contemporary
 American Artists*, John Michael Kohler Arts
 Center, Sheboygan, WI; University of North
 Dakota, Grand Forks (catalogue)
Drawn in Space, Washington Project for the
 Arts, Washington, DC (booklet)

1981
New Works of Contemporary Art and Music,
 Fruitmarket Gallery, Edinburgh (catalogue)
*Relief(s): Richard Tuttle, Nancy Bowen, Don
 Hazlitt*, Institut Franco-Américain, Rennes
 (booklet)
No Title: The Collection of Sol LeWitt, Wesleyan
 University Art Gallery and Davidson Art
 Center, Middleton, CT (catalogue)
Amerikanische Malerei: 1930–1980, Haus der
 Kunst, Munich (catalogue)
*Art Materialized: Selections from the Fabric
 Workshop*, organised by Independent Curators
 Incorporated, New York; New Gallery for
 Contemporary Art, Cleveland, Ohio; Gibbes
 Art Gallery, Charleston, South Carolina;
 Hudson River Museum, New York; University
 of South Florida Art Galleries, Tampa; Art
 Museum and Galleries, California State
 University, Long Beach; Alberta College of Art
 Gallery, Calgary; Pensacola Museum of Art,
 Florida (catalogue)
Murs, Centre National d'art et de culture
 Georges Pompidou, Musée national d'art
 moderne, Paris (catalogue)

1982
Du livre, Musée des Beaux-Arts, Rouen, France;
 Bibliothèque Minicipale, Rouen; Galerie
 Déclinaisons, Rouen; École des Beaux-Arts,
 Rouen, France; CRDP, Mont-Saint-Aignan
 (Booklet)
'60–'80: Attitudes/Concepts/Images, Stedelijk
 Museum, Amsterdam, (catalogue)
Documenta 7, Museum Fridericianum, Kassel
 (catalogue)

1983
Abstract Painting: 1960–1969, P.S. 1, Institute for
 Art and Urban Resources, New York
When Art Becomes Book, When Books Become Art,
 Annemarie Verna Galerie, Zurich
*10 Jahre Kunstraum München,
 Jubiläumsausstellung*, Kunstraum München,
 Munich

1984
Painting and Sculpture Today, 1984, Indianapolis
 Museum of Art, Indiana (booklet)
*Zeichnungen für die dritte Dimension (eigene
 Bestände)*, Basel Museum für Gegenwartskunst
Aquarelle, Kasseler Kunstverein, Kassel
 (catalogue)

1985
Dan Flavin, Morris Louis, Brice Marden, Richard Serra, Richard Tuttle: Neue Daierleihgaben aus der Sammlung Reinhard Onnach, Berlin, Städtisches Museum Abteiberg, Mönchengladbach
Affiliations: Recent Sculpture and Its Antecedents, Whitney Museum of American Art, Fairfield County, Stamford, Connecticut (booklet)
Spuren, Skulpturen und Monumente ihrer präzisen Reise, Kunsthaus Zurich (catalogue)
Correspondences: New York Art Now, Laforet Museum Harajuku, Tokyo; Tochigi Prefectural Museum of Fine Arts (catalogue)

1987
Skulptur Projekte in Münster 1987, Westfälische Landesmuseum, Münster (catalogue)
Sculptors on Paper: New Work, Madison Art Center, Wisconsin; Pittsburgh Center for the Arts, Pennsylvania; Kalamazoo Institute of Arts, Michigan; Sheldon Memorial Art Gallery, University of Nebraska, Lincoln (catalogue)

1988
Black and White, Fabric Workshop, Philadelphia

1989
Rain of Talent: Umbrella Art, Fabric Workshop and Museum, Philadelphia
The Library, A/D Gallery, New York

1990
Contemporary Illustrated Books: Word and Image, 1967–1988, Franklin Furnace Archive, New York; Nelson-Atkins Museum of Art, Kansas City, Missouri; University of Iowa Museum of Art, Iowa City (catalogue)
Concept Art, Minimal Art, Arte Povera, Land Art: Sammlung Marzona, Kunsthalle Bielefeld (catalogue)
The New Sculpture 1965–75: Between Geometry and Gesture, Whitney Museum of American Art, New York; Museum of Contemporary Art, Los Angeles (catalogue)

1991
Poets/Painters Collaborations, Brooke Alexander, New York
Den Gedanken auf der Spur blieben, Museum Haus Lange and Museum Haus Esters, Krefeld

1993
The Contemporary Artist's Book: The Book as Art, 871 Fine Arts, San Francisco

1994
Western Artists/African Art, Museum for African Art, New York (catalogue)
Ethereal Materialism, Apex Art, New York

1995
52nd Carnegie International, Carnegie Museum of Art, Pittsburgh (catalogue)

1997
La Biennale di Venezia, 47th Esposizione Internazionale d'Arte, Venice (catalogue)
Papierskulptur, Oberösterreichisches Landsmuseum, Landsgalerie Linz (catalogue)

At the Threshold of the Visible: Minuscule and Small-Scale Art, 1964–1996, Herbert F. Johnson Museum of Art, Cornell University, Ithaca, New York; Meyerhoff Galleries, Maryland Institute of Art, Baltimore; Art Gallery of Ontario, Toronto; Art Gallery of Windsor, Ontario; Virginia Beach Center for the Arts, Virginia; Santa Monica Museum of Art, California; Edmonton Art Gallery, Alberta; Center on Contemporary Art, Seattle (catalogue)

1998
Spatiotemporal, Magasin 3 Stockholm Konsthall (catalogue)

1999
twistfoldlayerflake, Institute for Contemporary Arts, California College of Arts and Crafts, Oakland
Afterimage: Drawing through Process, Museum of Contemporary Art, Los Angeles; Contemporary Arts Museum, Houston; Henry Art Gallery, Seattle (catalogue)
Size Immaterial, Department of Coins and Medals, British Museum, London

2000
The Contemporary Illustrated Book: A Collaboration Between Artist and Author, 1960 to the Present, Garcia Street Books, Santa Fe, New Mexico
Horizon 2000: Artist Woodturners, Brookfield Craft Center, New York

2001
Objective Color, Yale University Art Gallery, New Haven, Connecticut
Poetry Plastique, Marianne Boesky Gallery, New York (catalogue)
La Biennale di Venezia: Plateau of Humankind, Venice (catalogue)
Tramas y Ensamblajas, Museo de Arte Contemporaneo de Oaxaca (catalogue)
Extra Art: A Survey of Artists' Ephemera, 1960–1999, Logan Galleries, California College of the Arts, San Francisco; Institute of Contemporary Art, London (catalogue)
A Century of Drawing: Works on Paper from Degas to LeWitt, National Gallery of Art, Washington, DC (catalogue)

2003
Primary Matters: The Minimalist Sensibility, 1959 to the Present, San Francisco Museum of Modern Art, California

2004
Indonesian Textiles, Tai Gallery/Textile Arts, Santa Fe, New Mexico (catalogue; curated by Richard Tuttle)
Artists' Books: No Reading Required, Selections from the Walker Art Center Library Collection, Tribune Gallery, Minnesota Center for Book Arts, Minneapolis
Design ≠ Art: Functional Objects from Donald Judd to Rachel Whiteread, Cooper Hewitt National Design Museum, New York; Museum of Design, Atlanta, Georgia; Aspen Art Museum, Colorado (catalogue)

2005
Looking at Words: The Formal Presence of Text in Modern and Contemporary Works on Paper, Andrea Rosen Gallery, New York

2006
The Mediated Gesture, Brooke Alexander Editions and Leo Castelli Gallery, New York

2008
Styrofoam, The Museum of Art, Rhode Island School of Design, Providence, Rhode Island (booklet)
Action/Abstraction: Pollock, De Kooning, and American Art, 1940–1976, The Jewish Museum, New York (catalogue)

2009
The Third Mind: American Artists Contemplate Asia, 1860–1989, The Solomon R. Guggenheim Museum, New York (catalogue)
Unfolding Process: Conceptual and Material Practice on Paper, The Herbert F. Johnson Museum of Art, Cornell University, Ithaca, New York (catalogue)
Target Practice: Painting Under Attack 1949–78, Seattle Art Museum, Washington (catalogue)

2010
On-Line: Drawing through the Twentieth Century, Museum of Modern Art, New York (catalogue)

2011
Fabric as Form, Tilton Gallery, New York
The Language of Less (Then), Museum of Contemporary Art, Chicago
Painting Show, Eastside Projects, Birmingham

2012
Lines of Thought, Parasol Unit, London
Tracing the Century: Drawing from Tate Collection, Tate Liverpool

2013
When Attitudes Become Form: Bern 1969/Venice 2013, Ca' Corner della Regina, Fondazione Prada, Venice (catalogue)

2014
From Picasso to Sol LeWitt: The Artist's Book since 1950, Museum Meermanno, The Hague

Select Bibliography

Sparrow, Richard Tuttle, New York, 1965

Story with Seven Characters, Richard Tuttle, New York, 1965

Richard Tuttle, Constructed Paintings, Betty Parsons Gallery, New York, 1965

Two Books, 2 vols, Galerie Rudolph Zwirner, Cologne, and Betty Parsons Gallery, New York, 1969

Stacked Color Drawings 1971, Brooke Alexander, New York, 1974

Interlude: Kinesthetic Drawings, Brooke Alexander, New York, 1974

Book, Paul Bianchini Books, Editions des Massons, Lausanne, and Yvon Lambert, Paris, 1974

Poems Larry Fagin, Drawings Richard Tuttle, Topia Press, Bradford, NY, 1977

Five by Seven for Yvon Lambert. A Study of 45°, Color, 5″ × 7″ Rectangle and Corrugated Cardboard. Nine Works by Richard Tuttle, Yvon Lambert, Paris, 1978

Zwei mit Zwei. Two with Any Two, Heiner Friedrich, Munich, Brooke Alexander, New York, 1977

Richard Tuttle: Title 1–6, Title I–IV, Title A–N, Title I1–I6, Titre 1–8, Titolo 1–8, exh. cat., Stedelijk Museum, Amsterdam, 1979

Double Page nr. 5, Galerie Annemarie Verna, Zurich, 1979

Book for Nigel Greenwood, Artforum Vol. XX, no. 10, 1982

A Drawing Book, Galerie Hubert Winter, Vienna, 1983

Richard Tuttle. Δs: Works 1964–1985/Two Pinwheels: Works 1964–1985, exh. cat., Institute of Contemporary Art, London, and Fruitmarket Gallery, Edinburgh, 1985

Richard Tuttle, exh. cat., Städtisches Museum Abteiberg, Mönchengladbach, 1985

Neve, exh. cat., Galleria Marilena Bonomo, Bari, 1985

Richard Tuttle, le bonheur et la couleur, exh. cat., CAPC Musée d'art contemporain de Bordeaux, Bordeaux, 1986

Richard Tuttle, Palpa, Victoria Miro, London, 1987

Richard Tuttle: Nimes au printemps, exh. cat., Galerie des Arênes, Carré d'Art/Musée d'Art Contemporain, Nimes, 1987

Richard Tuttle: The Baroque and Colour/Das Barocke und die Farbe, exh. cat., Neue Galerie am Landesmuseum Joanneum, Graz, 1987

Loophole, with text by Simon Cutts, Victoria Miro Gallery, London, 1987

Hiddenness, with text by Mei-mei Berssenbrugge, Library Fellows of the Whitney Museum of American Art, New York, 1987

Richard Tuttle: XX Blocks, exh. cat., Galleria Marilena Bonomo, Bari, 1988

Richard Tuttle: Space in Finland, exh. cat., Galerie Schmela, Düsseldorf, 1988

Richard Tuttle: Portland Works 1976, exh. cat., Galerie Kartsen Greve, Cologne, and Thomas Segal Gallery, Boston, 1988

Richard Tuttle: Point from the Corner of the Room, 1973–74, Galerie Hubert Winter, Vienna, 1988

40 Tage/Zeichnungen: Mit Einem Text des Künstlers, Galerie Erhard Klein, Bonn, and Galerie Hubert Winter, Vienna, 1989

Richard Tuttle, Einleitung, Galerie Schmela, Düsseldorf 1990

Richard Tuttle: Lonesome Cowboy Styrofoam, Blum Helman Gallery, New York, and Gallery Casa Sin Nombre, Santa Fe, 1990

Richard Tuttle, box with four books and one object, exh. cat., Sprengel Museum Hannover, Hanover, 1990

Richard Tuttle, exh. cat., Sprengel Museum Hannover, Hanover, 1990

Richard Tuttle: Two Chairs, two Benches and a table, Galleria Victoria Miro, Florence, A/D, New York, 1990

Octavo for Annemarie, Annemarie Verna Galerie, Zurich, 1990

Eight Words from a Reading at Brooklyn College, Galleria Victoria Miro, Florence, 1990

Richard Tuttle: Twenty Floor Drawings, ICA, Amsterdam, 1991

Poem in the Corner No. 1, ICA, Amsterdam, 1991

Richard Tuttle: Crickets, exh. cat., Fundació 'la Caixa', Barcelona, 1991

The Altos, with text by Barbara Guest, Hine Editions/Limestone Press, San Francisco, 1991

Early Auden, text fragments Hine Editions, San Francisco, 1991

Plastic History, Wassermann Editions, Munich, 1991

The Poetry of Form: Richard Tuttle, Drawings from the Vogel Collection, exh. cat., Institute of Contemporary Art, Amsterdam, and Institut Valencià d'Art Modern, Valencia, 1992

Oxyderood/Red Oxide, exh. cat., Museum Boymans-van Beuningen, Rotterdam 1992

Charge to Exist, Kunstmuseum Winterthur, Winterthur, 1992

Sphericity, Mei-mei Berssenbrugge, Poems; Richard Tuttle, Drawings, Kelsey Street Press, Berkeley, 1993

Richard Tuttle: Book and Cover, Laura Carpenter Fine Art, Inc., Santa Fe, New Mexico, 1993

Chaos, the Form, Kunsthalle Baden-Baden, Baden-Baden, 1993

Folded Space, Limestone Press, University Art Museum and Pacific Film Archive, Berkeley, California, 1993

The Gyres: Source of Imagery, with text by W.B. Yeats, Kaldewey Press, Poestenkill, 1995

Richard Tuttle: Warm Brown, 1–67 and Mesa Pieces, Kärtner Landesgalerie, Klagenfurt, 1995

Checklist for North/South Axis, Museum of Fine Arts, Santa Fe, 1995

Pamphlet, 1995, Kohn Turner Gallery, Los Angeles, 1995

Proposal for Work in Das Kunsthaus Zug by Richard Tuttle, Kunsthaus Zug, Zug, 1995

Richard Tuttle. Selected Works: 1964–1994, exh. cat., Sezon Museum of Art, Tokyo, 1995

Painted Frames, for Alma Ruempol, Wassermann Edition, Munich, 1995

Richard Tuttle: Grey Walls Work, exh. cat., Camden Arts Centre, London, 1996

Richard Tuttle, Books and Prints, New York Public Library, New York and Trinity College, Hartford, 1996

I Thought I Was Going on a Trip But I Was Only Going Down Stairs, Art Gallery of York University, Ontario, 1997

Richard Tuttle: Small Sculptures of the 70's, Annemarie Verna Galerie, Zurich, 1998

Reading Red: Richard Tuttle, with text by Charles Bernstein and Wolfgang Becker, Verlag der Buchhandlung Walther König, Cologne, 1998

Four Year Old Girl, with text by Mei-mei Berssenbrugge, Kelsey St. Press, Berkeley, 1998

Richard Tuttle: Community, exh. cat., Arts Club of Chicago,1999

Richard Tuttle, One Voice in Four Parts, Edition Kaldewey, New York, and Printed Matter, New York, 1999

Richard Tuttle: Reservations, exh. cat., BAWAG Foundation, Vienna, 2000

Richard Tuttle: Perceived Obstacles, exh. cat., Verlag der Buchhandlung Walther König, Cologne, 2000

Open Carefully, Sperone Westwater, New York, 2000

Richard Tuttle: In Parts, 1998–2001, exh. cat., Institute of Contemporary Art, Philadelphia, 2001

White Sails, with text by Ilma Rakusa, Annemarie Verna Galerie, Zurich, 2001

Richard Tuttle, Replace the Abstract Picture Plane, Kunsthaus Zug, Zug, 2001

Richard Tuttle, exh. cat., Galerie Schmela, Düsseldorf, 2002

Cowboy Story, with drawings by Heather Deedman, text by Richard Tuttle and audio CD by Zoe Irvine, Morning Star/Baltic Centre for Contemporary Art, Gateshead, 2002

Celebration, Annemarie Verna Galerie, Zurich, 2003

Additional Handwriting supplied by Richard Tuttle, Esopus Magazine, 2003

Indonesian Textiles, Tai Gallery/Textile Arts, Santa Fe, 2004

L'EXCES: cette mesure, poems by Anne-Marie Albiach, Yvon Lambert, Paris, 2004

Color as Language, Drawing Center, New York, 2004

The Art of Richard Tuttle, ed. Madeleine Grynsztejn, exh. cat., San Francisco Museum of Modern Art, San Francisco, 2005

Richard Tuttle: Manifesto, Drawing Papers 49, Drawing Center, New York, 2005–6

The Kreutzer Sonata: Historical Work by Richard Tuttle, Nyehaus and Zwirner & Wirth, New York, 2005–6

Differentiation and Service, Annemarie Verna Galerie, Zurich, 2007

NotThePoint, Ivorypress, London, 2008

Unfold, Frac Haute Normandie, Frac Auvergne, Frac Domaine de Kerguéhennec, Bignan, 2008

Half-Light Alphabet, Galerie Ulrike Schmela, Düsseldorf, Galerie Lena Brüning, Berlin, 2008. (Attached to Unfold by a magnet)

Dogs in a Hurry, Green Paper Press, Leeuwarden, 2009

8 Poems, Richard Tuttle, University at Buffalo Art Galleries, State University of New York, Buffalo, 2011

Systems, I–XII, (four "separate pokers"), exh. cat., sequence of 15 poems, *Fashion all her Life*, by Richard Tuttle, Pace Gallery, New York, 2012

The Thrill of the Ideal, C.G. Boerner and Pocket Utopia New York, 2013

Agnes Martin, Religion of Love, Richard Tuttle, Illustration, Walther König Verlag, Cologne, 2014

Space in the Window, Tomio Koyama Gallery, Kyoto, 2014

Richard Tuttle, *Making Silver*, exh. cat., Bergen Kunsthall, Bergen, 2014

Whitechapel Gallery Supporters

The Whitechapel Gallery would like to thank its supporters, whose generosity enables the Gallery to realise its pioneering programmes.

EXHIBITION PROGRAMME SUPPORTERS
Dilyara Allakhverdova
Shane Akeroyd
The Ampersand Foundation
Heidi Baravalle
Nicholas Berwin Charitable Trust
Brian Boylan
Peter Blum Gallery
Beth and Michele Colocci
Contemporary Arts Society
Galleria Continua
Danish Arts Council Committee for
 International Visual Arts
Galerie Nagel Draxler
Sarah Elson
Ernst von Siemens Kunststiftung
The Edwin Fox Foundation
Lisa and Brian Garrison
Belinda de Gaudemar
Boris Hirmas
Hiscox
Leili Huth and Reza Afshar Kharaghan
Institut Français
David Knaus
Galerie Krinzinger
Lisson Gallery
Marian Goodman Gallery
Embassy of Mexico in the United Kingdom
The Henry Moore Foundation
Anne Mosseri-Marlio Galerie
Mourad Mazouz
Valeria Napoleone
NEON
Fayeeza and Arif Naqvi
Outset Contemporary Art Fund
Maureen Paley
Catherine and Franck Petitgas
Royal Norwegian Embassy in London
SAHA, Istanbul
Maria and Malek Sukkar
Embassy of the United States in the
 United Kingdom
Louis Vuitton
Wingate Scholarships
George and Patti White
and those who wish to remain anonymous

PUBLIC EVENTS PROGRAMME
Fondazione Giulio e Anne Paolini
Pictet & Cie
Stanley Picker Trust

EDUCATION PROGRAMME
Stavros Niarchos Foundation
Aldgate and Allhallows Foundation
ICE Futures
The Grocers' Charity
London Borough of Tower Hamlets
The Trusthouse Charitable Foundation
D'Oyly Carte Charitable Trust
Bawden Fund

Embassy of the Kingdom of the Netherlands
NADFAS
Mrs Gillian Eeley

TRAINEESHIP PROGRAMME
Heritage Lottery Fund

TRANSPORT PARTNER
Martinspeed

FRAMING PARTNER
John Jones

WHITECHAPEL GALLERY CORPORATE PATRONS
Berkeley
Max Mara
Swarovski
Withers LLP

FUTURE FUND FOUNDING PARTNERS
Mr Dimitris Daskalopoulos
NEON
Maryam and Edward Eisler
Arts Council England Catalyst Endowment
 Fund

FUTURE FUND SUPPORTERS
Swantje Conrad

CAPITAL IMPROVEMENT SUPPORTERS
The Ruth & Stuart Lipton Charitable Trust

WHITECHAPEL GALLERY DIRECTOR'S CIRCLE
Ivor Braka
Aud and Paolo Cuniberti
D. Daskalopoulos Collection, Greece
Joseph and Marie Donnelly
Maryam and Edward Eisler
Peter and Maria Kellner
Catherine and Franck Petitgas
Charlotte Philipps
Muriel and Freddy Salem
Anita and Poju Zabludowicz
and those who wish to remain anonymous

WHITECHAPEL GALLERY CURATOR'S CIRCLE
Erin Bell and Michael Cohen
Nicholas Berwin Charitable Trust
Ida Levine
Adrian and Jennifer O'Carroll
Jonathan Tyler
and those who wish to remain anonymous

WHITECHAPEL GALLERY PATRONS
Ursula and Ray van Almsick
Malgosia Alterman
Vanessa Arelle
Charlotte and Alan Artus
Hugo Brown
Beverley Buckingham
Ed Burstell
Sadie Coles HQ
Swantje Conrad
Alastair Cookson
Donall Curtin
Miel de Botton
Maria de Madariaga
Dunnett Craven Ltd
Jeff and Jennifer Eldredge
Sarah Elson
Alan and Joanna Gemes

Richard and Judith Greer
Isabelle Hotimsky
Amrita Jhaveri
Sigrid Kirk
Anna Lapshina
Victor and Anne Lewis
Keir McGuinness
Scott Mead
Jon and Amanda Moore
Bozena Nelhams
Genie Oldenburg
Maureen Paley
Dominic Palfreyman
Jasmin Pelham
Mariela Pissioti
The Porter Foundation
Lauren Prakke
Alice Rawsthorn
Jon Ridgway
Alex Sainsbury and Elinor Jansz
Ian and Cherrill Sheer
Kaveh and Cora Sheibani
Karen and Mark Smith
Bina and Philippe von Stauffenberg
Hugh and Catherine Stevenson
Tom Symes
Helen Thorpe (The Helen Randag
 Charitable Foundation)
Mr and Mrs Christoph Trestler
Audrey Wallrock
Kevin Walters
Susan Whiteley
and those who wish to remain anonymous

**THE AMERICAN FRIENDS OF THE
WHITECHAPEL GALLERY**
Dick and Betsy DeVos Family Foundation
Ambassador and Mrs Louis B Susman
and those who wish to remain anonymous

WHITECHAPEL GALLERY FIRST FUTURES
Cristian Albu
Sharifa Alsudairi
Katharine Arnold
Maria Arones
John L. Auerbach
Edouard Benveniste-Schuler
Fiorina Benveniste-Schuler
Natalia Blaskovicova
Livia Carpeggiani
Ingrid Chen
Bianca Chu
Nathaniel Clark
Tom Cole
Jonathan Crockett
Celia Davidson
Stéphanie de Preux Dominicé
Alessandro Diotallevi
Michelle D'Souza
Will Elliott
Christopher Fields and Brendan Olley
Laura Ghazzaoui
Lawrence van Hagen
Asli Hatipoglu
Constantin Hemmerle
Carolyn Hodler
Katherine Holmgren
Sophie Kainradl
Zoe Karafylakis Sperling
Deborah Kattan
Tamila Kerimova

Benjamin Khalili
Rasha Khawaja
Madeleine Kramer
Frank Krikhaar
Aliki Lampropoulos
Alexandra Lefort
Arianne Levene Piper
Georgina Lewis
Alex Logsdail
Julia Magee
Kristina McLean
Janna Miller
Gloria Monfrini
Indi Oliver
Yuki Oshima Wilpon
Katharina Ottmann
Juan Pepa
Josephine von Perfall
Alexander V Petalas
Hannah Philp
Patricia Pratas
Maria Cruz Rashidan
Eugenio Re Rebaudengo
Daniela Sanchez
Paola Saracino Fendi
Elisabeth von Schwarzkopf
Silvia Sgualdini
Henrietta Shields
Marie-Anya Shriro
Max Silver
Yassi Sohrabi
Alexander Stamatiadis
Roxana Sursock Karam
Gerald Tan
Edward Tang
Julia Tarasyuk
Billal Taright
Nayrouz Tatanaki
Abdullah Al Turki
Giacomo Vigliar
Alexandra Werner
Rosanna Widen
and those who wish to remain anonymous

WHITECHAPEL GALLERY ASSOCIATES
Ariane Braillard and Francesco Cincotta
John and Christina Chandris
Christian Erlandson and Reagan Kiser
Lyn Fuss
Crane Kalman Gallery
David Killick
Laetitia Lina
John Newbigin
Chandrakant Patel
Fozia Rizvi
Fabio Rossi and Elaine W Ng
David Ryder
Karsten Schubert
and those who wish to remain anonymous

We remain grateful for the ongoing support of Whitechapel Gallery Members and Arts Council England

Tate Modern Benefactors and Major Donors

Tate relies on a large number of supporters – individuals, foundations, companies and public sector sources – to enable it to deliver its programme of activities, both on and off its gallery sites. We would like to acknowledge and thank the following benefactors who have supported Tate Modern prior to June 2014:

29th May 1961 Charitable Trust
Sirine and Ahmad Abu Ghazaleh
Carolyn Alexander
The Ampersand Foundation
Gregory Annenberg Weingarten and the Annenberg Foundation
Art Fund
Art Mentor Foundation Lucerne
Arts Council England
Arts & Humanities Research Council
Artworkers Retirement Society
Charles Asprey
Marwan T Assaf
averda
Gillian Ayres
John Baldessari
Abigail and Joseph Baratta
The Estate of Peter and Caroline Barker-Mill
The Barker-Mill Foundation
The Barns-Graham Charitable Trust
Veronica and Jeffrey Berman
Rosamond Bernier
Anne Best
Big Lottery Fund
Billstone Foundation
Blavatnik Family Foundation
The Charlotte Bonham-Carter Charitable Trust
Pontus Bonnier
Lauren and Mark Booth
Charles Booth-Clibborn
John C Botts, CBE
Louise Bourgeois
Frances Bowes
Frank Bowling, Rachel Scott, Benjamin and Sacha Bowling, Marcia and Iona Scott
Sir Alan and Sarah Bowness
Bowness, Hepworth Estate
Pierre Brahm
The Estate of Dr Marcella Louis Brenner
The Deborah Loeb Brice Foundation
British Council
The Broad Art Foundation
Elizabeth and Rory Brooks
The Lord Browne of Madingley, FRS, FREng
Lucy Carter
John and Christina Chandris
James Chanos
The Trustees of the Chantrey Bequest
Henry Christensen III
Clore Duffield Foundation
The Clothworkers' Foundation
R and S Cohen Foundation
Robert T. Coffland
Steven Cohen
Contemporary Art Society
Paul Cooke
Isabelle and John Corbani
Douglas S Cramer

Alan Cristea Gallery
Bilge Ogut-Cumbusyan and Haro Cumbusyan
Thomas Dane Ltd
D.Daskalopoulos Collection
The Roger De Haan Charitable Trust
Ago Demirdjian and Tiqui Atencio Demirdjian
Department for Business, Innovation and Skills
Department for Culture, Media and Sport
Department for Education
James Diner
Anthony and Anne d'Offay
Peter Doig
Jeanne Donovan Fisher
Jytte Dresing, The Merla Art Foundation, Dresing Collection
George Economou
EDP – Energias de Portugal, S.A.
Maryam and Edward Eisler
The John Ellerman Foundation
Ibrahim El-Salahi
Carla Emil and Rich Silverstein
European Commission
Christopher Eykyn and Nicholas Maclean
Esmée Fairbairn Collections Fund
Fares and Tania Fares
The Estate of Maurice Farquharson
HRH Princess Firyal of Jordan
The Fisher Family
Jeanne Fisher
Wendy Fisher
Dr Kira and Neil Flanzraich
Eric and Louise Franck
Jay Franke and David Herro
Froehlich Foundation, Stuttgart
Glenn and Amanda Fuhrman
Gagosian Gallery
Mala Gaonkar
Johanna and Leslie J. Garfield
The Getty Foundation
The Ghandehari Foundation
Thomas Gibson
Liam Gillick
Milly and Arne Glimcher
Goethe-Institut
Nicholas and Judith Goodison
Marian Goodman Gallery
Douglas Gordon and Artangel
Lydia and Manfred Gorvy
Noam Gottesman
The Granville-Grossman Bequest
Sarah and Gerard Griffin
Konstantin Grigorishin
Guaranty Trust Bank Plc
Calouste Gulbenkian Foundation
The Haberdashers' Company
The Estate of Mr John Haggart
Paul Hamlyn Foundation
Viscount and Viscountess Hampden and Family
Noriyuki Haraguchi
Hauser & Wirth
The Hayden Family Foundation
Heritage Lottery Fund
Friends of Heritage Preservation
Mauro Herlitzka
Damien Hirst
David Hockney
The Estate of Mrs Mimi Hodgkin
Karin und Uwe Hollweg Stiftung
Vicky Hughes and John A Smith
Leili Huth and Reza Afshar Kharaghan

Iran Heritage Foundation
Amrita Jhaveri
Karpidas Family
Peter and Maria Kellner
J. Patrick Kennedy and Patricia A. Kennedy
Bharti Kher
Jack Kirkland
Anne Simone Kleinman and Thomas Wong
Madeleine Kleinwort
Leon Kossoff
Tomio Koyama Gallery
The Kreitman Foundation
Samuel H. Kress Foundation, administered by the Foundation of the American Institute for Conservation
Anselm Kuhn
Andreas Kurtz
Catherine Lagrange
Pierre Lagrange
Kirby Laing Foundation
The Estate of Jay and Fran Landesman
David and Amanda Leathers
The Leathersellers' Company Charitable Fund
Agnès and Edward Lee
Legacy Trust UK
The Leverhulme Trust
Gemma Levine
London Organising Committee of the Olympic Games and Paralympic Games
The Henry Luce Foundation
LUMA Foundation
Allison and Howard W. Lutnick
The Estate of Sir Edwin Manton
The Manton Foundation
Donald B. Marron
Fernanda Feitosa and Heitor Martins
Lord McAlpine of West Green
Fergus McCaffrey
The Andrew W Mellon Foundation
Sir Geoffroy Millais
Mondriaan Fund, Amsterdam
Anthony and Deirdre Montagu
The Henry Moore Foundation
Daido Moriyama
Mr and Mrs Mandy Moross
Elisabeth Murdoch
The Estate of Mrs Jenifer Ann Murray
National Heritage Memorial Fund
The Netherlands Organisation for Scientific Research (NWO)
Eyal Ofer Family Foundation
Averill Ogden and Winston Ginsberg
Tony Oursler and Artangel
Outset Contemporary Art Fund
Pace Gallery
Desmond Page
Maureen Paley
Midge and Simon Palley
Irene Panagopoulos
The Paolozzi Foundation
Mrs Véronique Parke
Stephen and Yana Peel
Daniel and Elizabeth Peltz
Andrea and José Olympio Pereira
Dogan J Perese
Catherine and Franck Petitgas
Stanley Picker Trust
The Porter Foundation
Gilberto Pozzi
Frances Reynolds
Susan and Dennis Richard

Sir John Richardson
Craig Robins and Jackie Soffer
Nick and Alma Robson Foundation
Barrie and Emmanuel Roman
Keith and Kathy Sachs
The Dr Mortimer and Theresa Sackler Foundation
Elchin Safarov
The Estate of Simon Sainsbury
Sir Anthony and Lady Salz
James Scott
Robert Scott
The Search Foundation
Stuart Shave/Modern Art, London
Edward Siskind
Candida and Rebecca Smith
Clive K Smith, OBE in memory of Ann Moya Smith
The Estate of Mrs Freda Mary Snadow
Anya Souza
Sperone Westwater
Nicholas and Elodie Stanley
Susana and Ricardo Steinbruch
Mercedes and Ian Stoutzker
John J Studzinski, CBE
Marjorie and Louis Susman
Swiss Arts Council Pro Helvetia
The Estate of Jiro Takamatsu
Tate 1897 Circle
Tate Africa Acquisitions Committee
Tate Americas Foundation
Tate Asia-Pacific Acquisitions Committee
Tate International Council
Tate Latin American Acquisitions Committee
Tate Members
Tate Middle East and North Africa Acquisitions Committee
Tate North American Acquisitions Committee
Tate Patrons
Tate Photography Acquisitions Committee
Tate Russia and Eastern Europe Acquisitions Committee
Tate South Asia Acquisitions Committee
The Taylor Family Foundation
Terra Foundation for American Art
Textile Arts, Santa Fe
The Estate of Mr Nicholas Themans
Luis Tomasello
The Tretyakov Family Collection
The Uggla Family
The Vandervell Foundation
Viktor Vekselberg
Marie-Louise Von Motesiczky Charitable Trust
Offer Waterman & Co.
The Wellcome Trust
The Estate of Fred Williams
Nina and Graham Williams
Jane and Michael Wilson
Samuel and Nina Wisnia
The Lord Leonard and Lady Estelle Wolfson Foundation
Rosemary and Tony Yablon
Anita and Poju Zabludowicz
and those who wish to remain anonymous

Index

Acknowledgements

I Don't Know . The Weave of Textile Language owes its existence to the passion, dedication and perseverance of many kindred spirits. We greatly appreciate the company of all of those who over these past months and years have joined us on the journey from idea to reality, a journey which has become all the richer and more pleasurable for it.

First among these are Praful and Shilpa Shah, as well as Sanjay Shah and their team at Garden Silk Mills Ltd, Surat. *I Don't Know . The Weave of Textile Language* is rooted in Richard Tuttle's long-standing interest in textiles, their history and cultural specificities. It was the design of three textiles that was at the very beginning of translating what was the germ of an idea into a monumental work of art that would eventually fill the Turbine Hall, a feat that could not have been achieved without finding the most generous and expert of collaborators. Praful, Shilpa and Sanjay were just that and we cannot adequately thank them, and the many individuals involved in the making of the fabrics, for the love and knowledge they brought towards the task, nor for making this appear so effortless.

A project of this ambition would not be possible without the generosity of a group of committed donors whose support has been critical to the success of the project both at Tate Modern and at the Whitechapel Gallery. Stuart Shave, together with Jimi Lee, at Modern Art, London over recent years has provided much appreciated opportunities to see Richard Tuttle's work in London and we thank him for his unswerving commitment to the project from the outset, as well as for securing the conditions that allowed us to produce this publication, which is an integral part of *I Don't Know . The Weave of Textile Language*. The publication also greatly benefited from the support of Craig Robins and Jackie Soffer as well as The Barker-Mill Foundation, to whom we remain deeply grateful.

The exhibition at Whitechapel Gallery and the new commission at Tate Modern have been generously supported by the members of the *I Don't Know . The Weave of Textile Language* Supporters Circle and we are indebted to: Stuart Shave/Modern Art, London; Pace Gallery, New York, especially Arnie Glimcher and Susan Dunne; Marian Goodman at Marian Goodman Gallery, New York and Paris; Sirine and Ahmad Abu Ghazaleh; Leili Huth and Reza Afshar Kharaghan; Tomio Koyama Gallery, Tokyo; Sperone Westwater, New York; Robert T. Coffland; Textile Arts, Santa Fe; Susan & Dennis Richard; Tate Americas Foundation; and those donors who wish to remain anonymous. We also thank The Henry Moore Foundation for its support of the exhibition at the Whitechapel Gallery.

At Tate Modern we have drawn on the expertise of numerous colleagues and collaborators, both internally and externally, in the planning and execution of Tuttle's sculpture for the Turbine Hall. Their combined energy, expertise and delight in making were channelled with great sensitivity and in continuous dialogue with Achim Borchardt-Hume, Head of Exhibitions, and Hansi Momodu-Gordon, Assistant Curator. Our foremost thanks go to Jim Leaver, Project Manager, who not only astutely and indefatigably orchestrated the fabrication and installation of the Turbine Hall commission but who became a true partner, not in crime, but in creation. In this he was aided by Ken Fleary, Matthew Scott and their team of expert welders, carpenters and engineers at Scott Fleary led by Andrew Mitchell, who helped to translate fluid idea into structural hard ware. Unusual Rigging did their name proud by suspending Tuttle's sculpture mid-air in the huge void that is the Turbine Hall. Tom Johnson and his team at Lightwave helped make both the Turbine Hall commission and the Whitechapel Gallery exhibition come to life. Craig Emerson worked hand-in-hand with Richard Tuttle to fix the fabric to the plywood structure, with the support of Martin Riley and Joe White, who became an indispensable part of the crew that sailed the commission safely into harbour.

Nicholas Serota, Director, Tate, was a steadfast advocate and supporter of the project, as were our former colleagues Vicente Todolí and Sheena Wagstaff in the nascent stages of Tate's conversation with the artist. Helen Sainsbury, Head of Programme Realisation, and Rachel Kent, Programme Manager, have given invaluable support with attention to contracts and logistics. We thank Phil Monk, Installation Manager, for his good humour and patience in overseeing this complex installation, aptly assisted by Rhona O'Brien as well as Caroline McCarthy, Registrar, for organising the transport of materials from India and within the UK. We are also indebted to Stephanie Busson, Neil Casey and Helen O'Malley for the care and attention they have given to aspects of administration as well as supporting key staff. We also thank our colleagues in Learning and Interpretation: Simon Bolitho, Minnie Scott, Corinne Scurr, Sam McGuire, Sandra Sykorova, Anna Murray, Susan Sheddan, Jean Tormey, Helen Davison, Chinami Sakai, Maggie Connelly and Sarah Carne. We are grateful to all those involved in deepening the connection between this unique project and the many who will come to see it: Duncan Holden, Press Officer, Elli Cartwright, Marketing Manager, Jon-Ross Le Haye, Senior Graphic Designer, and Hannah Morgan, External Relations Officer. Very special thanks go to Clare Gill, Development Manager, whose diligence and charm provided winning arguments in assembling the aforementioned circle of supporters.

At the Whitechapel Gallery, Poppy Bowers, Assistant Curator, alongside Sophie McKinley, Acting Head of Exhibitions, and Thomas Kennedy, Exhibitions Assistant, supported Magnus af Petersens, Curator at Large, in researching and bringing together works created over a fifty-year period. Each piece has been beautifully installed by Chris Aldgate, Head of Exhibition Design and Production and his team, Gallery Manager Patrick Lears and Installation Coordinator Tom Fleming.

Tuttle has suffused the public programmes with his heady and playful lyricism, inviting 'Wordsmiths' from poets to chefs and from lawyers to scientists, to join him in a series of events. In this he has found eager collaborators in the education team led by Daskalopoulos Head of Public Programmes, Sofia Victorino.

Bringing works from around the world is a costly business and our thanks go to the development team: Imogen Topliss, Individual Development Manager, Sue Evans, Development Manager, Andrea Ziemer-Masefield, Senior Development Events Officer, led by Darryl de Prez, Head of Development, for all their work in fundraising. We are committed to widening participation a task brilliantly undertaken by our Communications team, Anna Jones, Media Relations Manager, Sophie Thornberry, Marketing Manager, and Lucy May, Design and Production Manager, led by Rachel Mapplebeck, Head of Communications.

The artist has a long history of creating multiples and prints. We are deeply indebted to Richard for creating a superb edition, the proceeds of which support both Tate and Whitechapel Gallery. Behind the scenes our thanks go to Jo Melvin, Editions Manager and Gino Brignoli, Commercial Manager, Whitechapel Gallery; Rosey Blackmore, Merchandise Director, Tate Enterprises; Sidney Felsen, Gemini, for help in the early stages; and Stephanie Wagner for her collaboration.

An exhibition is the temporary constellation of works that are in public and private collections. For their tremendous generosity in lending works Whitechapel Gallery Trustees join us in thanking Brooke Alexander Inc, New York; Collection Michalke; Crown Point Press, San Francisco; Collection Lambert, Avignon; Collection of Craig Robins, Miami; CNAP Centre national des arts plastiques (France); Galerie Ulrike Schmela Berlin; Gian Enzo Sperone, Switzerland; Jacquelyn Soffer, Nominee; Museum of Contemporary Art Chicago; National Gallery of Art, Washington; Pace Gallery New York; Richard Tuttle; Stedelijk Museum, Amsterdam; Stuart Shave/Modern Art, London; Tate; Juan Carlos Verme; Verme Brothers Lima; as well as those who wish to remain anonymous.

In the hands of Richard Tuttle the book becomes another art form; our thanks to Kie Ellens who has lent a dazzling selection of his exquisite publications to accompany the Whitechapel Gallery exhibition. The Whitechapel Gallery is also very grateful to the wonderful shippers Simon Dent and Pino Escurin at Martinspeed who move works of art around the world with such care and efficiency.

Permission to reproduce the works was given by Annemarie Verne Galerie; Centro Galego de Arte Contemporánea, Santiago de Compostela; Collection Stedelijk Museum, Amsterdam; Getty Images; Kunsthuas Zug; Mary Boone Gallery, New York; Moderna Museet, Stockholm; Museum of Contemporary Art Chicago; Museum of Modern Art, New York/Scala Florence; National Gallery of Art, Washington; Pace Gallery, New York and Stuart Shave/Modern Art, London; Sammlung Michalke; CNAP Centre national des arts plastiques; Collection Lambert, Avignon; Brooke Alexander, Inc., New York; Crown Point Press, San Francisco, CA; Sperone Westwater, New York; Textile Arts, Inc., Santa Fe, New Mexico; The Fabric Workshop and Museum, Philadelphia. Invaluable guidance was also offered by colleagues at SFMOMA: Anya Graetch, Administrative Assistant, Painting and Sculpture; Sriba Kwadjovie, Intellectual Property Associate and Amanda Glesmann, Editor, Publications at SFMOMA.

I Don't Know . The Weave of Textile Language comprises three components that while distinct, form an inseparable unity. However, only one of these will last beyond the ephemeral nature of installation and exhibition, namely the present publication. Rooted in the singular vision and unique spirit of the artist this was brought into being principally by Mark Thomson, whose thoughtful approach to both image and text informs every aspect of this book. Whereas photographic reproduction more often than not seems to drain textiles of their liveliness here they seem to move and breathe thanks to the eye and skills of acclaimed photographer Nick Danziger who responded to our invitation to photograph textiles from Tuttle's personal collection with much valued enthusiasm. In this he was ably assisted by Ryszard Lewandowski, Senior Art Handling Technician. Olympus Cameras UK provided invaluable support with the microscopy photography. Marcus Leith and Andrew Dunkley in Tate Photography documented the process of installation in great detail, while James Morris captured the final installation masterfully to convey a sense of scale and proportion within the confines of the pages of a book. Rosemary Crill and Clare Browne, two esteemed curatorial colleagues at the Victoria and Albert Museum, were crucial conversation partners in the early stages of the project and we thank especially the latter for her help with fact-checking and consistency. We also gratefully acknowledge Roger Thorp, Publishing Director and his team at Tate Publishing: Nicola Bion, Roanne Marner, Christopher Mooney, Emma O'Neill, and Emma Woodiwiss.

On behalf of Richard Tuttle we would like to express gratitude to Mary Hunt Kahlenberg, The Getty Research Institute, and Alfred and Suzanne Saulniers.

To all of them, and the many more who cannot be named here, we express our deepest gratitude.

Our final thanks are reserved for Richard Tuttle himself: for the determination with which he insists on his singular way of looking at and thinking about the world, and for his generosity in sharing this with others by virtue of making his work. To have been part of his endeavour has been both a pleasure and privilege for all of us.

Iwona Blazwick
 Director, Whitechapel Gallery
Chris Dercon
 Director, Tate Modern

Credits

First published 2014 by order of
the Tate Trustees
by Tate Publishing, a division of
Tate Enterprises Ltd,
Millbank, London SW1P 4RG
www.tate.org.uk/publishing

on the occasion of the exhibition
and commission
I Don't Know . The Weave of Textile Language

Tate Modern, London
14 October 2014 – 6 April 2015

Whitechapel Gallery, London
14 October – 14 December 2014

The publication has been made possible with
the support of:

Stuart Shave / Modern Art, London
Craig Robins and Jackie Soffer
The Barker-Mill Foundation

The exhibition and commission have been
generously supported by the *I Don't Know . The
Weave of Textile Language* Supporters Circle:

Stuart Shave / Modern Art, London
Pace Gallery
Marian Goodman Gallery
Sirine and Ahmad Abu Ghazaleh
Leili Huth and Reza Afshar Kharaghan
Tomio Koyama Gallery
Sperone Westwater
Robert T. Coffland
Textile Arts, Santa Fe
Susan & Dennis Richard
Tate Americas Foundation
and those donors who wish to remain
anonymous

with additional support at Whitechapel Gallery
by The Henry Moore Foundation

Textiles for the Turbine Hall commission have
been generously provided by Garden Silk Mills
Ltd, Surat

Supported using public funding by
ARTS COUNCIL ENGLAND

A catalogue record for this book is available
from the British Library

ISBN 978 1 84976 319 6

Distributed in the United States and Canada
by ABRAMS, New York

Library of Congress Control Number
applied for

Designed by Mark Thomson

Set in Sabon Next and Brown
Colour reproduction by die Keure
Printed in Belgium by die Keure

Photography pp.2–3, 12–65, 156–7, inside cover
by Nick Danziger
Photography pp.6–7, 166–93, cover
by James Morris

Measurements of artworks are given in
centimetres, height before width and depth